MEDIA MATRIX

SEXING THE NEW REALITY

Barbara Creed

ALLEN&UNWIN

First published in Australia in 2003

This book has been assisted by the Commonwealth Government through the Australia Council, its arts and advisory body.

Allen & Unwin
83 Alexander Street
Crows Nest NSW 2065
Australia
Phone: (61 2) 8425 0100
Fax: (61 2) 9906 2218
Email: info@allenandunwin.com
Web: www.allenandunwin.com

National Library of Australia
Cataloguing-in-Publication entry:
 Creed, Barbara.

 Media matrix: sexing the new reality.

 Includes index.

 ISBN 1 86508 926 5

 1. Sex in mass media. I. Title.

306.7

Typeset in 10.5 pt Palatino by Midland Typesetters, Maryborough Victoria
Printed by CMO Image Printing Enterprise, Singapore

10 9 8 7 6 5 4 3 2 1

This book is dedicated to my late mother, Nanette, who brought me up to believe that nothing is more important than standing up for one's beliefs.

Contents

Acknowledgements

As is often the case, this volume has taken longer than planned and I would therefore like to thank friends and colleagues for their extra support and assistance: Mark Nicholls, Scott McQuire, Angela Ndalianis, Felicity Colman and Tim Drylie. Thanks are also due to Shaune Laikin for his research, Freda Freiberg for her critical comments and Mark Spratt of Potential Films for his generosity.

My thanks in particular go to my editor Emma Cotter for her expert criticism, professionalism and her remarkable Xray vision when it comes to spotting errors. I also wish to thank Claire Murdoch for her invaluable comments, Elizabeth Weiss for her support and all of the staff from Allen & Unwin who helped put the book together. I owe the anonymous readers from Allen & Unwin a special thanks for their insightful comments.

John Iremonger, who died before the book was completed, supported this project in his unique and indomitable way. He is greatly missed.

Many thanks to Ishara for her spontaneous comments on *Big Brother*.

Various parts of this book were presented to audiences from whose feedback I benefited enormously. The University of Melbourne provided assistance in the form of research leave and the Centre for Cross Cultural Research, Australian National University, Canberra, provided a fellowship which allowed me just the right space to write the final chapter 'The global self'.

Most importantly, I would like to thank Jeanette Hoorn for her unfailing intellectual and emotional support and for keeping the author in good spirits.

Introduction

matrix—womb; place in which thing is developed. [L= breeding-female, womb, register (mater matris) mother]— The Oxford Dictionary of Current English, 1975

In Kathryn Bigelow's futuristic cult movie, *Strange Days* (1995), the main character, a techno-drug dealer, just loves to 'jack in', to experience exactly what it is like to be inside the mind of another person. 'Jacking in' has the power of a reality-altering drug. All the user has to do is attach a device called a 'squid' to the skull and let its transmitter create a virtual world of someone else's memories. 'Jacking in', or experiencing 'playback', opens up a world of virtual reality. The only problem is that the new world may not be a happy or pleasant one. The squid software might take you on an orgasmic trip, or the software might be 'blackjack', that is, a snuff movie which compels you to live through someone else's death. The difference between 'jacking in' and going to a movie—as one of the characters wryly comments—is that in the movies 'the music comes up and you know it's over'. The hit blockbuster *The Matrix* (1999) took the experience of 'jacking in' to a higher level. The characters of *The Matrix* discovered that the world in which they lived was a gigantic hoax; it didn't exist. The world was actually a form of virtual reality manipulated by the Matrix, a virtual or cyber womb with the power to clone reality.

From its beginnings in fin-de-siècle culture, the popularity of the cinema was based on the promise of being transported,

1

through the powers of identification, into the world of the main character; the spectator could sit back, relax and enjoy the thrill of watching moving images and imagining they were somebody else. In the twenty-first century, virtual reality promises the cyber traveller the thrill of actually being somebody else, of sharing their most intimate experiences exactly as they happen. Cyber sex promises the possibility of experiencing sex in a myriad new ways: disembodied sex, sex with strangers, sex as somebody else, virtual sex (see Chapter 7).

A crucial difference between earlier media formats and the new virtual ones is the relationship of each to 'distance'. Whereas the older media forms always maintained a distance, or gap, between the user and the medium in question, the newer forms promise to obliterate that distance, to 'jack in', to close that gap forever. Through the powers of virtual reality, the individual may enter a cyber world which is indistinguishable from the real world. This is one of the key paradoxes of virtual reality. If the virtual world is impossible to distinguish from the real world, why go there in the first place? Presumably because one can enter and leave at will, adopt a new identity, establish relationships one might not normally entertain. The virtual world offers flexibility, fluidity, fantasy.

There are other key differences. The new formats (film, radio, television, newspapers, popular fiction) of the first half of the twentieth century emerged from a media matrix characterised by the modern thirst for the new, the need to understand and communicate, the fascination with the unusual and perverse, and the desire to be amazed or shocked. The virtual media of the late twentieth and twenty-first centuries (the Internet, email, websites, virtual reality) are characterised by the postmodern impulse to play with reality, obliterate time and distance, cross borders, destabilise notions of a fixed personal identity and immerse oneself in the activity of becoming other. Despite crucial differences, one constant subject which all media forms—old and new—have in common is an intense interest in the human subject and sex—sexuality, sexual expression, desire. Because the new virtual media and sexual desire are both potentially diverse, multilayered and free-flowing, the two areas have the potential to complement each

other, to offer individuals an array of opportunities in which they might experience sexual complexity and diversity.

A central aim of the essays in *Media Matrix* is to analyse various media formations (cyberfilm, reality TV, the woman's romance, virtual pornography, crisis TV, the Internet, queermedia, cybersex, virtual reality) and their representation of sexuality and the self in order to explore the changes brought about by the new forms of reality. A second key aim is to examine the breakdown of traditional boundaries between public and private. The various chapters, which have been written to stand alone, also question the extent to which the media have been prepared to endorse ideas associated with radical change, particularly in relation to sex, sexual preference, masculinity, the lesbian and gay world, pornography, virtual sex. Has reality TV affected the way viewers think about sex and relationships? Given that pornography has entered the mainstream, does it make sense any more to talk about pornography as offering an alternative view of sex? Does pornography made by women challenge mainstream porn? Does *Sex and the City* really challenge every taboo known to society? Why do women enjoy writing slash fiction? To what extent will the creation of cybersex change the way people think about and experience sexual desire?

Media Matrix also looks at the emergence of a new way of thinking about the self: through the metaphor of the global self. The idea of the global self brings together the characteristics which historically have been described as 'feminine' and assigned to the media and popular culture—as distinct from those of the so-called classical, higher or elite forms of culture (Huyssen 1986). Like the new virtual media, the global self is fluid, hybrid, mobile and interactive not only in relation to identity and sexuality, but also in terms of the politicisation of the self (see Chapter 11). The global self does not see others in terms of classical oppositions such as male/female; white/black; straight/gay; global/local. Rather, the identity of the global self is multiple, fluid, malleable and multisexual. The global self morphs across boundaries into unknown spaces.

Boundaries are ultimately essential to the definition of what it means to be 'human', 'civilised', 'progressive', 'cool', 'wired',

'virtual'. Boundaries and the exciting promise of their total collapse—a possibility which is almost always withdrawn as soon as it is raised—also ensure the continuing existence of media debate. In western democracies, the media's questioning of and play with boundaries have also proven essential to the complex processes of social, cultural and political change and, in some instances, advanced radical thinking about sex. These essays do not argue that the boundaries under discussion—whether associated with the traditional or virtual media forms—have actually collapsed; rather, they argue that the traditional media, while seeking to undermine boundaries, are simultaneously always in the process of drawing new ones, new philosophical and moral borders beyond which one should not push or penetrate just yet. The virtual media, however, offer the possibility of traversing boundaries altogether. Women are now beginning to use the Internet in greater numbers than ever before. Does the virtual world offer women, whose powers of communication are considered equal to if not greater than those of men, a potent world of new freedoms?

Cynics might argue that the media, particularly tabloids, sex films and pornography, set out solely to transgress traditional boundaries, particularly moral and sexual boundaries, in order only to increase circulation and profit. Even if this were true, it does not necessarily change what the public does with the information it gathers and the emotional and aesthetic experiences it undergoes in its interaction with the media. Like Neo from *The Matrix*, the modern subject is eager to explore unknown territory and to make new discoveries, even if doing so involves the blurring of boundaries between the public and private, reality and fantasy.

Historically, the public sphere has been defined as a male domain designed to separate the public worlds of business, politics, law and commerce from the private domestic terrain of home, family, sexuality, women and children. The media, and in particular journalism, were initially intended to be the impartial voice of the public sphere. Before the arrival of television in the 1950s' household, many writers considered it improper to report publicly on intimate personal matters such as family life,

sex, relationships, health, housework, divorce, abuse, addiction—the very topics which have become central to contemporary media—from the evening news to TV sitcoms. Gradually, the media have feminised the public arena, which helps explain why some critics argue that the media, in comparison with high art, constitute a debased and feminised cultural formation. In this context, the media have truly emerged from a matrix, a point of origin which is definitively female.

The mass media have eroded, decisively and fundamentally, the boundaries that traditionally separated the spheres of public and private. In the first half of the twentieth century, the new popular media (the press, cinema, radio, pulp fiction, television) played a key role in the gradual transformation of the distinction between public and private spheres. People married via the telegraph, witnessed the first screen kiss and watched intimate dramas of family life unfold in public cinemas, and learned about sex scandals, political corruption and the state of world politics by reading newspapers and listening to the radio. The movies brought intimate sexual and family dramas into the public arena: radio, newspapers and television brought public, national and international politics into the private domain of the home. At the beginning of the twenty-first century, the new virtual media (the Internet, cable and satellite television) continue the process of eroding boundaries. The media no longer report on politicians, for example, solely in terms of party politics, power and the public. The private life of politicians is considered just as newsworthy: their relationships, private affairs, sexual peccadilloes, personal habits, lifestyle choices.

After Bill Clinton's affair with Monica Lewinsky had been made public, the independent prosecutor, Kenneth Starr, released his voluminous report onto the Internet, making it instantly available to Internet users worldwide. *The Starr Report* contained detailed descriptions of intimate sexual acts between the President and Ms Lewinsky. The *Washington Post* stated that the report included details of at least twelve sexual encounters, some of which were described in such lurid detail that they could not be presented in the mainstream electronic or print media. Some people were outraged, calling for cyber censorship to protect their

children from exposure to the details of the Internet's most infamous affair. The posting of the report on the Internet aroused so much public interest that the public was warned that they might not be able to log on because of congestion on the site.

The posting of intimate details of the Clinton–Lewinsky affair on the Internet, available to a global audience, not only created a new form of virtual political-porn; it also eroded for all time the distinction between public and private spheres in relation to the lives of the rich and famous. Significantly, however, the publicisation of the affair did not result in a fall in President Clinton's public approval rating. On the contrary, his personal popularity rose. What the event ultimately did was draw an even wider division between the majority of people, who did not want to judge the President in relation to his private life, and the moral minority, who believe that one's private life should be open to public scrutiny. Ironically, it was the latter group that made the lurid details available to the world. The Clinton–Lewinsky scandal created a space on the Internet that was intimately public and publicly private.

As a matter of philosophical and moral commitment, some forms of the media may endorse the values of openness and change so strongly that they are prepared to run the risk of offending sections of the public. By reporting on and representing world crises, sensational events and extreme forms of human behaviour— whether in newspapers, television dramas and documentaries, pornographic novels or film—the media have found themselves exploring previously taboo areas, particularly in relation to sexuality and the meaning of the self. In other words, the media bring the individual into contact with those things which threaten the definition of what it means to be moral, civilised and, in some instances, human. One area in which all cultures have drawn up rigid boundaries governing behaviour is sex.

Theorists such as Sigmund Freud, Michael Bakhtin and Julia Kristeva have explored the role of boundaries or markers in human cultures. Their ideas are helpful in understanding the modern subject, changing attitudes to sexuality and the emergence of a sexualised media sphere in which pornography has invaded the mainstream. The evolution of the media and

psychoanalysis run parallel, in that both were born into the modern world and shaped by its sexual ethos: the desire for free sexual expression, a personal interest in the self and the importance of sexual happiness.

Regarded as the founder of the modern conception of the self, Freud argued against traditional notions: the self was not some pre-given divine essence implanted in the body at birth; nor was it a superior, transparent entity which interpreted the world around it according to positivist, rational principles (Robinson 1993, p. 116). Rather, Freud saw the self as an evolving, active force, a participant, interacting with people and events in the outside world in ways which it did not necessarily understand or even condone.

In 1901 Freud published *The Interpretation of Dreams*, based on his analysis of his own dreams and on his theory of the unconscious. To Freud, the concept of the unconscious was indeed revolutionary. It can be best thought of not as a 'place' in the mind but as a way of thinking, responding to its own laws of operation, such as those of repression and displacement. The key aspect of the unconscious is that it exerts a profound influence on conscious thought and behaviour. Influenced not just by conscious thoughts but also by irrational forces, unconscious desires, secret wishes and even by events beyond its comprehension, the self, Freud argued, was actively implicated in its own decisions and responses, even if it did not always understand the rationale for these. Freud's theories attacked the traditional belief that the individual was a rational being in full control of his or her actions. 'Above all, the modern self is a site of internal tension and conflict. This new conception made Freud the central figure in the emergence of the modernist sensibility in the early twentieth century' (Robinson 1993, p. 117). This sensibility sought to question older, traditional forms of thinking, to see the self as a mix of rational and irrational desires and behaviours.

Freud's theory of the modern subject helps us understand the interconnected and complex ways in which a person might respond to the popular media. The Freudian self is open to dialogue with the media. If Freud had analysed the modern media—from newspapers and radio to the Internet and virtual

reality—he would not have pictured the self as a passive helpless thing so damaged by the supposed lies and sensationalism, pornography and violence of the media that it was turned into a mindless puppet, hysteric or violent psychopath, as some conservative media critics would have us believe. The key question becomes not what the media *do to* the individual but what the individual *does with* the media. The modern subject is thus, I believe, positioned as an active participant in his or her encounters with the media.

The essays in *Media Matrix* endorse the view that meaning does not reside out there 'in the media text', but that the reader or viewer actively produces meaning as she/he engages with the text. There is not one 'true' or fixed interpretation or point of view, but many interpretations. The media's intense interest in the sexual subject has largely been characterised by a plurality—but not equality—of viewpoints. From their beginning, the modern media have explored different forms of sexual desire and behaviours—often to the point of invoking enraged responses from conservative sections of the public. The modern subject as understood by Freud is open to all kinds of debates about sexuality because sexuality is never transparent, 'fixed' or 'complete'.

Freud was interested in the relationship between boundaries, subjectivity and repression. Drawing on the work of anthropologist Mary Douglas, Julia Kristeva has explored the role of the abject in the creation and maintenance of boundaries. Boundaries are central to religion and ritual, and to the definition of what it means to be civilised and human (Kristeva 1982).

All societies construct notions of the abject. At the same time, the abject is constituted by those things or acts which cross the boundary between civilised and uncivilised. The abject is also relative; its definition changes from society to society. All societies define the abject in relationship to sex. In many, abject sexual behaviour would include incest, homosexuality, sado-masochism, bestiality and necrophilia. The display of bodily fluids such as semen, urine, faeces and menstrual blood in a sexual context would be considered by many as abject.

The crucial thing about the abject is that although it repels, it also fascinates. The human subject is deeply attracted to those

things which the culture defines as uncivilised, 'other', non-human. In order to know what one is, the human subject must know what it is not. In the West, where people enjoy relatively comfortable modes of living, the public has turned more and more to the media as the main avenue for contact with, and understanding of, the abject. The media bring images of abjection—war, violence, sexual perversity, child abuse, cruelty, death—to the public. To pretend that the abject is not a crucial part of daily life is to deny the realities of human nature. To decry the necessary emergence of an abject media sphere is shortsighted and foolish.

The prime task of the popular media is to record and respond to the processes of change, to comment on events—whether uplifting or abject—as they occur. Since the beginnings of modernity, change has taken place with increasing rapidity in the social, cultural and moral spheres of daily life. In times of crisis, such as September 11, the public may turn to religion for comfort, but it is far more likely that the media will guide and shape public thinking. In the case of sexual controversies, such as the exhibition of so-called obscene works of art (Andre Serano's *Piss Christ* exhibit) or the screening of provocative films (*Romance,* 1999; *Baise-Moi,* 2000), it is the media which will offer the individual the most relevant and up-to-date commentary and criticism. The media are at the forefront of change. Part of the power of the film *The Matrix* is that it explores the meaning of one of the media's newest phenomena, virtual reality. Morpheus, the rebel leader, asks Neo, the saviour, this question: if he had a dream that was so real he couldn't wake up, how would he be able 'to tell the difference between the real world and the dream world'? Neo is unable to answer.

The media tell stories of human behaviour—uplifting and abject—to a public which may respond either by consolidating its resistance to change or by gradually accepting and adjusting to the material it has encountered. The process is neither simple nor transparent. Individuals relate to new information in a myriad complex ways; in the end, however, the majority of people will either reject or endorse the gradual shifts that take place in the wake of cultural, sexual and social change. In other words, in

an increasingly secular world, the contemporary media have adopted the traditional role of a ritual guide; it has become the media's responsibility to steer the public on a journey into unknown spaces, and to return the travellers to familiar ground where they are able to think about what they have experienced or encountered (see Chapter 10).

In relation to the reporting of real-world crises, the media are not neutral or impartial observers: the media are participants, pathfinders whose own perceptions of an event, such as the global movement of refugees or the September 11 attack on the World Trade Center, are susceptible to bias and distortion. It is the responsibility of the media to seek accurate information, demystify hype, present careful analysis, reject emotional reportage and scare tactics and provide a context within which the public can assess the situation thoughtfully and intelligently. It is also the responsibility of writers, artists and filmmakers to represent their material with similar respect for the public, and to avoid prejudice and stereotyping.

The media frequently draw upon the political potential of humour to explore diverse forms of sexuality. In his writings on the political significance of cultural events such as carnivals, fairs and public theatre, Michael Bakhtin argued that the maintenance of class and gender boundaries is essential to the proper functioning of society, but that a period of time—that of carnivals and fairs—when the boundaries are relaxed and values are turned upside down is also essential (Bakhtin 1984).

Bakhtin was writing about the sixteenth century, but it is clear that modern forms of the carnivalesque still exist—in the rock concert, Mardi Gras, sporting carnival and cinema, for example. These occasions, when everything seems topsy turvey, act as a kind of safety valve, creating a space where people can let off steam and legitimately overturn rules and regulations. The Sydney Gay and Lesbian Mardi Gras, one of the largest festivals of its kind in the southern hemisphere, offers a perfect example of a contemporary carnival in which conventional attitudes towards sexual preference, bodily display and gender roles are temporarily upset, overturned, satirised. Popular culture and the media are also carnivalesque. In their more popular forms and

genres (television talk shows, soaps, Hollywood comedy, underground comics, women's romances, pornography, Internet chat rooms), the media create a space in which boundaries are traversed and prevailing moral values and acceptable modes of behaviour are challenged. The media, actually or potentially, have the power to constitute a contemporary form of the carnivalesque.

Film, television, computer images, virtual reality—these media forms do not merely appear to capture the real world in accurate vivid images; they also have a directness, a visual transparent immediacy which speaks with a new immediacy to the modern subject. The contemporary viewer's desire for immediacy and public displays of intimate, private moments has led to the recent phenomena of reality television programs such as *Big Brother* and Internet sites which show people having sex, getting married, dying. The Oklahoma bomber, Timothy McVeigh, suggested his own execution be screened worldwide on the Internet as it took place. Although his request was refused, his desire to die before a global audience is symptomatic of the shift that is taking place in the traditional relationship between public and private. The power of the modern media to create an impression of immediacy and realism means that media representations of the abject (images of death, victims of accidents and war, instruments of torture, scenes of deviant sexual behaviour) can be conveyed with great intensity, hence increasing the fascination of the taboo. It could be argued, on the one hand, that the degree to which the media hold back from revealing too much of reality, thus maintaining the taboo, depends on the relative strength of censorship bodies. On the other hand, it could be argued that one of the functions of the media is to permit the individual to come into contact with those acts which threaten the norms of the day, to create a legitimate space for interchange before withdrawing and redrawing the boundaries established by the dominant social and cultural discourses of the day.

The media play with boundaries—trouble, tease, undermine, confront. For some concerned members of the public the media have already gone too far, particularly in relation to the topic of sex and the concept of the self as less fixed and more fluid, open to change and experimentation. Traditionally, it was the role of

religion to draw the line between the acceptable and the taboo. If this task has been taken over by the media, then a fundamental change has taken place, a change which signifies the end of a role traditionally assigned to religion. Now everything rests with the self—a global self which, through the power of the Internet and new media, is able to easily communicate around the world, experience life from the viewpoint of others. The media matrix continues to gestate . . . it will eventually give birth to new media inventions, and advanced forms of virtual reality. If the world does not exist—as *The Matrix* argues—the media will be the first to break the news.

References

Bakhtin, M. 1984, *Rabelais and His World*, trans. H. Isowlsky, Indiana University Press, Bloomington and Indianapolis.

Freud, S. 1982, *The Interpretation of Dreams*, Pelican Freud Library, vol. 4, Penguin Books, Harmondsworth.

Huyssen, H. 1986, 'Mass culture as woman: modernism's other', in T. Modleski (ed.) *Studies in Entertainment*, Indiana University Press, Bloomington and Indianapolis.

Kristeva, J. 1982, *Powers of Horror: An Essay on Abjection*, trans. L.S. Roudiez, Columbia University Press, New York.

Natoli, J. and Hutcheon, L. 1993, *A Postmodern Reader*, State University of New York, Albany.

Robinson, P. 1993, *Freud and His Critics*, University of California Press, Berkeley.

1

Film and fantasy: The perverse gaze

Your graduation from innocence to experience occurs when the feverish business of imagining begins—Peter Conrad, *The Hitchcock Murders*, 2000, p. 3

Today it is difficult to imagine the public outrage generated when Fatima, who had performed a belly dance (the 'hoo-chi-coochi') at the Chicago World's Fair in 1893, made her debut on film. The sight of her hips 'moving' (she was fully clothed) was considered too shocking for the decent citizen to see in its entirety—as a result, two panels were inserted, over the top and bottom half of her body, to prevent an unimpeded view of her performance (Lennig 1975). Ironically, partial glimpses of Fatima's body no doubt increased the sense of titillation. Fatima's belly dance provoked one of the world's first cases of film censorship. It doubtless inspired Elvis Presley's hit 'Little Egypt' (Fatima's stage name), in which the provocative crooner did not mince his words: 'Little Egypt came a struttin' wearing nuttin' but a button 'n a bow/She let her hair down and she did the hoo-chi-coochi real slow'. Little Egypt's screen fame lives on in popular song.

During the first decades of the twentieth century, world audiences clamoured to see the latest attraction and to experience a sense of connectedness with people from other cultures. Described as the 'Esperanto of the eye', silent cinema spoke to all people regardless of nationality; optimists hoped that the world's newest art form would unite people globally and do away with the possibility of another world war. One thing

audiences all over the world did share was a marked interest in sexually explicit narratives. The preponderance of sexual themes in early films makes it clear that audiences wanted to be aroused, to experience the thrill of being shocked by what they hoped to see in the first place. Film appealed to a universal human characteristic—voyeurism. *The Tiger Woman* (1917), *Prisoner of the Harem* (1913), *When A Woman Sins* (1918)—titles such as these were designed to draw crowds to the early peep and movie shows. The growth in nickelodeons and movie houses catered to the rising demand from the modern individual. As the cinema became more and more popular, it was publicly denounced by various civic and church groups who claimed the moving image was 'bad for the eyesight' and even worse for public morality. By 1912, just five years after the first short narrative films began to appear, London had 400 cinemas, and in the United States approximately 5 million people per day visited cinemas. In 1913 the Melbourne *Argus* claimed that an eighth of the Australian population went to the movies on a Saturday night. Gradually, the cinema was attended by all social classes—even the wealthier, better-educated middle class, which initially shunned the new art form as vulgar entertainment for the illiterate. By 1914 film had become the most popular form of entertainment in the world; it remains so today. It had evolved into an affordable universal art form with mass appeal.

The increasing permissiveness of the film industry, during the 1920s and early 1930s, combined with heated debates over censorship, helped create an environment in which it was acceptable to refer to issues once considered shocking. The 'fallen woman' cycle of films justified discussion of topics such as adultery, unwanted pregnancy and prostitution. Newspaper articles on sex, from reviews of the latest hot movie to salacious tales of the scandalous lives of Hollywood film stars such as Roscoe (Fatty) Arbuckle, legitimated public discussion of once taboo subjects. Not everyone applauded the ascendancy of film; those who believed the moving image had the power—more than any other art form—to corrupt the individual were particularly damning. In the 1930s the Catholic Church began to publish 'white lists'— lists of films it deemed suitable for viewing.

From its inception, the cinema explored themes of vampirism and necrophilia (*Nosferatu*, 1922), the white slave trade (*Traffic in Souls*, 1913; *A Fool There Was*, 1928), sadism (*The Cheat*, 1915), prostitution (*Blonde Venus*, 1932), bestiality (*Island of Lost Souls*, 1933; *King Kong*, 1933), miscegenation (*Trader Horn*, 1931), sex and death (*Pandora's Box*, 1928). Despite the introduction of a censorship code in the early 1930s, public interest in the taboo did not dissipate; during periods of strict censorship the representation of perverse themes was either disguised, expressed through the workings of the sub-text, or explored in a genre which appears to have been created specifically in order to shock—the horror film.

Almost a century after the first films appeared, world audiences are still drawn to the cinema for its power to disturb and shock. When popular entertainment films tell stories of sex and desire, they speak to a very large audience. The introduction of sound did not weaken the global appeal of film; the power of the moving image to communicate allows film to bridge cultural divides, notwithstanding the techniques of dubbing and subtitling. In particular, audiences remain fascinated by the perverse. Films continue to delve—but with greater explicitness—into taboo areas: necrophilia (*Bad Timing*, 1980; *Kissed*, 1996), bestiality (*Max My Love*, 1986; *Cat People*, 1982), sado-masochism (*The Night Porter*, 1974; *Maitresse*, 1976; *Basic Instinct 1992*), anal sex (*Crash*, 1996) even inter-species or alien rape (*Elephant Man*, 1980; *Rosemary's Baby*, 1968; *Alien*, 1979 and *Aliens*, 1986). A film that signifies a benchmark in sexual transgressiveness has created controversy in each decade—*Midnight Cowboy* (1969), *Last Tango in Paris* (1972) and *Basic Instinct* (1992).

More recently, audiences have flocked to films about serial killers, sex and cannibalism. Commencing with Alfred Hitchcock's *Psycho* in 1960, the first film to locate horror within the family, public interest in the serial killer has remained constant. Films such as *Texas Chain Saw Massacre* (1974), *Halloween* (1978), *Friday the 13th* (1980), *Seven* (1995), *Copycat* (1995) and *American Psycho* (2000) are classics of the genre. Public interest in sex and cannibalism rose to new heights with *Silence of the Lambs* (1991) and *Hannibal* (2001). Sexually explicit films that draw on the conventions usually associated with pornography have now entered the mainstream with

Basic Instinct, Crash, 8MM (1999) and *Sitcom* (1998). Two French films by women directors, *Romance* (1999) and *Baise-Moi* (2000), depict scenes of actual, not simulated, sex. Films which depict violence in surreal and shocking ways have drawn huge audiences. These include *Fargo* (1996), *Reservoir Dogs* (1992), *Pulp Fiction* (1994), *8MM* and *American Psycho*. Special effects Hollywood blockbusters, such as *The Terminator* (1984), *Die Hard* (1988), *Speed* (1994) and *Mission Impossible* (1996) have transformed the genre through the aestheticisation of sex and violence. Postmodern teen horror films such as *Scream* (1996), *I Know What You Did Last Summer* (1997) and *Scary Movie* (2000) stage scenes of gory horror in mocking, self-referential modes. For those who enjoy deliberately transgressive films, there is much to see. Even television has become more sexually explicit. Film Four in London has transmitted *Man Bites Dog* (1992) uncut. The sexually explicit gay sitcom *Queer as Folk* is available on cable and, in Australia, on free-to-air.

The adherents of Dada and surrealist avant-garde art were perhaps the first to recognise the power of film to shock the viewer. They set out to use the world's newest art form to upset ideals of middle-class order and respectability, conformity, monogamy, religious piety and sexual purity. Their early films, such as *Entr'acte* (1924), *The Seashell and the Clergyman* (1927), *Un Chien Andalou* (1929) and *L'Age D'or* (1930), explored themes of religious repression, sexual perversion, *l'amour fou*, violence, death and the absurd. They also deliberately eschewed the art of logical storytelling in favour of narratives which made no sense and which progressed in the manner of a dream or nightmare. The darlings of the avant-garde, these outrageous filmmakers upset audiences (who pelted the screen with fruit and vegetables) and the Catholic Church, which immediately banned what it considered their most offensive creations. Now acknowledged as masterpieces of early cinema, these films are taught in university film courses around the world.

When Luis Buñuel learnt that critics had described his shocking film, *Un Chien Andalou*, as 'poetic', he expressed dismay; he saw the film, which he made with the painter Salvador Dali, as 'a passionate, desperate appeal to murder'. *Un Chien Andalou* commences with the opening line of all fairytales: 'Once upon a

time . . .'. A good-looking young man (Buñuel himself) stands by a window, smoking. The cigarette hangs casually from the side of his mouth as he carefully sharpens a razor. Through the window he sees the full moon and a solitary cloud moving across the night sky. A young woman stares ahead; her eyes look into the eye of the camera. A cloud cuts across the moon; the razor slices an eye. It seems as if this is the girl's actual eye. In tight close-up, the jelly-like contents of the slit eyeball spill forward. Subsequent viewings do not lessen the shocking impact of that image. Although Buñuel and Dali argued passionately that their film defied interpretation, it is tempting to see the slashed eye as a metaphorical warning that everything which is to follow will speak not to actual vision but the mind's inner eye. From 1928 to the present, the surrealist's eye has continued to haunt the cinema, from the giant close-up of Norman Bates' voyeuristic eye in *Psycho* to the inhuman eyes of the cyborg in *Terminator* and the terrified eyes of *Minority Report* (2002). In the last-mentioned, electronic spiders storm an apartment block in order to scan the retinas of the inhabitants, who seem used to such shocking invasions of their privacy.

Why do the perverse and shocking still exert such a fascination for cinema audiences? American film theorist Mary Ann Doane argues that:

> Sexual desire for the modern consciousness is never an entity
> in itself but the by-product of the moral ideals which will
> never fully and finally collapse and whose taboos engender its
> excitement and terror (Doane 1991, p. 159).

This is why cinema's depiction of the taboo is so successful. Mainstream film thrives on the tension created between the public's desire to see all and cinema's refusal to reveal all; cinema insists on reintroducing and reinforcing the power of the taboo, which is ultimately what engenders terror and shock.

Much has been written about spectatorship in early modernity, with emphasis on the gaze not as voyeuristic, but as marked more by astonishment and amazement (Gunning 1986). Viewers of the first films could not believe their eyes as they watched

images of the real world flickering across a screen. As films began to tell complex stories, the gaze of the spectator became more voyeuristic, particularly as the female body was placed on exhibitionistic display (Mulvey 1975). With the advent of sound in the late 1920s, narratives were able to encourage close viewer identification with the main protagonist and intimate scenarios of human behaviour. By the 1960s, a relaxation of censorship laws gave directors a space in which to depict scenes which were openly designed to arouse, disturb and shock. Cinema's persistent desire to explore the taboo and to shock its audience has given rise to what might be described as the 'perverse gaze'—a form of looking that has always been present, though not always acknowledged.

One director whose films have always recognised the dark desires of the individual is Alfred Hitchcock. In his recent book, *The Hitchcock Murders*, Peter Conrad discusses his obsession with 'the master of suspense'. He dates his loss of innocence, and the awakening of his imagination, to his first viewing of *Psycho*.

> During my first under-age exposure to the film, the images that thrilled me were those of trespass and guilty surveillance. This, surely, was why the cinema existed: to depict what you were not supposed to be looking at . . . (Conrad 2000, p. 3).

The adolescent's clear awareness that there are certain images in films that 'you were not supposed to be looking at' signifies a peculiarly modern anxiety. It springs from the coalescence of two of the major developments of the twentieth century: psychoanalysis and the cinema.

New ideas about sex and the self were brought into the public arena in the writings of Charles Darwin, Richard Krafft-Ebing, Havelock Ellis and Sigmund Freud, all published in the late nineteenth century. Their theories contributed to the appearance of a new kind of human subject—one who was more introspective, and who questioned human sexuality and the nature of taboo forms of desire, and the role of these in everyday life. Public debate over what constituted immoral and moral displays of the body and sexual desire gave 'permission' for people to discuss

issues of sexuality and morality in public—in coffee houses, restaurants, cinemas.

The broadening of the public sphere to include intimate sexual topics helped constitute a sexual public sphere, a public space in which it gradually became acceptable to introduce matters once considered private, intimate, personal. In his biography of Sigmund Freud, Peter Gay writes that the culture gave people 'licence to reveal what was on their minds with exhibitionistic freedom'.

> The 19th century was the psychological century par excellence. It was a time when confessional autobiographies, informal self-portraits, self-referential novels, intimate diaries and secret journals grew from a trickle to a stream, and when their display of subjectivity, their purposeful inwardness, markedly intensified (Gay 1989, p. 129).

Emerson made a similar observation: 'The key to the period seemed to be that the mind had become aware of itself' (Gay 1989, p. 129). The evolution of the sexual public sphere offered a space in which society could talk to itself about its innermost desires, private fears, taboos and secret pleasures. The desire to question sexuality and the self was intensified by new forms of living in new cities, where all kinds of social codes and forms of morality were opened up for discussion. The modern self of the early twentieth century was well on the way to becoming the irreverent self of postmodernity—the self open to new expressions of sexual practice and permissiveness.

Of all the new forms of public entertainment, film became—and remains—the focus of such views, particularly in relation to sexuality and the perverse. With its documentary-like appeal to the 'real', the cinema is able to portray perverse desire and illicit sexuality with confronting credibility, bringing intimate areas of human experience, once the domain of painting and photography exclusively, to life in new and unexpected ways. Because film, through the powerful techniques of editing, was able to yoke together dissimilar images, it seemed, of all art forms, to resemble most closely the rhythms of a dream. In the hands of the avant-garde filmmakers of the silent period, film appeared to represent

the workings of the unconscious mind, illustrating with disturbing authority the writings of Sigmund Freud on the unconscious, sexuality and repression. As a medium, film is perfectly suited to the narration of stories about desire and perversity (Creed 1998).

As a consequence of the development of the sexual public sphere, and the practices of the contemporary media, the modern subject has become fascinated with what might be described as the practices of perversity. The individual is drawn to the media as offering a site for the representation of 'otherness', of unconventional, bizarre, shocking forms of desire and behaviour. From the beginning, the media have reported and represented stories connected with the bizarre or dark self. Although these stories are usually dismissed as 'sensational', their consistent and increasing popularity indicates that such widespread interest is central to understanding contemporary subjectivities and the way in which they are represented by the media. This is not to suggest that such an interest is new; on the contrary, human beings have always been drawn to the abject— classical Greek tragedy explored controversial themes from incest to murder and patricide.

What is new is the way in which perversity is constructed by the modern mass media, from film to the Internet. The early modern desire to encounter new, shocking forms of behaviour has intensified. The postmodern penchant for the perverse has led to public discussion of the pleasures of bestiality, the erotic appeal of Shirley Temple as a child star and our fascination with films about sex and cannibalism. The modern desire to encounter taboo forms of behaviour has transformed into a postmodern desire to perform or enact intimate personal experiences which shock and horrify others. The porn star and performance artist Annie Sprinkle, for instance, has her own Website in which she playfully reveals intimate details of her personal life as well as close-up shots of her genitalia. In a series of films (*Sacred Sex*, 1991, *Sluts and Goddesses*, 1992, and *Weirdo New York*, 1993), Sprinkle, who describes herself as 'post porn modernist', delights in the art of sexual outrage. On other Websites individuals have posted images of themselves having sex in conventional and unconventional ways. The controversial documentary *Sex: The Annabel*

Chong Story (1999), tells the story of Grace Quek, a female under-graduate in gender studies, whose claim to fame is that she once had sex with 251 men over the duration of a ten-hour day. The film explores Quek's reasons for taking part in what was described as 'the world's largest gang bang' while screening explicit footage of the marathon event. A harrowing journey into the nature of desire, *Sex* both shocks and disturbs.

The controversial award-winning documentary *Sick: The Life and Death of Bob Flanagan, Supermasochist* (1997), is about the life and death of Flanagan, a performance artist suffering from cystic fibrosis. In order to control the pain of his illness, he subjects himself to episodes of even greater pain. In one of the most shocking scenes, Flanagan nails his penis to a wooden board during a live performance at a New York art gallery. Barbet Schroder depicted an actual, not simulated, penis nailing scene in the fiction film *Maitresse*, in which a masochist submits his body to a professional female dominatrix. The sequence is edited into the film, which stars Gerard Depardieu in the role of an 'innocent' in love with a woman who runs a sado-masochistic chamber in the basement of her apartment. Both films were initially caught up in censorship battles but eventually given public release.

The postmodern desire to shock has been accompanied by a related desire—to transform the body, as part of performance art. The Australian artist Stellarc pioneered cybernetic body art, using robotic medical and new media systems to restructure and trans-form his body. In his performances his almost naked body is suffused with wires, electrodes and prosthetic limbs. He argues that the body is not perfect; it needs to be redesigned in order to interface more effectively with the world. The feminist perform-ance artist Orlan has also restructured her body; she has had surgical operations on her face screened in cyberspace. (McDonald 2001). Watching the performances of body artists is confronting and shocking.

Arguably the best way to understand the workings of the perverse gaze is through the theories of Sigmund Freud, who was the first theorist to analyse perversity in depth. In 1900 Freud published *The Interpretation of Dreams*, a book which revolutionised the way people thought about themselves. He argued that the

'most persistent human wishes are infantile in origin, impermissible in society . . . they are the buried forces that lie beneath all dreams' (Freud 1982, pp. 130–1). Freud's theories of infantile sexuality and of sexuality and perversion scandalised the European world. According to Freud, the perverse is constituted by deviation from the 'normal' sexual act, which he defined as heterosexual sex, the aim of which is attainment of orgasm through genital penetration; this is central to the preservation of patriarchal societies. Sexual acts and desires are defined as perverse when orgasm is attained by other means. Perversion also occurs in some situations 'where the orgasm is subordinated absolutely to certain intrinsic conditions which may even be sufficient in themselves to bring about sexual pleasure' (Laplanche & Pontalis 1985, p. 306). This would include acts associated with transvestitism, exhibitionism, sado-masochism, fetishism and voyeurism. 'In a more comprehensive sense, "perversion" connotes the whole of psychosexual behaviour that accompanies atypical means of obtaining sexual pleasure' (Laplanche & Pontalis 1985, p. 306).

Although considered radical in Freud's day, his theory of perversion has been strongly criticised in feminist and queer writings, partly because it depends so heavily on heterosexual genital sex as the norm, and partly because nearly a century later, as Emily Apter argues, 'the term itself may have become an anachronism' (Apter 1992, p. 311). She argues that now other behaviours, such as rape, sexual abuse and domestic violence, might be more appropriately described as forms of perversion. The concepts of immorality and perversion, however, continue to be debated in the contemporary media.

Freud's original contribution was that he used the concept of perversion to question the very idea that there was such a thing as 'normal sexuality' in the first place. In 1905 he published his 'Three essays on the theory of sexuality'. Unlike the sexologists of the period (Krafft-Ebing, Havelock Ellis), Freud argued that all individuals, from infancy onwards, have a 'natural' tendency to be perverse. 'The disposition to perversions is itself of no great rarity but must form a part of what passes as the normal constitution' (Freud 1981, p. 86). In other words, the individual is not born with so-called 'normal' sexuality; this is attained in the

individual's transition into full genital sexuality. The individual also learns that certain forms of behaviour are unacceptable to the civilised adult world and that desire to enact these behaviours must, in the interests of civilisation, be repressed. Repression, of course, leads to neuroses. According to Freud: 'Neurosis is the negative of perversion' (Freud 1981, p. 155). Freud also argued that what is repressed will inevitably return, in nightmares, slips of the tongue, pathological behaviour and artistic practice.

However, because desire is so complex and repression never fully successful, human sexuality itself is coloured by perversity in that 'it never fully detaches itself from its origins' (Laplanche & Pontalis 1985, p. 308).

It was the cinema, the century's newest form of entertainment, which above all gave rise to the formation of a sexualised public sphere, where it was possible to discuss sexuality in its perverse aspects. In its power to depict realistic stories about human relationships, and to represent realistic images of the body in erotic scenarios, the cinema drew upon the seductive power of the perverse gaze. The perverse gaze is defined by both its object and its context. It is curious about, and seeks out, images of perverse behaviour; and it situates itself in a voyeuristic context. Sitting in a darkened auditorium, spectators can voyeuristically enjoy the intimate details of the lives of 'strangers' as they unfold before their very eyes, almost as if the events were being enacted for them alone. In contrast to the television viewing situation, in which viewers sit together, lights on, in a familiar domestic context, film spectators sit in the dark, surrounded by strangers. The conditions of viewing and the nature of the technology produce a voyeuristic gaze and a voyeuristic subject. In 'Technology's body: cinematic vision in modernity', Mary Ann Doane explores the voyeuristic power of the camera in early film. She argues that the way in which the camera required the viewer:

> . . . to occupy a series of impossible places, particularly in its depiction of song-and-dance routines in the early musical, suggested very strongly Certeau's comment concerning the gaze, the 'lust to be a viewpoint and nothing more' (Doane 1993, p. 17).

The seductive ability of film to encourage audience identification, to involve the spectator emotionally while speaking to his or her private fantasies, is perhaps unmatched by any other art form.

The cinema offers a perfect space for the exercise of a perverse gaze, and is itself a rich medium for representing illicit forms of desire. This is because of its ability, through the power of editing, lighting and sound, to suggest the possibility of the perverse without actually presenting it on the screen. Three sequences from early cinema illustrate this. The erotic scene from *Blonde Venus*, in which Marlene Dietrich seductively emerges from a gorilla skin as she sings 'Hot Voodoo', hints strongly at the possibility of bestial desire. The play of light and dark and the hazy flow of movement and gesture on screen as Dietrich sings and sheds her animal skin intensify the suggestiveness of the moment. Similarly, the use of shadows, imaginative editing and costume design combine to signify the possibility of lesbian desire in the dance scene between Lulu and the Countess in *Pandora's Box*, and of necrophilia in the final scenes of *Nosferatu*, where the vampire takes sadistic possession of the traumatised heroine. Each of the above three films plays throughout on sexual pleasure associated with fetishisation, voyeurism and repressed desire.

What is unique is cinema's distinctive ability to suggest, to offer a glimpse of the possibility of eroticism, illicit sexuality and perversity. The power of film to shock arises from two seemingly contradictory elements: its unique ability to capture the 'real' and its unusual power to present the world as if it were a dream, to screen images and activities which flow across the screen not necessarily in terms of narrative logic but as if they had risen from the depths of a reverie, fantasy or nightmare. Through editing, film can yoke together disparate images to create atmosphere, mood, sensation, eroticism, desire. The evocative power of the cinema is perfectly equipped to suggest, reveal and display those desires considered perverse or illicit. Whereas pornography—and documentary—favour a graphic display of the 'real', the popular fiction film which is designed to reach as wide an audience as possible favours less explicit presentations of perverse forms of desire.

In 1899 Freud published his essay 'Childhood memories and screen memories', which is of particular relevance to an understanding of the way erotic moments may powerfully affect the audience. It is also significant that Freud chose a cinematic metaphor to describe this process. Freud defined screen memories in three contexts. Firstly, screen memories can be those which the adult remembers from childhood but which are really a cover for memories which have been repressed. Freud argued that: 'a person's earliest childhood memories seem frequently to have preserved what is indifferent and unimportant'. The explanation was that the 'indifferent memories' of the child's early years are 'substitutes, in [mnemonic] reproduction, for other impressions which are really significant. This process is "retroactive" or "retrogressive"' (Freud 1981, p. 83). He concluded that:

> As the indifferent memories owe their preservation not to their
> own content but to an associative relation between their
> content and another which is repressed, they have some claim
> to be called 'screen memories', the name by which I have
> described them (Freud 1981, p. 83).

Freud went on to argue that the 'opposite relation' is more frequent: that screen memories can be 'pushed ahead' or 'displaced forward' when a recent event is remembered and functions as a cover for an earlier event which has been repressed:

> . . . an indifferent impression of recent date establishes itself in
> the memory as a screen memory, although it owes that
> privilege merely to its connection with an earlier experience
> which resistances prevent from being reproduced directly
> (Freud 1981, p. 84).

A third kind of screen memory is 'contemporary', and occurs when a contiguous memory covers an event that has been repressed. Retroactive, displaced forward, contiguous—in all three instances Freud is describing a temporal relationship between the screen memory and the essential event it covers.

The cinema created a unique relationship between the viewer and the passage of time. Films—like memories—can transport

viewers across time, moving them between present, past and future in any sequence. Freud's account of the associative power of memories—their content conveyed through images and sounds—reveals the rich, complex and multilayered power of the image. While it is impossible to specify the multitudinous ways in which viewers respond to sexual and erotic imagery, given the heavy burden placed on such images by cultural and religious censorship, Freud's theory of screen memories explains how a particular image can evoke in the viewer other related and/or repressed associations. Many films which seek to avoid censorship will deliberately play on the complex and rich associative power of the image.

Hence one of the most powerful ways in which a film arouses the viewer is through the suggestion of even more explicit images or scenes, scenes which are alluded to but withheld. The film which sets out to arouse and/or shock the viewer may draw on a process similar to Freud's concept of 'screening' by offering an image which activates the viewer's repressed desires and then protecting the viewer from the shocking image by offering a more acceptable one in its place, one which does not offend public morality and is likely to avoid censorship restrictions. In film, 'to screen' thus has a double and contradictory meaning: to show and to cover. In the first instance, a film screens or shows the images: in the second it has the power to present a suggestion of controversial scenarios and then 'screen' them over with other images which are less disturbing but which do not fully block out the original taboo scenario.

Walter Benjamin observed that modernity was characterised by the experience of shock. Looking back over the past century we can see that the history of the cinema has involved continually exposing the audience to images which are more shocking than those of the previous decade; this, in turn, has created in audiences a desire, perhaps insatiable, to be shocked even more deeply and disturbingly than on previous occasions. The gradual relaxation of censorship laws over the century has led—years or decades later—to the eventual screening of images once considered too explicit or perverse for consumption. The images being screened simultaneously screen out other images, yet when

watching an erotic film it is impossible not to imagine what the latter might have been. The suggestion of more sexually explicit images or the possibility of catching a glimpse of a forbidden scenario is exactly what arouses yet ultimately frustrates the viewer.

Public interest in sexuality and perversity continues unabated. Questions about sexuality are openly debated in public: discussed in cafes and restaurants, in the workplace and on all the media— radio, newspapers, television, the Internet—as well as at arts festivals, galleries, performance spaces, religious places and centres of learning such as schools and universities.

In the words of the French theorist Jacques Derrida, the twentieth century was a century 'where sexuality is common to all the small talk and also a currency of philosophical and scientific knowledge, the inevitable *Kampfplatz* of ethics and politics . . .' (Petro 1989, pp. 24–5). Marshall Berman's description of public spaces as those in which individuals could be 'private in public' has been transformed—whatever tension between private and public existed in early modernity has long since disappeared (Berman 1982, p. 152–3). In the open public sphere of post-modernity, the borders between private and public appear to have collapsed. It is possible to speak about almost anything, to break taboos, to cross boundaries and to open oneself to the perverse. Even the term 'pornography' is being emptied of all meaning. The screen, of course, mediates the shock engendered by confronting images. Even when actual events are filmed, such as the sex scenes in the French films *Romance* and *Baise-Moi*, the viewer can take some comfort in the fact that he or she is not watching an unmediated view of reality. However, the contemporary fascination with reality television, surveillance cinema and live Websites suggests that audience fascination with the perverse and shocking is now bound up more directly with reality than with the world of fantasy and fiction.

The power of film to shock also relies on cinema's unique ability to create a sense of anticipation in the spectator through the dynamics associated with screen memory. This was literally demonstrated in the early film of Fatima's belly dance, where panels were inserted to 'screen' other more erotic movements.

The power of film, in its flow of dream-like images, to play provocatively on the spectator's personal collection of memories, repressed and present, is unique among artistic media. Also unique is the power of film, which explores issues of human desire, to appeal to a global audience. If the spectator relies on the protective response of scepticism ('I know . . . but') to draw a screen over the threat of too much reality, or an excess of taboo significations, this is perfectly understandable. What is most important about the roles played by the perverse gaze and screen memories in the way the individual views a film is that these two factors draw attention to, and give support to, the argument that meaning does not reside in the text. Rather, meaning is produced in the interaction between the screen and the spectator. Similarly, perversity does not exist in and of itself, but is constructed in the interplay of image, memory, morality and taboo.

References

Apter, E. 1992, 'Perversion', in E. Wright (ed.), *Feminism and Psycho-analysis*, Blackwell, Oxford, UK and Cambridge, Massachusetts, pp. 311–14.

Berman, M. 1982, *All That Is Solid Melts into Air*, Verso, New York.

Conrad, P. 2000, *The Hitchcock Murders*, Faber & Faber, London.

Creed, B. 1998, 'Modernity and misogyny: film and the public erotic' *Melbourne Art Journal*, no. 2, pp. 4–14.

Dekkers, M. 1992, *Dearest Pet: On Bestiality*, Verso, London.

Doane, M. 1991, *Femmes Fatales*, Routledge, New York.

—— 1993, 'Technology's body: cinematic vision in modernity' *Differences: A Journal of Feminist Cultural Studies*, vol. 5, Summer 1993, pp. 1–23.

Freud, S. 1976, 'Childhood memories and screen memories', in *The Psychopathology of Everyday Life*, Pelican Freud Library, vol. 5, Penguin, Melbourne.

—— 1981, 'Three essays on the theory of sexuality', in *On Sexuality*, Pelican Freud Library, vol. 7, Penguin Books, Harmondsworth, pp. 45–87.

—— 1982, *The Interpretation of Dreams*, Pelican Freud Library, vol. 4, Penguin Books, Harmondsworth.

Gay, P. 1989, *Freud: A Life For Our Time*, Macmillan, London.

Gunning, T. 1986, 'The cinema of attraction: early film, its spectator and the avant-garde' *Wide Angle*, vol. 8, nos 3/4, pp. 63–70.

Laplanche, J. and Pontalis, J-B. 1985, *The Language of Psycho-Analysis*, The Hogarth Press, London.

Lennig, A. 1975, 'A history of censorship of the American film', in R. Atkins (ed.), *Sexuality in the Movies*, Indiana University Press, pp. 36–75.

McDonald, H. 2001, *Erotic Ambiguities: The Female Nude in Art*, Routledge, London.

Mulvey, L. 1975, 'Visual pleasure and narrative cinema' *Screen*, vol. 16, no. 3, pp. 6–18.

Petro, P. 1989, *Joyless Streets: Women and Melodramatic Representation in Weimar Germany*, Princeton University Press, Princeton (NJ).

2

Big Brother: Peep shows to reality TV

Wherever the cultural tastes and practices of some people disgust and offend others, there can be little doubt that we are in the presence of the political.—Kevin Glynn, *Tabloid Culture*, 2000, p. 9

There is no doubt that reality TV programs are designed to offend those who see themselves as possessing 'highbrow' or elite tastes. Even the middle-brow might well be offended. In its obsession with sensational scenes of police arrests or firearm battles, its screening of intimate moments of people's lives and its conscious appeal to voyeurism, reality TV has been described as a form of tabloid television. Reality TV, or reality programming, is an umbrella term which covers a number of different formats or program types whose beginning can be traced to the 1980s. Its distinguishing feature is its appeal to the 'real'—the audience is made aware that the events (police work, accidents, robberies, social interactions) which are unfolding are not fictions but actual happenings. Reality footage is clearly not the result of pro-fessionally staged video filming. Camera movements are jerky, sounds hard to discern, lighting is often poor and editing minimal. The real-life footage is sometimes shot by amateurs who happened to be at the scene of the crime or accident, by camera crews accompanying police or rescue units on their jobs, or by hidden cameras and surveillance videos.

The first forms of reality TV originated in America in the early 1990s with programs such as *COPS* and *LAPD*. Programs are structured around the main dramatic event, such as a car accident

or a killing; this is accompanied by eyewitness accounts, interviews with family, announcements from the police. The September 11 terrorist attack on the United States has been described by some commentators as reality TV. The live television footage of the second hijacked passenger jet as it ploughed through the South Tower of the World Trade Center in New York was a horrific sight. It has been claimed that the terrorists deliberately paced the second attack to give television crews enough time to set up their equipment and film the disaster. Although the coverage by stations such as CNN drew on many of the features of reality TV—live footage, eyewitness accounts, interviews with rescue workers, the suspenseful search for survivors—most would be reluctant to describe the reporting as 'reality TV', for two main reasons.

First, the event was so shocking that commentators went out of their way to play down the horror and potential for voyeurism—features strongly associated with reality TV— although film of the collisions and collapse of the towers was replayed constantly. Second, the coverage could not be described as 'entertainment' in any sense of the word. However, the reportage did gradually assume features usually associated with a fictional drama. Several weeks after the event, people reported that they were still glued to their screens—caught up in the suspense of what would happen next, in the hope of finding survivors, the desire for closure. In fact, the question as to whether this horrific event did constitute a form of reality TV hinges on the extent to which reality TV is defined as 'entertainment'.

Australian media theorist Jane Roscoe defines reality TV as a form of 'factual entertainment' (Roscoe 2001, p. 9). To what extent is a series such as *COPS*, which screens events that shock and disturb, a form of factual entertainment? Would a documentary series on the Second World War or the Gulf War qualify as reality TV, that is, factual entertainment? The answer depends on a combination of interrelated factors: the stated intention of the program (to capture the 'real' in real time), the subject matter (actual events), the presentation of the material (primarily direct, unaltered footage). The composition of the audience also plays

a key role in determining whether or not the footage is viewed as entertainment.

The *Oxford Dictionary*'s definition of entertainment is to 'amuse' or to 'occupy attention agreeably'. The term 'agreeably' presumably includes a variety of emotional responses such as pleasure, awe, astonishment, horror, outrage, suspense, fulfilment—many of these responses would have been evoked by the coverage of the terrorist attack on New York, but it is impossible to say that 'pleasure' or 'agreeable' were among them. What reality TV does is blur the boundary between television programs which meet the conventional definition of entertainment and those which do not. The televised programs on September 11 did not entertain. When the factual event being screened takes the form of cataclysmic horror, which is of course subject to different definitions, the definitional status of the program (reality TV, news, tele vérité) becomes blurred. The televised broadcasts of September 11 exceed the definitional boundaries of reality TV. The screening of the events of September 11 are more accurately described as 'crisis TV' (see Chapter 10).

Media theorist Arild Fetveit defines reality TV as an 'almost frantic obsession with the evidential powers of the camera'. The viewer is entertained by the power of the camera to capture the real, to show it as it actually happened. He argues that the aim of reality TV is to explore the 'visible surface of the here and now'. In analysing an example of Norwegian reality TV footage, which caught the midair collision of two planes, he argues that reality TV is at its most intense in the presence of death. 'The deepest fascination with the evidential—when slow motion and repetition serve a close scrutiny of the footage—seems to occur when death is only inches away' (Fetveit 1999, p. 794).

The CNN footage of the terrorist attack on the World Trade Center returned again and again to the image of the second plane as it slammed into the South Tower, transforming it into a burning inferno. These images were still being replayed weeks later. I was told by a friend from the University of California, Berkeley, that since the attack there had been a run on disaster epics in video shops. One reason might be that people were trying to come to terms with terrorism by constantly replaying versions of fictional

scenes of disaster; the disaster epic promises closure at the end—something which television coverage of the September 11 attack could not offer.

Another form of reality TV is the docu-soap, such as *Sylvania Waters* and *Popstars*. These programs combine the structure (seriality) and subject matter (relationships, family, work) of the soap opera with a documentary approach to presentation. Roscoe argues convincingly that the success of these formats is also due to the way the docu-soap draws on the popularity and structures of the talk show by creating 'a forum for the performance of the subjective', letting ordinary people do the talking (Roscoe 2001, p. 11). Roscoe observes that reality TV combines aspects of documentary and fiction. These 'hybridised forms require us to watch in a different way. They require us to view them as factual, while expecting us to engage our imagination in order to understand the characters and their experiences' (Roscoe 2001, p. 12). If we consider the meaning of reality TV in relation to 'talk', we can see that more is at stake than the conversation itself. Just as the reality TV camera captures 'the visible surface of the here and now' in relation to dramatic life-threatening events, the docu-soap's privileging of 'voice' captures the 'sounds' of ordinary talk.

Audience fascination focuses as much on what is said as the way (tone, pronunciation, rhythm) it is spoken. In contrast to the rehearsed and scripted dialogue of television dramas and the carefully modulated tones of the newsreader, the viewer is able to relate directly to the familiar cadences and sounds of unrehearsed speech. Reality TV appeals not only to the viewer's fascination with the everyday but also to the here and now of visual and aural authenticity. Fetveit argues that reality TV, which reclaims 'the evidential quality of photography said to be lost after digitalization', might represent 'a longing for a lost touch with reality [and] a sense of connectedness, of contact with the world' (Fetveit 1999, p. 800).

A third and highly popular form of reality TV is the 'reality game show', such as *Survivor* and *Big Brother*—both of which could be said to appeal to audience desire for 'connectedness' and 'contact' with 'ordinary' people. These shows select 'contestants', people who do not know each other, and place them in a confined

environment or some form of delineated context where they are required to perform pre-established tasks. In the American *Survivor* (first series), sixteen strangers were taken to a desert island for five weeks. Once there they were divided into two teams, forced to compete to survive (for instance, by eating live worms), and required to vote members off the island one at a time, until only one remained. The survivor won over $1 million. Throughout the ordeal, the audience was entertained and entranced by displays of 'human nature'. The program attracted 52 million viewers when it was first shown on CBS in August 2000.

The desire to reveal the best and worst of human nature is one of the constant features of reality TV programs. The audience of *Survivor* was totally engaged, particularly by the possibility of being present when the unexpected erupted—liaisons, displays of cunning, intimate revelations, uplifting moments, sudden outbursts of emotion. The most powerful of such moments took place in the final episode when Susan Hawk confronted her friend Kelly, who she felt had destroyed her chance to win the prize by voting against her when only three contestants remained. Her outpouring of fury (she called Kelly a 'two-faced' rat she would happily feed to vultures) was exactly the kind of 'human' moment that *Survivor* had hoped to deliver to its addicted viewers. But it also presented viewers with a drama of survival and the opportunity to witness human nature in all its complexity. American film theorist Bill Nichols writes that 'the value of reality TV may lie in the gleeful abandon with which it mocks, or rejects civic-mindedness and the positivist social engineering behind it' (Nichols 1999, p. 393).

Capturing an even wider audience, *Big Brother* added a new dimension to the reality game show—interactivity. Originating in Holland, *Big Brother* has proven popular in many countries. By June 2001 there were 40 programs worldwide designed along the lines of *Big Brother*. In France the series was called *Loft Story* and attracted 10 million viewers every evening.

Big Brother deliberately plays on the appeal of surveillance and voyeurism through its title. The term itself comes from George Orwell's nightmare novel about the future—*1984*. Billboards around Australia displayed a large pair of eyes which subjected

the passer-by to scrutiny while simultaneously conjuring up the promise of scrutinising others. In *Big Brother* (the first series), the twelve contestants were carefully selected from a group of 14 000 applicants. Applicants were psychologically profiled to screen out those who might be emotionally vulnerable. The twelve contestants were brought together in a specially designed, secluded house (actually a TV set) for three months; their every movement was filmed 24 hours a day by 23 hidden cameras—the multiple eyes of George Orwell's 'Big Brother'. Contestants had no access to any media (television, newspapers) and were not permitted visits from friends or family.

While nothing of great import actually happened in the house, viewers became addicted to watching 'reality' unfold moment by moment, hooked on the trivial, waiting for the unexpected—the sudden outburst, the beginnings of a relationship, scenes of sex, evidence of deceit, dirty tricks, an intimate revelation, weeping fits, a moment of compassion. The only factor which interrupted what appeared to be a 'real' flow of unmediated images was the voice of the commentator. The material seen on television is, of course, highly edited. According to cultural critic Mark Boal, who watched editors compile scenes from Germany's version of *Big Brother*, the senior editor selected the most 'riveting scenes' from the up to 100 hours of tape filmed daily in order to create each half-hour program. The editor 'orders them into plot points that do not always match the sequence in which they actually happened' (Overington 2001). A great deal of effort is expended to make reality TV look 'real'.

As in *Survivor*, the players nominated those who were to be evicted; the new strategy was that the audience was invited to vote on which of the three house members nominated would actually leave. The winner would be, of course, the final remaining house member. The prize money for the winner of the Australian series was $250,000. The effect of this audience interaction was to suture the audience even more firmly into the reality-drama. In addition, the *Big Brother* Website enabled addicted spectators to watch (more intimate) events in the house as well as cast their votes online and converse with those evicted in chatrooms. The ratings were spectacular. In Australia,

an average of 1.6 million viewers watched the premiere of the first series. *Big Brother*'s appeal to the act of watching, to the pleasure of looking, was a major part of its success. Online viewers were able to access the program round the clock, to subject the contestants to greater scrutiny than in any other reality TV game. The series dominated radio talkback, and the first eviction was reported in the newspapers.

Reality TV programs such as *Big Brother* have proven so popular, and commercially attractive, that television companies have created a series of similar reality formats. One of these is *Temptation Island*. In the US pilot series, four married couples were placed on an island in Belize where 26 attractive single contestants, male and female, awaited them. The aim was to put every temptation in the way of the married couples, to seduce one or both and break up their marriage. *Temptation Island* plays very directly to the audience's desire to watch 'reality' sex. The series was strongly criticised by some community groups, who objected to the idea of trying to destroy a relationship for ratings and profit.

A particularly bizarre version of reality TV is *Chains of Love*. Four male contestants are chained together and locked in a house where their jailer is a woman. Big Brother becomes Big Sister. The four men are under continuous surveillance. They even sleep together in a large bed and are only unchained when they need to go to the toilet. The woman in control, a figure similar to the dominatrix of male porn, selects the male contestants she wishes to banish from the house, again one at a time. The man she ends up with is the winner; they share the prize money.

Reality TV has been described as nasty, manipulative and pornographic. It has inspired many articles with disparaging titles: 'Has reality TV gone too far?' 'Reality TV and its dingbats', 'TV tempter puts voyeurs in box seat'. Reality TV has been described as blatantly voyeuristic—as if media voyeurism were a new phenomenon.

From the earliest days of the movie camera, spectators came in droves to see the wonders of the world's latest invention. Viewers were fascinated by moving images of people in real-life situations, walking on the streets, catching trains, leaving facto-

ries after work. Also popular were brief flickering scenes of intimate moments, particularly Edison's *The Kiss* (1896), the world's first film scene of a couple embracing. The public taste for visual stimulation was enormous—crowds flocked to wax museums, folk museums, amusement parks, peep shows, panoramas, the new arcades, movie houses. Even the Morgue in Paris displayed its dead (on the pretext of identifying unknown bodies) to a fascinated public. The Morgue was listed in guide-books, attracting as many as 40 000 on 'big days, when the story of a crime circulated through the popular press and curious visitors lined the sidewalk waiting to file though the *salle d'exposition* to see the victim' (Schwartz 1995, p. 298).

In addition, cities grew rapidly in the twentieth century, and people found themselves, more than ever before, catching the eye of strangers in the street, finding themselves the object of the curious glance of others. Public desire for looking—at the unfamiliar, exotic, deviant, even cruel—remains unabated, from the beginning of the twentieth century to the beginning of the twenty-first century. Such a desire is no doubt as old as humankind (consider the blood sports of the Coliseum), but not until the advent of modernity, and the emergence of modern forms of media entertainment, has the public taste for sensational sights been catered to on such a massive scale.

Freud defined the act of deriving pleasure from looking, particularly erotic pleasure, as scopophilia (Freud 'Three essays on the theory of sexuality', 1981). Many critics have objected to reality TV on the grounds of its voyeurism, describing its contestants as so desirous of fame—possessed by the 'thymotic urge'—that they are prepared to submit to the 'voyeuristic fetishes of others' (Podhoretz 2000, p. 52). It could be argued that watching movies *per se* is a far more 'voyeuristic' act, in that the cinema spectator is sitting with strangers in a darkened auditorium watching intimate events unfold in a context which hides its modes of production and pretends that the spectator is viewing unmediated reality. *Big Brother*, on the other hand, makes no such pretence. All the contestants have agreed to put themselves on display in a live context—that is an essential part of the program's structure and appeal.

Voyeurism is an extreme or perverse form of looking, in which the voyeur is able to derive sexual pleasure only by looking at others who are usually unaware that they are the object of a hidden gaze. According to this definition, it seems clear that *Big Brother* does not appeal to the voyeur—unless we use the term very loosely. *Big Brother* in fact plays to a century-old activity of taking pleasure in looking at 'ordinary' people (subject to a selection process, of course) being 'themselves' in the glamorous world of the media.

If *Big Brother* appeals to any excessive desire in the viewer, it is most likely to be that of narcissism: that is, a narcissistic form of scopophilia. Watching moving images of other human beings allows the viewer to identify with his or her 'likeness'. In her discussion of the spectator's strong urge to look at and identify with film stars in the cinema, British film theorist Laura Mulvey emphasised this factor. 'Here, curiosity and the wish to look intermingle with a fascination with likeness and recognition: the human face, the human body, the relationship between human form and its surroundings, the visible presence of the person in the world' (Mulvey 1975, p. 9). Although Mulvey was talking about the cinema, the big screen and the glamorous star, her comments are particularly relevant to *Big Brother*. However, the screen–spectator relationship is very different. In *Big Brother* the appeal is similarly narcissistic—and I am not using the term in a derogatory sense—but the desire is to identify not with the glamorous star but rather with the someone just like the viewer. The characters, particularly the winner, may come to assume a star-like persona by the time of the final episode (another reason for its appeal) but, in the main, the house members are just like members of the audience. The latter embody a reassuring familiarity. Viewer fascination is also related to the opportunity to identify with the daily, routine, domestic events of the household. Although trivial, the ensuing events come to form a complex set of interactions and a dynamic network of unfolding relationships.

Although media critics are strongly divided over the 'worth' of reality TV programs such as *Big Brother* and *Survivor*, one characteristic which many agree upon is the way in which these series cross boundaries and challenge dominant social taboos. They do

so in relation to what should or should not be revealed in public about traditionally private subjects related to the body, sex and relationships. 'It's a moral question that prompts the question of why we consider privacy so sacred and how certain subjects came to be taboo' (Lumby 2001, p. 44). This transgressive aspect of the reality TV format is also viewed as deliberate. They 'license the selfish, the perverse, the eccentric, although in a way that always *seems* to demand that the audience is aware that social boundaries are what is at stake' (Bell 2001, p. 110).

Some writers have argued, though not in a negative context, that reality TV constitutes a form of tabloid television (Glynn 2000); others have argued that reality TV formats represent a 'debased' form of ethnographic filmmaking (Bell 2001; Nichols 1994). In my view, programs such as *Survivor* and *Big Brother* constitute a new, postmodern form of ethnographic television which is different rather than 'debased'. In modernist forms of ethnographic filmmaking, such as television documentaries, the 'other' is almost always a pre-industrial, non-western subject; in postmodern ethnography the western filmmaker has turned the camera on western culture, on its mores, values and lifestyles.

Dennis O'Rourke's documentaries, *Cannibal Tours* (1987) and *The Good Woman of Bangkok* (1991), provide examples of the latter. In *Cannibal Tours*, he takes as his subject a party of European tourists on a trip into the jungles of New Guinea. O'Rourke explores the desires of those filmed, never hesitating to display their less admirable characteristics. The European tourists emerge as the actual cannibals—symbolically devouring the exotic lifestyles of their hosts. *The Good Woman of Bangkok* explores the life of a female prostitute, but a large part of the debate about the film focuses on the filmmaker himself. Why did he decide to make a film about an Asian prostitute? Why does he try to rescue her from her situation? Was he motivated by racism and/or sexism? Is he being paternalistic? The fact that O'Rourke includes images of himself filming within the film space suggests that he intended to make himself an object of scrutiny. He also interviews western men who come to Bangkok in search of sex. In so doing, he turns the camera on the desires of western men, subjecting them to an ethnographic gaze.

Programs such as *Survivor* and *Big Brother* train the camera on the desires, actions, relationships and lifestyles of a group of ordinary people in the style of an ethnographic or documentary film in order to let them 'reveal' themselves to the viewing audience in the style of postmodern ethnography. This is perhaps the most original and refreshing feature of this form of reality TV; it subverts the conventional ethnographic gaze in order to represent the dominant culture looking at itself 'warts and all'. Similarly, the audience is encouraged to identify with the situations presented and to ask themselves whether or not they would make the same decisions and act in the same way. It is perhaps not by accident that *Survivor* and *Survivor II* adopted the traditional non-urban locations of ethnographic filmmaking—an island, and the rugged outback. In *Survivor II* the setting was the Queensland outback, and the group was split into two 'tribes'. Participants had to learn to work as a community and attend a tribal council once a week. The impulse behind the show was clearly ethnographic, right down to the structuring of events.

The programs make it clear that there is no ideal television actor/performer or ideal pre-packaged format. The recent phenomenon of *The Osbournes* supports this. Whereas shows like *Survivor* and *Big Brother* transform ordinary people into celebrities, *The Osbournes* took a famous rock star and turned him into someone ordinary. Ozzy Osbourne, a member of the world-famous heavy metal band Black Sabbath, his wife and two of their offspring, Kelly and Jack, have let television cameras into their Beverly Hills home, and their every movement is filmed, edited down and broadcast to a fascinated public. *The Osbournes* has proven the biggest hit ever for MTV. Perhaps one of the reasons for such public interest is that Ozzy Osbourne is a colourful, perverse figure: he is best known for his foul language, his head-banging and for biting the head off a bat during a performance. The thought of Ozzy as a family man going through a daily domestic routine is too tempting for fans of reality TV. *The Osbournes* is fascinating not for its revelation of celebrity lifestyles, but because it shows how ordinary famous people are in reality.

Ordinariness, the everyday, commonplace, familiar—these qualities are essential to reality TV. Earlier I discussed the appeal,

for the viewer, of identifying with someone just like themselves. Television programs in which ordinary people are the 'stars', such as daytime talk programs, new talent and quiz shows, have proven immensely popular with audiences. Reality TV takes the process of popularising the ordinary even further, expanding the definition of what constitutes a successful television program. The contestants, however, are not 'innocent' media participants. Although they are not professional actors, they are still, in a sense, giving a performance, playing to the camera, possibly even creating a persona for the program. Raised in a world dominated by the media, television and film, the participants in reality TV bring a significant degree of knowledge about acting to the show, a mix of the rehearsed and unrehearsed. It is impossible to know to what extent the contestants are presenting 'themselves' and/or an image of themselves they have fashioned in response to their knowledge of and interaction with the television world as viewers and consumers.

The extent to which the contestants are also 'performing' for their audience raises the question of responsibility. If reality TV continues to challenge and break various sexual and moral taboos, the responsibility for this should be seen as one shared between contestant, viewer, sponsor, programmer and the various media outlets which promote the program. The critics of reality TV cannot simply or simplistically blame 'the media' for eroding values and traversing taboos.

If nothing else, reality TV makes clear that the media are not monolithic and manipulative entities responsible for seducing the innocent viewer and destroying the values of so-called good taste and ethical behaviour. Reality TV makes it clear that meaning is actively constructed in the relationship between performer and spectator, text and audience—even, or particularly, when the actor is an ordinary person performing without a script. If reality TV has violated the boundaries between what is acceptable and unacceptable then it has done so with the participation and support of its cast and its viewing public. Given the post-modern disrespect for traditional forms and values, reality TV promises to offer ever more explicit and dramatic glimpses into areas once considered taboo.

References

Bell, P. 2001, 'Real new formats of television: looking at *Big Brother*' *Media International Australia*, no. 100, pp. 105–14.

Fetveit, A. 1999, 'Reality TV in the digital era: a paradox in visual culture? *Media, Culture & Society*, vol. 21, no. 6, pp. 787–804.

Freud, S. 1981 [1905], 'Three essays on the theory of sexuality', in *On Sexuality*, Pelican Freud Library vol. 7, Penguin Books, Harmondsworth, pp. 48–87.

Glynn, K. 2000, *Tabloid Culture*, Duke University Press, Durham and London, p. 9.

Lumby, C. 2001, 'The naked truth' *The Bulletin*, 29 May, pp. 42–4.

Mulvey, L. 1975, 'Visual pleasure and narrative cinema' *Screen*, vol. 16, no. 3, pp. 6–18.

Nichols, B. 1994, 'At the limits of reality (TV)', in *Blurred Boundaries*, Indiana University Press, Bloomington and Indianopolis, pp. 43–62.

—— 1999, 'Reality TV and social perversion', in P. Marris and S. Thornham (eds), *Media Studies: A Reader*, Edinburgh University Press, Edinburgh, pp. 393–403.

Overington, C. 2001, 'The human zoo' *The Sunday Age*, 29 April, p. 15.

Podhoretz, J. 2000, ' "Survivor" and the end of television' *Commentary*, November, pp. 50–2.

Roscoe, J. 2001, 'Real entertainment: new factual hybrid television' *Media International Australia*, no. 100, pp. 9–20.

Schwartz, V.R. 1995, 'Cinematic spectatorship before the apparatus: the public taste for reality in fin-de-siècle Paris', in L. Charney and V.R. Schwartz (eds), *Cinema and the Invention of Modern Life*, University of California Press, Berkeley.

3

Television and taboo: The limits of *Sex and the City*

'. . . sensationally disregarding every television taboo ever created.'
—Channel 4 press release when the series premiered on British TV

'I'm a trisexual,' says Samantha Jones. 'I'll try anything once.' And she and her three female friends do just that—oral sex, anal sex, ordinary sex, sex for pleasure (not procreation), gay sex, s/m sex, secret sex, instant sex and no sex. *Sex and the City* focuses on the sex lives and loves of four professional women who live in Manhattan and who spend most of their waking hours talking, thinking and having sex. Each half-hour episode is viewed through the eyes of Carrie (Sarah Jessica Parker), a journalist who writes a column on sex for a daily newspaper.

Describing herself as a 'sexual anthropologist', Carrie's voice-over guides us through each episode, commenting on its particular theme, her own feelings on the subject and the thoughts of her three friends: Samantha, Miranda and Charlotte. Apart from the outspoken sensualist Samantha, who believes in sex without commitment, the other three are searching for their own impossible versions of Mr Right. The series presents, in a comic context, a discussion of what women want from relationships. Deep down the women appear to want commitment and domesticity, but whenever they find a potential partner, there is always a problem. For instance Samantha meets a man with whom she wants to become serious. He is tall, handsome, intelligent and sensitive. What could be the problem? He has a tiny

penis—a fact which would not bother the others, but presents a formidable stumbling block to Samantha, who likes to fetishise the well-endowed male body.

Maureen Dowd interprets the series as an exploration of the current media obsession, fuelled by public exposure of the sexual peccadilloes of past presidents such as Kennedy and Clinton, with why men are so irresponsible and immature when it comes to relationships—summed up as the 'men-are-dogs' debate (Dowd 2001, p. 15). It seems to me, however, that the main intention of *Sex and the City* is to use the traditional battle of the sexes as a narrative ploy, a pretext for presenting a funny but serious examination of the major sexual 'taboos' or prohibitions of American society, from a woman's perspective. The series clearly encourages viewers to debate the issue of sexual permissiveness—not just at home after the show, but also on the Internet. As with all popular television programs, *Sex and the City* has its own interactive Website. There is a notice board where viewers can post their comments on particular episodes and characters and talk to a 'real live therapist' about 'relationship issues'. If you miss an episode, don't panic. *Sex and the City* is now available on DVD.

Sex has always been a hot topic that sells well, but now more than ever, at the beginning if the twenty-first century, traditional sexual values are under attack. This has largely come about because of second-wave feminism, which demanded that women should have the right to sexual autonomy and pleasure, and postmodern irreverence, which refuses to sanctify (monogamous heterosexual) sex as part of God's 'divine plan'. A new, more liberating approach to sexual issues has even begun to shake the foundations of evangelical and Christian groups.

Cultural critic Michael McMahon reported in the *Spectator* that in the United States, Christian sex manuals are becoming million-dollar bestsellers. These include the updated 25-year-old classic, *The Act of Marriage: The Beauty of Sexual Love*, as well as audio cassettes with illuminating titles such as: *How to Have Holy Sex* and *Hot Sexual Stimulation & The Christian Woman*. This boom in Christian sexual manuals appears to have been stimulated by the belated discovery, in evangelical circles, of the clitoris and its crucial role in female sexual pleasure. McMahon quotes one

popular book which informs the reader that the clitoris is 'the most keenly sensitive organ in the woman's body', which 'your Heavenly father placed there for your enjoyment' (McMahon 2000, p. 27).

Considered too shocking for commercial networks, *Sex and the City* is screened in America on cable television's Home Box Office network (HBO), which doesn't baulk at focusing on the naked female body but has a ban on full frontal male nudity. The program's views on the postmodern woman and her sexual desires are apparently too scandalous for the average American to imbibe with their evening meal. In Australia it is programmed on commercial television, later in the evening, when the kids are supposed to be in bed. In Britain, *Sex and the City* is aired on Channel 4, which has a reputation for promoting controversial issues. Channel 4 advertised the series as 'sensationally disregarding every television taboo ever created'. The various episodes not only explore virtually all the obligatory Freudian perversions (see Chapter 1) from masturbation to group sex, and a range of sensual pleasures from oral to anal; they also examine s/m sex, Viagra, transsexuality, gay straight men, tantric sex, straight gay men, and so on. The episodes are also visually confronting. There are scenes of nudity, voyeurism, topless dancers, bare bottoms, heaving breasts and simulated sex. Characters talk in intimate detail about their desires, orgasms, secret longings. Not unlike a sex menu, *Sex and the City* takes its viewers on a humorous romp through what might be termed 'best sexual practice'.

Much has been written on the way in which the media, particularly television, have transformed everyday life. Some people, particularly champions of high culture, see this change as destructive; those who allot less significance to the 'high' and 'low' culture divide are more optimistic (Hawkins 1990; Cartmell et al. 1997). Theorists who have written about the changes that accompanied the first decades of the twentieth century expressed concern that the new urban masses, with their taste for sensual attractions such as the cinema, would undermine the power of the educated classes, who preferred high culture (Hansen 1995). The rise of popular entertainment media such as television has

created a public space where private topics are circulated. They have also created a space where women are able to give voice to their views. Television is probably the most powerful medium through which to stage controversial dramas of sexual behaviour—which are then debated in the sexualised public sphere.

One of the most significant features of the twentieth century was the opening up of all values and moral codes to question. Modernity brought about the growth of the large metropolis—so central to *Sex and the City*—with its vast urban sprawl, new streets, shopping malls, coffee shops, bustling crowds and traffic. These physical transformations were accompanied by the experience of speed, change, shock and sensory stimulation of all kinds. Not only did people travel and move about the metropolis more rapidly; so too did new ideas, values and morals. The key arena in which debates about changing moral values have been staged in the previous 100 years is the mass media—the cinema, pulp fiction, newspapers, magazines, radio, television, video, the Internet.

Programs such as *Sex and the City* literally test the public's view of traditional taboos on sexual practices—gay sex, group sex, and oral and anal sex. Before *Sex and the City*, *Golden Girls* explored the subject of sexual permissiveness among the middle-aged, and before that comedies such as *Soap* explored every form of whacky sex imaginable, including sex with aliens. *Sex and the City* argues that if four well-brought up, attractive professional women are prepared to engage in new forms of sexual behaviour, it is clear that there has been, or should be, a major shift in levels of public tolerance.

Thirty years after the sexual revolution of the late 1960s, the four women, now thirty-something adults, were once the babies of the great urban social movement of 'sexual liberation'. Anything is possible. The women are not on the same journey as the heroine of the woman's romance, who is yearning for the kind of emotional and sexual fulfilment which will resonate through her very being, transporting her to new realms of sensual and spiritual ecstasy. No. The four friends are more interested in pleasure, experimentation, discovering what kind of sex they like, the men who excite them, the man with whom they might have

a relationship, even fall in love. The series might have been, just as aptly, named 'Sex and Shopping' or 'Shopping for Sex'.

While the image of the imaginary Mr Right hovers over each episode, the details of the plot are primarily concerned with the exploration of a particular sexual issue. The idea that each one will eventually meet Mr Right is essentially a device, a lure, which both drives the narrative and bestows on each one of the quartet a necessary degree of moral depth. After all, these are women with whom the viewer is asked to identity and empathise week after week. This is why each of the four represents a slightly different position on the scale of sexual permissiveness. The fact that, apart from Samantha, all the friends are hoping that one day they will meet Mr Right functions to condone their sexual experimentation and transitory pleasures as part of their journey towards heterosexual true love rather than as an end in itself. Of the four, Samantha, who is played by English actor Kim Cattrall, is the most transgressive. Even before the lesbian sex episode occurred it was obvious that Samantha (definitely not a home-grown American actor) would be the one called upon to break this final taboo.

Modelled on real-life journalist Candace Bushnell (whose book of the same title provided the blueprint for the series), Carrie compiles her sex column during the episode, as she talks to us and her friends about the sexual issue on the agenda for the week. In an episode entitled 'The Drought', Carrie tells us: 'New York city is all about sex. People getting it. People trying to get it. People who can't get it. No wonder the city never sleeps. It's too busy trying to get laid.' As if to give symbolic weight to her utterance, the opening credit sequence features the ill-fated Twin Towers, shot in tilt-up in order to endow them with phallic significance. They hover over the city like pagan fertility gods.

The women try all kinds of sex, from the conservative to the perverse. Despite her role as a 'sexual anthropologist', and her candid observations of the sexual antics of her friends, Carrie remains strangely untouched or unmoved by her experiences. Although she meets and falls in love with Mr Big (Christopher Noth), a handsome, likeable womaniser, Carrie rarely unleashes her feelings. She remains our reliable, observant, steadfast guide

throughout each sexual escapade, even delivering the odd moral homily at the end of an episode.

In the first episode of the entire series, itself called 'Sex and The City'—or 'Cupid Has Flown the Coop'—the women debate whether or not love is still possible in Manhattan. The questions and the respective responses of the four are designed to introduce us to each of the women and familiarise us with their different views on love, sex and the mating rituals of city life. Carrie sets the scene. The fairytale nature of her opening words, 'Once upon a time an English journalist came to New York', is deliberately ironic. The opening episode is actually about the 'end of love in Manhattan'. Much to her surprise, Elizabeth, the beautiful English journalist, discovers that serious dating in New York leads not to the altar but to the singles bar. Elizabeth commences a relationship with one of the city's typical eligible bachelors. 'Tim was 42, a well-liked and respectable investment banker who made about 2 million a year,' Carrie informs us. 'They met one evening in a typical New York fashion. At a gallery opening.' Immediately we are plunged into the world of the urban rich—a young, beautiful and cultured class. Like everything else in this postmodern fairytale, sex and romance are lavishly packaged, commodified, available only to those with access to power. The four women and their men are well-groomed, white, affluent and heterosexual.

The issue of this episode concerns the nature of love in a postmodern world. When Elizabeth imagines that she and Tim are about to marry (he has even 'popped the question'), Manhattan's typical bachelor disappears, evaporates into thin air like Cinderella's dream. 'In England,' Carrie tells us, 'looking at houses together would have meant something. Then I realised that no-one had told her about the end of love in Manhattan.' New York registers social, cultural and sexual changes first, before London and presumably other great cities—Paris, Rome, San Francisco. This is the 'Age of un-Innocence'. 'No-one has *Breakfast at Tiffany's* and no-one has "affairs to remember".'

Looking directly at the camera/us, Carrie confronts us with the question for the night: 'How the hell did we get into this mess?' As the camera focuses on the faces of the crowds of New York women going about their daily business, Carrie informs us

that there are 'thousands, maybe tens of thousands of women like this in the city . . . It's like the riddle of the Sphinx. Why are there so many great unmarried women and no great unmarried men?' The camera cuts to various men working out at the gym. One tells us that women in their thirties make him feel as if he is being 'devoured'; another says single women in their thirties should forget about marriage and have a good time. Carrie also consults her gay male friend Stanford Blatch (Willie Garson) who appears throughout the series. He tells her that the only place to find love in New York is in the gay community. 'It's straight love that's become closeted,' he says knowingly.

Next we meet Carrie's three female friends, the group who feature in each episode, each of whom gives her views on love in New York. Charlotte (Kristin Davis), an art dealer, is the most conservative. She wants marriage, doesn't believe in sex on the first date, hates giving men blow jobs and doesn't enjoy anal sex. 'I just don't want to be known as the "up-the-butt girl",' she wails in one of the most hilarious episodes of the series. Her search for Mr Right appears doomed. Samantha (Kim Cattrall), a public relations executive, is the most extreme of the quartet. She will try anything once and firmly believes that women should be like men; that is, they should have sex without feeling. Completely uninterested in finding Mr Right, Samantha is poised to exploit her independence and freedom. 'Sweetheart,' she tells Charlotte, 'This is the first time in the history of Manhattan that women have had as much money and power as men plus the equal luxury of treating men like sex objects.' And this is exactly what Samantha does, seducing men and then walking away. Then there is Miranda (Cynthia Nixon), the lawyer, whose warmth, wit and cynicism serve as a perfect foil to Charlotte's excessive innocence and Samantha's excessive indifference. Too cynical to believe in Mr Right, Miranda's partners always seem a mismatch.

Sex and the City has been dismissed outright by some critics as 'trite', 'predictable', 'psychobabble'. Media critic Alix Johnson, however, offers several thoughtful comparisons between the series and the novels of Jane Austen. Comparing Carrie Bradshaw with Elizabeth Bennett, the heroine of *Pride and Prejudice*, Johnson argues that there are some striking similarities. 'Carrie

is a sex columnist, Elizabeth a social commentator whose speciality is marriage. Carrie likes to match her mate in bed, Elizabeth matches hers in spirit . . . Via different channels, and almost two centuries apart, Carrie and Lizzie confront the same confounding issue: romantic love' (Johnson 1999). The Bennett sisters also offer a range of views on love, marriage and relationships.

While it is true that both heroines do address the issue of romantic love, *Sex and the City* uses this concept primarily as a narrative ploy, to leave the viewer dangling at the end of each episode (will Carrie marry Mr Big?) and eager to watch the next; however, the actual subject matter of the nightly events is not romantic love but the modern woman's attitude to love, marriage and sex. Helen Fielding, in *Bridget Jones' Diary*, similarly uses the concept of romantic love (to make her point clear, she names her hero Mr Darcy) as the foil against which to test the limits of her heroine's apparent sexual equality. *Sex and the City* is also interested in the extent to which women really have won sexual equality with men. Its other prime focus is the taboo.

In his 1913 book, *Totem and Taboo*, Sigmund Freud attempted to explain the origins of human society via the workings of totem and taboo; he firmly believed that the 'taboos' of so-called primitive societies were 'not so remote from us' (Freud 1985, p. 75). Taboos which once signified those things considered both dangerous and sacred persist in modern life in the form of prohibitions. Designed to prevent people from acting out desires considered dangerous or harmful to the group, modern prohibitions (laws against murder, incest, anal sex, under-age sex, polygamous sex, gay male sex) are similar to the taboos of earlier societies.

Whereas earlier societies looked to ritual and religious practices to reinforce moral standards, the modern world appears to seek guidance from the mass media. More and more, television has taken on the role of determining the effectiveness and desirability of enforcing various sexual practices once prohibited by church and state. The old precept 'As long as it takes place in the privacy of one's home' no longer applies. Television, and other forms of the media, have opened up the bedroom door and released behaviours once considered personal and private into the public arena.

Watching the four friends engage in intimate conversations about their sexual experiences and preferences offers the viewer a decidedly private/public experience. It is as if we were eavesdropping, secretly listening in to private moments as one might in a coffee shop or restaurant. Television is eminently suited to the practice of eavesdropping. Compared with the cinema which, with its darkened auditorium and intense narratives of close identification, encourages voyeurism, television is more suited to pleasures associated with overhearing. Located in the rumpus room or lounge room, the television set is part of the family or household. With visual emphasis on 'talking heads', its soap operas and sitcoms are ideally suited to the airing of controversial conversations about changing standards of morality. Television has evolved into a medium which has collapsed boundaries—often in a comic format—between the traditional public and private spheres, in order not only to entertain, but also to become an arbiter of moral values.

As its title indicates, the bustling metropolis is crucial to *Sex and the City*. As we watch the steamy, sensational events unfold, we are continuously reminded of the urban landscape—its crowded footpaths, traffic-clogged streets, hooting taxis, bustling workers, smog, congestion, frantic pace and phallic towers. Carrie tells us that 'this is Sex and the City—not Sex and the Suburbs'. The city is a key player in this series, which presents urban life as a crucial factor in its exploration of the postmodern female psyche. The four friends venture out onto the streets to negotiate their way to work, to shop and to meet each other at restaurants, cafés and nightclubs. Sometimes they also meet men on the streets—they exchange glances, cast a direct look, mentally assess the stranger as potential lover.

The series constructs heterosexual desire within a culture of display and shopping. Like Coleridge's Xanadu, postmodern Manhattan is an earthly pleasure-dome, but one in which sex is aligned with commerce and in which women are free to try out all forms of sexual pleasure. Sex is increasingly defined by the city: sex is a commodity, something to be 'tried on', discarded or purchased like a new outfit, enjoyed with a stranger or a group, preceded by one of the city's pleasures—

a show or restaurant—talked about afterwards with close friends in a café.

Carrie, our guide, is not unlike the late nineteenth-century *flâneur* who strolled through the shopping arcades and sidewalks of Paris, drawn to new sights, observing and recording everything he saw from an anonymous distance. As postmodern *flâneuse*, Carrie also walks alone through the city, gathering information for her newspaper column. She records the excitement of the city, mingling with strangers on the street, meeting with her friends for coffee and chat, experimenting with sex. The four women are part of city life—rarely do we see them indoors at the mercy of domestic routines. Shopping for clothes and sex is depicted as a singularly female experience. The cafés and restaurants of the city constitute a space which is both public and private, a space where women, like men, are free to indulge in sexual and erotic pleasures.

Sex and the City represents a new sexual permissiveness for single women while simultaneously regulating the limits of these changes; it discards old boundaries, but sets up new ones. Specific forms of sexual permissiveness are condoned (oral, anal, casual heterosexual sex) while other areas remain more or less taboo. Interracial sex, gay and lesbian sex are discussed and occasionally portrayed, but they are not part of the norm. Although Samantha tries lesbian sex, her conversion lasts only two episodes; in the end, going to bed with another woman is put down as a failed experiment. *Sex and the City* maintains certain boundaries—it does not venture into areas deemed too radical for public taste.

In this context, *Sex and the City* clearly adopts a regulatory role: female viewers are encouraged to adopt a free attitude to sex as long as they don't 'cross the line'. They are also overwhelmingly heterosexual. There is no question that the centre of their focus is men—how to meet them, how to seduce them and how to keep them. The most enjoyable episodes, however, are when the four friends discuss sex together, with no man in sight.

The most confronting episode in the first series, however, involved not sexual behaviour but the uttering of the most taboo word on the media—'cunt'. The previous week's promotional

material emphasised that this episode would 'say the unsayable'. In order to ensure that the 'unsayable' was uttered with some style, Susan Seidelman, who directed Madonna in *Desperately Seeking Susan* (1985), was appointed as director. In this episode, 'The Power of Female Sex', Charlotte takes a trip into the country-side, to visit and view the latest work of a well-known but reclusive artist, Neville Morgan. Apprehensive about his motives, Charlotte arrives at the farm. Morgan leads her into his studio, pronouncing that his latest canvases are about the 'most powerful force in the Universe. The source of all life and pleasure and beauty'. Charlotte is stunned when he turns the lights on to reveal his paintings: large, colourful canvases with a suggestion of Georgia O'Keefe and Judy Chicago's 'Dinner Party'. Morgan announces that this 'force' is none other than 'the cunt'. The loud utterance of a word traditionally used by men to humiliate and degrade other men but here used ironically in its correct context throws Charlotte completely off balance.

Significantly, 'cunt' is also spoken in the 'country', where it is aligned with the natural rather than the urban landscape. Viewers wonder how the program will restore equilibrium. At this crucial moment, Carrie, our trusty guide and columnist, rushes to the rescue. In voice-over she tells us that Charlotte 'hated the "C" word'. Then Morgan's sweet, middle-aged wife enters the studio and offers Charlotte lemonade and cookies. The artist's grand claims are humorously deflated: Charlotte regains composure. Worse follows. Morgan invites Charlotte to pose for him. She turns helplessly to his wife, hoping that she will put a stop to her husband's unusual request. No such luck. 'I bet you have a beautiful cunt, dear,' his wife says warmly, still holding the tray of cookies.

By displacing anxiety through humour, the episode undercuts the force of the prohibition surrounding public utterance of the word 'cunt'. It is spoken many times in the episode, but in a context which, for *Sex and the City*, is atypically asexual. The episode reminds us that the sexual revolution fell short when it came to changing public attitudes about 'saying the unsayable'. (When I was a film reviewer for ABC Radio in the early 1990s, I was told this was the one word I should *never* say on air.)

In the first half of the twentieth century, modern western societies expended a great deal of time and energy regulating the sexuality of single women, particularly the lives of the working-class girls and women who had moved in large numbers into the rapidly growing cities, where they were able to find work. They shared rooms with other young women or lived alone, free of the restraining influence of the family. A weekly salary gave them a new-found independence; they sought pleasure in their free time or between shifts at the new movie houses and dance halls or shopping in the big department stores. Many young women, alone in the city, were prey to unscrupulous men: some of the less fortunate found themselves pregnant and unemployable; others were forced into prostitution (Barron 1999). Whereas the poor were subjected to intervention by government authorities seeking to 'rescue' single girls and women from 'moral danger', single girls from wealthier backgrounds were protected from such intervention:

> Middle- and upper-class families were able to purchase privacy and insulate their daughters from external intervention . . . by institutions, courts, and professional organizations set up to address problems of transgressive sexuality (Barron, 1999, p. 839).

In the first decades of the century, some of the most popular films explored the theme of the single girl, usually alone in the city, at the mercy of the sexually exploitative man. At the end of the century, the single girl and professional woman are perfectly at home in the urban jungle, although still not always safe to walk the streets alone.

The first thing that is immediately clear from viewing *Sex and the City* is that there is no longer a single correct position or line on proper female behaviour. A central tenet of 1970s feminism was that, if nothing else, women had as much right to enjoy sex as men. Further, women argued that they could enjoy sex in its own right; a woman did not have to be 'in love' to experience sensual, bodily pleasures. Feminism held that women should be free to try all forms of sexual relationships including lesbian sex, multiple relationships and casual sex.

Apart from lesbian sex, *Sex and the City* has certainly taken the above tenets of feminism to heart. In fact, so many once-controversial ideas, ideas which were debated by feminists worldwide in the 1970s, have now become such an accepted part of the philosophies behind contemporary media and television programs such as *Sex and the City* that they no longer draw attention to themselves as 'feminist'. These ideas have become an integral part of contemporary urban life. Women, not just men, now seek out sexual encounters as a way of gaining confidence and experience.

The sexual and social practices of western women have become fluid and experimental, inspired by a sense of autonomy and a determination to challenge traditional boundaries. Postmodernism, which seeks to destabilise the master discourses of the nineteenth and twentieth centuries, such as family, religion, nation and patriarchy, has also re-evaluated the belief that 'sex is sacred'; instead, sex has become something we can discuss, explore and demystify.

The changes have been accompanied by new terminology. 'Lipstick lesbians' dress for glamour, refusing to conform to the mannish stereotype which is designed to make straight society feel comfortable; 'sex positive' is used by women to refer to something which endorses good sex for women; 'girl-walking' describes the new fashion of straight girls being seen at public events with the right girl on their arm rather than a man (Watson 2001). The right girl is glamorous, cool, fun. The direct link between a sex and lifestyle program such as *Sex and the City* and social attitudes has become manifest in reality TV shows which set out to explore in real life the philosophy behind the television show.

In Australia, Channel 9 created a reality TV show called *Single Girls* which was based directly on *Sex and the City*. Five attractive women were selected to live together in a luxury Sydney house situated by the sea; their goal was to find Mr Right in ten weeks. Like the four women of *Sex and the City*, the stars of *Single Girls* were very different from each other, with varying views on sex, men and relationships. There were no double standards in sight; no attempt to compromise. If Mr Right turned up, terrific;

if he didn't, the world wouldn't come to an end.

The creation of *Single Girls*, as a response to *Sex and the City*, served to support not only the social and moral values endorsed by the latter but also the right of single women to choose their own sexual experience: '. . . there are a lot of different feminisms now. Even stranger, there are a lot of different feminist ideas in today's popular culture and prime-time TV' (Probyn 2000, p. 32). Issues once discussed behind closed doors in the private domestic sphere are now circulated globally via the media in the public domain. The degree to which viewers endorse the social and sexual values expressed by *Sex and the City* is not easily determined. The important factor is that the media are prepared to present changing moral values for public consideration and debate. While not attempting to break all conventional taboos, television programs such as *Sex and the City* permit sufficient transgression of boundaries to keep new ideas and social practices in the public domain.

Sex and the City challenges traditional sexual taboos for women and promotes, to its global audience, a particular lifestyle for women—a rewarding profession, independence, sexual pleasure, shopping, good food and wine, sexual freedom. Of course the lives of the four women—and the women themselves—represent, to some extent, a fantasy. Most women do not look like models, or earn enough money to dress like a film star or have enough time to shop for sex. *Sex and the City*'s central aim is not to present a 'realistic' portrait of life in Manhattan, but rather to create a space for fantasy or wish fulfilment in order to explore the controversial areas of female desire and sexual taboos. In so doing, sex is treated as if it were a commodity. In a sense, the women 'shop for sex'. If the series threatens anyone, it may well threaten male viewers, because women have always made better shoppers than men. They demand quality and know a bargain when they see one.

References

Barron, D.L. 1999, 'Sex and single girls in the twentieth-century city' *Journal of Urban History*, vol. 25, no. 6, September, pp. 838–47.

Cartmell, D., Hunter, I.Q., Kaye, H., Whelchan, I. 1997, *Trash and Aesthetics*, Pluto Press, London.

Charney, L. and Schwartz, V.R. (eds) 1995, *Cinema and the Invention of Modern Life*, University of California Press, Berkeley, p. 173.

Dowd, M. 2001, 'Men: more predictable than a pile of wood' *The Age*, 27 July, p. 15.

Freud, S. 1985, 'Totem and taboo', in *The Origins of Religion*, The Pelican Freud Library, vol. 13, Penguin Books, Ringwood, Australia, pp. 43–224.

Hansen, M. 1995, 'America, Paris, the Alps: Kracauer (and Benjamin) on cinema and modernity', in Leo Charney and Vanessa R. Schwartz (eds) *Cinema and the Invention of Modern Life*, University of California Press, Berkeley.

Hawkins, H. 1990, *Classics and Trash*, Harvester, Wheatsheaf, New York.

Johnson, A. 1999, 'Return of the hero' *The Sun-Herald (Tempo)*, 28 November, pp. 6–8.

McMahon, M. 2000, 'Much more sex please, we're Christian' *The Spectator*, reprinted in *The Weekend Australian*, 8–9 January, p. 27.

Probyn, E. 2000, 'Gun girl talk on the box' *The Australian*, 25 October, p. 32.

Watson, S. 2001, 'The ultimate accessory: another girl' *The Age*, 30 April, p. 15.

4

Women and post-porn: *Romance* to Annie Sprinkle

I had a feeling that Pandora's box contained the mysteries of woman's sensuality, so different from man's and for which man's language was inadequate.—Anaïs Nin, *Delta of Venus*, 1978

Throughout the twentieth century an increasing number of women novelists, filmmakers and writers have explored the nature and meaning of the pornographic imagination. They have cast a critical eye on a debased cultural form which has historically been the preserve of men, and have produced a body of work which is both diverse and confronting. Some have produced pornography for money, either for artistic and experimental reasons or in order to explore the concept of pornography for women. In almost all instances, they have pushed the limits and expanded the boundaries of what was considered culturally and morally acceptable by their generation. This group includes Anaïs Nin, Pauline Réage, Helen Zahavi, Catherine Breillat, Monika Treut, Elfie Makesch, Pat Califia, Lyndal Jones and Annie Sprinkle. Pornography is one of those rare cultural spaces where it is acceptable for women to voice their own desires (Creed 1983). An important result of these sexual voyages has been the presentation of pornography, its codes and conventions, from a woman's perspective.

In a similar vein, male artists, writers and filmmakers, such as D.H. Lawrence, Henry Miller, Barbet Schroeder and Robert Mapplethorpe, have explored the nature of pornography from a male perspective. Male interest in pornography has, however,

been regarded by the public as understandable and less shocking, because men have historically been seen as more outspoken about their sexual interests and desires. After all, an entire sex industry exists with the sole aim of catering to a range of male desires and fantasies. It is acceptable for men to enjoy perverse forms of sex; normal women, however, are not supposed to desire the pornographic. The aim of this essay is to consider the relationship of women to pornography in a range of works.

One of the most recent contributions is from French director Catherine Breillat, whose film *Romance* (1999) presents a confronting exploration of the pornographic imagination. The film's release created widespread controversy. In Australia, it was initially banned on the grounds that the sex scenes were real and not simulated. In France, where women are supposedly revered for their femininity (*vive la différence*), Breillat's film was considered *too* different. Critics were divided as to whether or not the film succeeded as a piece of pornography. A number of male critics argued the film failed because it was not erotic; it did not sexually stimulate the viewer.

Pornography is notoriously difficult, if not impossible, to define. 'If it turns you on it's pornographic; if it arouses me it is erotic', is a common way around the difficulty. All definitions are morally, socially and culturally relative. Most would agree that pornography is intended to cause sexual excitement, leading to sexual activity. Those things which arouse us are, however, impossible to pin down. They may include any or none of the following: a high-heeled shoe, Michelangelo's statue of David, a sado-masochistic scene of whipping, an erect nipple, an image of ejaculation. Desire remains elusive. Nonetheless, all cultures do offer definitions of pornography in order to police the boundaries between what is and is not acceptable in the public domain. The meaning of pornography in different societies is intimately related to pornography's function, legal definition and regulation. Definitions also change. In 1972 the British *Longford Report* defined pornography as images of sex or violence that were divorced from their proper context, and thus 'a symptom of preoccupation with sex which is unrelated to its purpose' (Segal 1993, p. 207). In 1979 the *Williams Report* adopted a more objective definition

of pornography, as 'sexually explicit material designed for sexual arousal' (Segal 1993, p. 207).

The critical response to *Romance* raises important questions about women and pornography—why female artists create pornographic texts, how these works are viewed by the public and the extent to which they push boundaries. *Romance* deliberately sets out to question the meaning of love and its importance in a sexual relationship. It explores the sexual odyssey of its heroine, Marie (Catherine Ducey), who is in a loveless relationship with a man who seems unable to offer passion or pleasure. If Marie wants sex she must 'force' it on her uninterested partner. *Romance* is based on an amusing conceit which reverses the traditional portrayal of the sexes: the woman has a strong sexual appetite; the man, contrary to the stereotype of the romantic French lover, appears frigid. Marie responds to her lover's indifference by embarking on a number of sexual encounters in order to experience a range of sexual pleasures. She also wants to see whether or not she is able to separate her sexual desires from her emotional needs. In other words, she wants to experience sex like a man; unlike women, men are frequently portrayed as being able to negotiate this dichotomy with ease.

Breillat places her heroine in a series of difficult situations. Can she have sex with a stranger she picks up in a bar? Can she place herself in the hands of a man who practises sado-masochistic bondage rituals? Can she reduce herself to a collection of 'raw desires'? Can she continue to masturbate and fellate the man she loves in a desperate attempt to win his love? Can she leave love and romance—'that sentimental bullshit'—behind? Most men don't seem to need it, so why should she? Playing with Brechtian distanciation, *Romance* deliberately eschews romantic love in order to traverse sexual boundaries and to explore themes of female desire, fantasy and sexual perversity. Some writers have criticised the clinical style and serious intent of the film, but they have missed the point. Breillat did not set out primarily to make an erotic or even a pornographic film; she is interested in fantasy, film and female agency.

Romance does draw upon conventions of the pornographic genre. It captures a series of iconic or stock images and scenes

from hardcore pornography (close-up shots of genitalia, sado-masochistic sex, fellatio, bondage, masturbation, ejaculation, group sex), and represents them, perhaps for the first time, in a mainstream art-house film. I say 'capture' because Breillat claims that pornographers have 'stolen' explicit images of sexuality 'from the rest of us' and made them the sole preserve of pornography. Her main intention was not to create a conventional pornographic film, but to open up mainstream cinema to the possibility of representing sexuality in as direct and uncompromising a manner as possible and to present the narrative from a woman's perspective. *Romance* explores the limits of representation, of what is acceptable in the mainstream at the end of the twentieth century.

In keeping with her intention to breathe new life into the stereotyped images of sexuality from the pornographic film, Breillat has filmed sequences of actual, not simulated, sex. Various shots in mainstream pornography—particularly the 'money shot' or 'cream pie shot'—are usually faked. The 'money shot' is the image of the erect penis at the moment of ejaculation. In most porn films the male withdraws his penis from the vagina so that the spectator can see the action of ejaculation. This demonstrates that the sex is actually happening; it is not faked. The money shot is thought to encourage sexual arousal of the male spectator. In some films, however, a small tube, not visible to the spectator, is taped to the penis and fluid is pumped mechanically into the air. As American film theorist Linda Williams points out, the money shot is used in feature-length films to 'signal the climax of the hardcore action' (Williams 1990, p. 73). 'Cream pie' refers to the image of the vagina after ejaculation—a much easier shot to fake.

Some critics appear to have attacked *Romance* for the wrong reasons; they have assumed that the film was intended to duplicate male pornography. One claimed that 'as pornography *Romance* is a dismal failure' (McDonald 2000, p. 10). *Romance* is not pornographic—rather, it restores explicit images of sexuality (now almost entirely the preserve of pornography) to mainstream cinema, but not in a pornographic form. A rudimentary knowledge of the conventions of mainstream pornography will make it easier to understand Breillat's intentions in making *Romance*.

The major aim of the mainstream conventional pornographic film is to arouse the (male) viewer by depicting as many sexually explicit images and sexual scenarios as possible within a relatively short time frame (Creed 1983, pp. 67–88). The viewer is placed in direct visual contact with close-up images of breasts, vagina, clitoris, anus, penis and testicles. Hard-core pornography is usually defined as that which contains images of the erect penis. Film theorist Paul Willemen argues that:

> The viewer is left squarely facing the image without even a semblance of an alibi justifying his or her presence at the other end of that look. Porn imagery is perhaps the most blatant and uncompromising form of direct address short of physical contact (Willemen 1980, p. 77).

The display of genitalia is so excessive in pornography that it suggests a dearth, a complete lack of genital visibility in the mainstream—something which films such as *Maitresse* (1976) and *Basic Instinct* (1992) have begun to overturn. There is also a constantly replayed catalogue of sexual scenarios which include the following: scenes of masturbation; group sex; lesbian sex (but not gay male sex); anal, oral and vaginal sex; and sado-masochistic sex in which men and women play both roles. The popular view is that only women are portrayed as victims of sadistic sex (rape, abuse) in pornography. There is in fact a sub-genre of pornography, best described as the 'bondage' film, in which men, called 'slaves', surrender to the cruel caprices of the dominatrix, a voluptuous tyrant who submits the male to verbal abuse and physical torture. The dominatrix whips the slave's body, ties him up and tortures his penis with pins, nails and cigarette butts.

A second main feature of the pornographic film is that it is not interested in character development; hence there are very few filmic devices, or narrative strategies, to encourage viewer identification with the characters, who usually remain nameless. Third, there is usually only a minimal narrative structure, or story, and this, combined with the absence of character development, results in a lack of narrative suspense. A common criticism of pornography is that it is repetitive and boring. The narrative structures are relatively weak and primarily there to generate as

many sexual encounters as possible within the time available. The lack of identification and suspense leads to an emotional flatness which opponents of pornography argue creates an 'inhuman' attitude to sex. The alternative explanation is that pornography's refusal to create a situation of narrative involvement or generate suspense is designed to create a 'space' in which the spectator can fantasise, a necessary prelude to sexual stimulation.

Finally, the couple as a viable unit is largely absent from pornography. Pornographic films might depict scenes of sex between a couple, but these almost always lead on to scenes of group sex and/or sex with different partners. The aim of the sexual experience is not reproduction but pleasure. Hence monogamous sex and the couple are repudiated in pornography. Some pornography adopts a playful tone, particularly in relation to mainstream film. This is most evident in the choice of titles such as *Debbie Does Dallas*, 1988; *Edward Penishands*, 1991; *Pulp Friction*, 1994 and *Wham Bang Thank You Spaceman*, 1975.

All the above elements are present in the 1972 porn classic *Behind the Green Door* (Creed 1983, pp. 67–88). The narrative, or story-line, is basic. A female protagonist is captured and taken 'behind the green door', where she is 'forced' to submit to both lesbian and heterosexual encounters with groups of men and women. There is an audience within the film, watching what happens to the female victim until its members become so aroused that they begin to engage in similar sexual encounters. There is virtually no narrative and certainly no attempt to construct a couple—the pleasure presumably lies in the fact that everyone is free to do everything to everyone without the constraints imposed by emotional involvement. No-one speaks; the sound track consists of a continuous low moan punctuated by the odd gasp of pleasure. The aim of *Behind the Green Door* is to offer the viewer explicit sexual images and scenarios which will help promote sexual arousal, leading to masturbation and orgasm. Non-violent erotica, a more recent category of pornography directed at female viewers, usually contains a slightly more developed narrative and has less emphasis on close-up shots of genitalia; its prime intention, however, is also that of arousal and orgasm.

Breillat's film combines the conventions of mainstream film (narrative and character development) with those of pornography in order to explore the status of the 'pornographic' image. *Romance* belongs to a genre of films (*A Winter Tan*, 1987; *The Virgin Machine*, 1989; *The Girl Next Door*, 2000 and; *Baise-Moi*, 2000) directed by women, in which female protagonists peel back the seductive myths of romantic love in an attempt to discover the meaning of sexuality for themselves—no matter how disturbing or degrading their experiences. Marie, the heroine of *Romance*, has encounters with four men, all very different, who offer her their preferred versions of sex without romance. The first, her partner Paul (Sagamore Stévenin), with whom she is in love, is frigid and offers her nothing very much apart from the opportunity to masturbate and fellate his uninterested member; the second, Paolo (Italian porn star Rocco Siffredi), a well-endowed stud she meets in a bar, tries his hand at everything in an attempt to give her complete fulfilment, but she leaves fearing he will make her forget Paul; the third, Robert (François Berléand), the unprepossessing principal of her school, who claims to have made love to over 10 000 women, gently ties her up as a prelude to a sado-masochistic ritual which leaves her aroused; and the final encounter is with a stranger she hopes will make her feel just a body, a bundle of physical needs, beyond romance, but he ends up raping her. The encounter which seems to arouse Marie most is with Robert, whose gentle manner is strangely at odds with the bondage scenario in which he places her. She enjoys perverse sex (being tied up and gently masturbated), and as a 'proper' woman, she is not supposed to.

The final and most brutal of all the episodes occurs after Marie—empowered by her search—assumes the dominant role and makes love to Paul as if he were the woman. Then, she finds herself pregnant with his child. In a scene in which the line between reality and fantasy is completely blurred, Marie finds herself the test patient for a bunch of trainee interns; she lies on the examining table, legs spreadeagled as each one mechanically probes her vagina. This is followed by a bizarre sequence of excessive sex between Marie and an anonymous group. Pregnant and unable to kindle any passion in her partner, not even jealousy,

Marie realises that she no longer needs him. The most confronting scene is of the baby's birth; Breillat films the infant head-on as it emerges from between her bloody legs. The explicit scene suggests that for most women, sexual experiences are inseparable from the pain and pleasure of childbirth.

In contrast to traditional Hollywood narratives of the fallen woman, Marie, the sexual woman par excellence, enacts a deadly revenge on the man for his total indifference (she blows him up), takes the baby and hits the road. In the 1930s Dietrich also hit the road with her son (*Blonde Venus*, 1932), but the moral codes of the time would not permit her to triumph on her own terms at the end. The sudden explosive ending of *Romance* could also be read as a fantasy and parody of the more conservative endings of the classic Hollywood romance genre. The fact that Marie's baby is a boy (a humorous dig on the theme of the indestructible Freudian family) suggests, however, that woman can never completely free herself of a male-defined Oedipal circuit of desire. As Marie herself says, with just a touch of irony, 'A woman is not a woman until she's a mother'.

Although *Romance* draws upon stock images and scenarios from pornography, it does not fit the definition of pornography as discussed above. In contrast to pornography, the spectator is encouraged to identify with the heroine, and to take an interest in her journey. Breillat's film also explores the nature of contemporary relationships in a world in which women speak openly about their own needs and desires. In contrast to conventional pornography, *Romance* is not interested in the sexual arousal of the viewer. This does not mean that viewers will not find some scenes erotic. *Romance* combines images and scenarios from pornography with the narrative and conventions of mainstream film in order to raise questions about the nature of relationships between female fantasy and desire.

A number of male critics found *Romance* serious and deadly. *Time*'s Richard Corliss denounced it as 'slow' and 'morose'—an 'ordeal' for the audience. John McDonald (*The Australian's Review of Books*) criticised the film for presenting a 'singularly bleak and depressing view of human relationships' and for being a 'deadpan, bitter film' that—in comparison with earlier films about

romance such as *Now Voyager* (1942)—tempts one to believe 'that Hollywood occasionally got it right'. Hollywood may well have got it right (and more than occasionally), but 60 years later, many viewers want something more appropriate to the times. They also want to know what women novelists and filmmakers think about sex, romance and pornography. Not even Kubrick's *Eyes Wide Shut* (1999), which offered a powerful depiction of a relationship in crisis, and also explored pornographic fantasies, allowed a space in which the heroine was able to play a part in or respond to the film's controversial orgy sequence.

In my view, however, the major reason why some critics, including the Australian censors, found *Romance* so threatening has nothing to do with the explicit imagery. Breillat's film threatens because it not only features a woman who speaks openly about her own sexual desires and who is prepared to take responsibility for what happens to her, regardless of how demeaning; it also makes it very clear that a woman's sexual pleasure is not dependent on the phallus—no matter what its size—nor on the splendid physique of the body to which it is attached. The only scene in which we see Marie sexually aroused is the one with the middle-aged, unprepossessing schoolteacher who prefers bondage to penetration—the penis plays no part. Even when she is with the magnificent Paolo, his phallic prowess is of little consequence. The conventional Hollywood depiction of the sexual act almost always involves vaginal penetration with the man on top—pretending to push his penis in and out—while the woman's facial expression (lips slightly parted, eyes shut, head thrown back) registers the orgasm—on behalf of them both. Rarely is the man's face invited to express sexual pleasure. Even in the recent classic *The End of the Affair* (1999), we find this well-worn visual cliché. In stark contrast to the pornographic underground, the mainstream rarely suggests that the woman's pleasure is anything but vaginal. *Romance* confronts, head on, the Hollywood myth of the vaginal orgasm. It also questions prevalent assumptions about relationships which have led us into the cul-de-sac of what Stephen Heath calls 'the sexual fix', that is, the modern belief that if we are not continuously in love and enjoying great sex with our ideal partner then something is seriously wrong (Heath 1982).

The controversial film *Baise-Moi* similarly undercuts all notions of romantic love, and phallic sex, as the holy grail of relationships. Directed by novelist Virginie Despentes and porn star Coralie Trinh Thi, the film tells the story of two young women who band together in a liberating spree of murder and sex as they travel across France. One of the women, Manu (Raffaella Anderson), has starred in a porn film; the other, Nadine (Karen Bach), is a sex worker. Just before they meet, each woman accidentally commits a murder. The two also share a transgressive outlook on life. Nadine is happiest when she is masturbating in front of hard-core pornography. Manu knows how to get the better of men, even when she is the victim. Early in the film, Manu and a female companion are raped by two men. Unlike the other woman, Manu simply lies there, refusing to struggle or scream for help. The rapist is furious with Manu for her passivity. She really knows how to irk him. 'Shit,' he yells, 'It's like fucking a zombie. Move your ass a bit!' Later, when her distraught companion asks how she could have been so compliant, Manu replies that she 'doesn't give a shit about their scummy dicks'.

When Manu and Nadine meet in the subway they form an instant friendship; they pick up men (not necessarily for sex) and then shoot them in cold blood. The outlaw couple also shoot a number of women, but these deaths are not dwelt on in the narrative. Unlike *Thelma and Louise* (1991), the film never addresses the question of morality. The couple are simply having fun. Their murderous spree eventually ends in Manu's death. Despite its hard-edged style, *Baise-Moi*'s intention is to explore the outer reaches of fantasy, where the two female protagonists simply react spontaneously and violently whenever they feel affronted and/or seek emotional release. Of course it is not hard for them to feel anger; the French social climate is decidedly phallocentric and misogynistic. It could be argued that *Baise-Moi* is a rape-revenge fantasy, since Manu's rape is represented as the event which triggers the action, but the film seems more intent on presenting an anarchic black comedy about what happens when two sexually charged young women with loads of front decide to have fun.

The sex is real but the violence is simulated. There are a number of sex scenes which are typical of conventional pornographic films. As in *Romance*, *Baise-Moi* successfully interweaves pornographic imagery with the narrative events. The difference is that Nadine and Manu really seem to enjoy sex, but on their own terms. *Baise-Moi* similarly represents woman's pleasure as not dependent upon men or sexual penetration. This is the real reason why some critics have acted with such hostility to *Baise-Moi*, which has been banned in a number of countries. The film argues that women's pleasure is not bound up with the phallus; men are basically irrelevant to the bloody but exhilarating journey of the two women.

Another interesting parallel between *Baise-Moi* and *Romance* is that male reviewers have stated that they found the film completely unerotic. When the film was screened at Cannes, the reviewer for *Libération* stated: 'I tested it, impossible to have a hard-on' (quoted in Vincendeau 2002, p. 38). He decided that *Baise-Moi* belonged to a new category of pornography—'post-porn'. More obviously, *Baise-Moi* belongs to another category which is not necessarily exclusive of post-porn: it offers a contemporary example of porn made by women. Women viewers have found the film's raw sexual energy and powerful female protagonists a turn-on; in its reworking of classical (male) porn, women's porn has unsettled traditional porn conventions and emerged as post-porn. Like Catherine Breillat, the directors of *Baise-Moi* have taken back explicit sexual images that have been colonised by the porn industry and reworked them for contemporary audiences.

Romance also resonates with another key pornographic text by a woman author, *The Story of O*, written almost 50 years ago, in 1954, under the pseudonym Pauline Réage. Until recently, it was generally assumed that the novel was written by a man. Critics argued that *The Story of O* could not have been written by a woman because it was too sexually explicit and morally depraved. In 1994, the true author was revealed as Dominique Aury, a highly respected French woman of letters. Aury wrote *The Story of O* as a love letter to her married lover, Jean Paulhan, France's pre-eminent literary critic. It was originally intended for

his eyes only, but Paulhan persuaded Aury to publish it. In this way a private love letter became 'the first explicitly erotic novel to be written by a woman and published in the modern era' (Jorre 1994, p. 43). It has never been out of print. Translated into over 24 languages, it has sold millions of copies. The *Story of O* attests to the transgressive power of the female novelist and artist.

Like *Romance*, *The Story of O* centres on a female character who has dedicated her life to the pursuit of sexual pleasure. In Réage's novel, the eponymous heroine justifies her quest in the name of romantic love, while Marie is interested in sensual/sexual pleasure for its own sake. Unlike O, Marie wants to see whether or not she is able to separate her sexual desires from her emotional needs. For O, the two are inseparable. O will submit herself to the most humiliating sexual experiences, which she comes to enjoy, in order to demonstrate her total devotion to her lover. In both novel and film, the narrative structures are organised so as to foreground the question of female sexual pleasure, or the question that so perplexed Freud and, more recently, Mel Gibson—what do women want?

THE STORY OF O

Until the 1970s, with the advent of second-wave feminism and the publication of journals such as *Cosmopolitan*—and now programs such as *Sex and the City*—the question of woman's sexual pleasure was rarely seriously posed in the popular media. In *The Story of O*, sexual pleasure for women is associated with the fantasy of sado-masochistic encounters, of being taken against one's will. Significantly, as in *Romance*, woman's orgasmic pleasure is not related primarily to genital penetration.

The novel tells the story of a heroine—known only by the initial of her first name—who agrees to undergo a series of sexual and physical tortures to prove her love for the two men in her life: René and Sir Stephen, her future master. These tortures initially take place at Roissy (a chateau in the best tradition of the nineteenth-century French 'libertine' pot-boilers), where O is taken by her lover René who, unbeknown to O, is preparing her

for his close friend, Sir Stephen. At Roissy, O joins a group of women who are not unlike an order of religious initiates, in that they have all dedicated themselves to a higher ideal—that of love—and are all prepared to undergo a systematic scourging of the flesh, presumably in order to transcend the limitations of the body and, through this endurance of pain and humiliation, achieve a higher state, in which they will become at one with their master/lover. The religious devotion of the women and their desire to serve their lord lead to their participation in sado-masochistic sexual rituals. The narrative points to the historical connections in Christianity between masochism (flagellation, self-abnegation, acts of endurance), religious ecstasy and love.

The novel situates the master/lover fantasy alongside a larger one, the fantasy of being taken against one's will. Having agreed of her own free will to undergo trials at Roissy in order to prove her love for René, O is then forced to submit to every sexual command. She is no longer free to refuse; this constitutes the main clause in her contract. One of the functions of the bondage fantasy is to use the scenario as a metaphor for total abandonment to sexual pleasure. 'The pleasure of the fantasy [is based in] the woman's complete control over the scenario even as she imagines being compelled' (Lesage 1981, p. 47). The sado-masochistic fantasy constructed in *The Story of O* certainly works in this way: although O is forced to submit, nothing 'terrible' actually ever happens to her. Furthermore, she knows she is always free to leave. The first detailed literary account of the (male) bondage fantasy is Leopold von Sacher-Masoch's *Venus in Furs* (1870), in which the male must submit to a beautiful but cruel female tyrant. Réage's novel owes much to Sacher-Masoch (from whose name the term 'masochism' is derived).

Written in 1954, prior to the advent of second-wave feminism, and in an excessively phallocentric culture, *The Story of O* draws on the metaphor of woman-as-sex-slave to explore the nature of female sexual desire in a world where men make the rules. France created the rules of courtship and romantic etiquette: *The Story of O* extends the practices of male gallantry and 'courtship rituals' to a perverse extreme. The woman must submit so completely to the man she loves that her erotic pleasure eventually becomes

intimately bound up with acts of submission. Unlike male pornography of the period (such as Henry Miller's *Sexus*, *Nexus* and *Plexus*), Réage's main intention is to explore the extremes of female devotion and desire in a phallocentric world. In her encounter with the male, the heroine is rendered so abject that even her name signifies her status—she is 'nothing'.

What some readers and viewers have found shocking about *The Story of O* and *Romance* is that their female creators push the boundaries of the pornographic imagination to its limits through extremely explicit, frank depictions of what would traditionally be seen as perverse forms of sexuality. The 40 years between the appearance of Réage's novel and Breillat's film have made a clear difference to the structure and style of the works and to their endings; however, both explore the same theme—the nature of female desire and sexual pleasure in a predominantly hetero-sexual, phallocentric world. Both works also encase their stories within metaphors which reflect the inequalities of male/female relationships of the day. Like Breillat, Réage also lifts from the pornographers a range of pornographic scenarios, particularly the sado-masochistic, and locates them in a different context by aligning them with love and religiosity.

Breillat draws on a different metaphor, that of sex as consumption. Unlike O, the heroine of *Romance* lives in a world where woman is free to choose from a range of sexual practices. Her intention is to adopt a 'male' attitude to sexual experience—to see if she can enjoy sex as a purely physical act, one divorced from the demands of love. Unlike O, Marie has a proper name and is free to explore a range of sexual practices and possibilities, including masochism, which she responds to but ultimately rejects. As mentioned earlier, Breillat's stated intention was to re-work images from mainstream pornography and place them in a different context. Both Réage and Breillat extend the represen-tation of sexual desire for women beyond the tyranny of 'normal' or proper sex, which is conventionally defined as penetrative and procreative (Freud 1977, p. 61).

Not all feminists condone the idea of women exploring or creating pornography; some see pornography as a totally male enterprise which demeans and humiliates all women. In the

mid-1970s, US feminist Robyn Morgan coined the famous slogan 'Pornography is the Theory: Rape is the Practice'. This view deemed pornography responsible for male violence against women. US feminists such as Catherine McKinnon and Andrea Dworkin define all pornography as the exploitation and subordination of women. In her influential book *Pornography: Men Possessing Women*, Dworkin argued that pornography was the ideology behind all forms of women's oppression. She also defined pornography as a genre about male power. 'The major theme of pornography as a genre is male power, its nature, its magnitude, its use, its meaning' (Dworkin 1979, p. 24).

Despite growing support for the anti-pornography movement among feminists in the 1980s, a number of feminists opposed the Dworkin–McKinnon position. They argued that the actual subordination of women in society could not be explained in terms of the representational world of pornography and its images. Further, women's oppression long pre-dated the appearance of the porn industry. They also called for women to create their own sexually explicit material in order to open up debate and to give women a means of expressing female desire and fantasy. One of the most active responses came from lesbian feminist groups such as SAMOIS, which published books endorsing lesbian s/m practices. Australian media theorist Catharine Lumby astutely notes:

> In fantasy, contradictory impulses and impossible coalitions of subjects and objects coexist quite happily. Pornography is sometimes a funnel for this kind of wish fulfilment. In a similar sense, the feminist debate about pornography is also a kind of fantasy. It's a meeting point for the desires of different feminists—a forum for articulating what we want feminism to be (Lumby 1997, p. 115).

Seduction the Cruel Woman (1985), a film made by German film-makers Elfi Mikesh and Monika Treut, addressed the issue of women, representation and pornography in a bold manner. When this film was screened in Australia at the Feminism and Humanities Conference at the Australian National University, Canberra, many women were outraged; they argued that a film which

depicts women exercising power for their own sexual pleasure is not a feminist film. A film which explores sexual power must cater to male pleasure. Others passionately rejected this view; they held that women as well as men were able to experience sexual pleasure grounded in the play of power.

Seduction the Cruel Woman begins with a sentence attributed to French theorist Jean Baudrillard, which underlines the seductiveness of power play:

> Seduction, as an illusion, as the devil of passion, undermines the power of eroticism by the majestic powers of play.

Wanda, the heroine, is the director of a boutique theatre which caters to spectators with unusual sexual desires. With her small acting ensemble, she stages a series of sexual scenarios, each of which draws on a sado-masochistic fantasy.

The various sequences depict lesbian and heterosexual sex, pain and pleasure, fetishism, excrement and bodily wounds. Male figures are primarily victims. The stage becomes a dream-world, not unlike the cinema itself, where the players perform for their select audience. Their onstage and offstage actions merge so much that it becomes impossible for the spectator (of the film) to distinguish between the two. The various scenarios are also staged like scenes from classical sculpture or painting—the Death of Marat, Cleopatra and her Burning Barge. The effect is to merge art, pornography, film and dream. The sequences are linked by shots of the sea, water and underground tunnels. Tilted angles and repeated motifs (chains, blood, water, sewers, whippings, shoes) suggest the workings of dream and the unconscious. Wanda dominates the narrative, a mocking majestic figure who is playfully modelled on Sacher-Masoch's dominatrix, the cruel Venus in furs.

Performance and video artist Lyndal Jones has explored the nature of the male erection in her artistic practice. In one work (*The Darwin Translations*) Jones has filmed an image of a penis in close-up, as it becomes erect then flaccid; the sequence is screened in slow motion and played over and over, imbuing the scene with a dream-like quality. In order to view the film, the spectator must walk along a narrow passageway which leads directly to the

screen; the experience resembles that of a 'peep-show', in which the viewer is positioned as voyeur—or indeed the progress of sperm. For female spectators, not familiar with the voyeuristic conventions of viewing pornography, the experience is strange. In contrast to classic images from pornography, the penis does not represent phallic prowess; it is completely demystified through the repetition of slow-motion images of erection followed by detumescence. The effect is one of de-familiarisation and strangeness—the penis assumes the quality of a flower or plant, opening and closing to the rhythm of time-lapse photography.

All the texts I have discussed take pornography out of its traditional context and rework its stock images and scenarios from a female perspective. They use pornographic images and fantasies to present woman as an active desiring subject and to question the dominant view that pornography can speak only about men and to men. Because the authors of these texts have consciously set out to rework stock pornographic conventions, it could be argued that they have created a form of art-house pornography, as distinct from conventional porn. This, however, would be to create an artificial divide between high and low culture, to ignore the fact that there are no clear-cut boundaries between the so-called classic and the popular.

ANNIE SPRINKLE, POST-PORN MODERNIST

On the popular front, Annie Sprinkle directly challenged the notions of the pornographic with her one-woman shows and description of herself as a 'post-porn feminist' (Sprinkle 1998). Sex worker, performance artist, writer and photographer, Sprinkle consciously sets out to blur boundaries between artistic performance and conventional porn. Sprinkle has starred in a series of films (*Sacred Sex*, 1991; *Sluts and Goddesses*, 1992; *Weirdo New York*, 1993), directed her own film (*Annie Sprinkle's Herstory of Porn*, 199?), written her autobiography (*Annie Sprinkle: Post-Porn Modernist*, 1998), and created 'pornographic' performances on her own Website. Sprinkle engages in all forms of sexual perversion. Australian media theorist Kath Albury, who calls for the desta-

bilising 'of the "normalcy" of heterosexism', notes: 'Fetish clothing, bisexuality, tattoos, exhibitionism, domination and submission—these are not legitimate sexual expressions for the "nice girl"' (Albury 1998, p. 62). It is Sprinkle's intention to undermine heterosexism by becoming a 'bad girl'.

In one of her most famous performance pieces, Sprinkle invited her audience, male and female, to step forward and look at her cervix. Her aim was to demystify the female body. Sprinkle explains how she orchestrated the unusual event in her autobiography.

> I move to centre stage and sit in the armchair. Adopting the manner of a teacher, I present a chart of the female reproductive system, pointing out the ovaries, uterus, fallopian tubes and cervix. (I learned to say 'cervix' in seven languages!) I open my legs, insert a metal speculum into my vaginal canal, and screw it open, joking: 'Hmmm, still so tight after all these years.' I explain why I am showing my cervix, then invite the members of the audience to come up and take a look with the aid of a flashlight (Sprinkle 1998, p. 165).

Sprinkle explains that as a queue forms and each person looks inside her vagina, she holds a microphone up and invites them to describe their responses. The audience is surprisingly relaxed, and not at all hesitant in offering comments. Sprinkle describes the crowd as similar to 'worshippers at communion or kids waiting to see Santa'.

Hailed as the 'modern-day love child of Genet and Duchamp', Sprinkle knowingly questions the meaning of pornography by staging events which raise questions about the female body, female agency, voyeurism, and the relationship between representation and pornography. Her public performances, publications and Website play with the pornographic imagination in a bold and uncompromising manner. Like Pauline Réage and Catherine Breillat, Sprinkle is also attempting to reclaim images of sexuality and the female body that pornographers have made the preserve of pornography.

In their various and unique attempts to re-create the nature of pornography, women artists have clearly eroded the line

between the pornographic and non-pornographic. In their artistic works, where the 'pornographic' sits alongside the everyday, the term 'pornography' has been emptied of its conventional meanings. It no longer signifies woman as masochistic, passive or compliant—the object of male pleasure. The majority of modern works (*Romance, Baise-Moi, Seduction the Cruel Woman*) draw on strategies of violence and transgression to explore the meaning of the pornographic image. The authors of these works speak in strong, challenging voices, which may help explain why their artistic works have been the subject of controversy and censorship. Although the pornographic works of women artists, writers and filmmakers differ markedly in content and style, they leave no doubt that women can speak eloquently and powerfully about their own fantasies and desires.

References

Note: This chapter expands upon some issues I raised in a short review of *Romance* published in *The Australian Book Review*, no. 220, May 2000, p. 45.

Albury, K. 1998, 'Spanking stories: writing and reading bad female heterosex' *Continuum: Journal of Media & Cultural Studies*, vol. 12, no. 1, pp. 55–68.

Corliss, R. 1999, 'Romance' *Time*, 4 October.

Creed, B. 1983, 'Pornography and pleasure: the female spectator' *Australian Journal of Screen Studies*, 15/16, pp. 67–88.

Dworkin, A. 1979, *Pornography: Men Possessing Women*, Perigee Books, New York.

Freud, S. 1977, *On Sexuality*, The Pelican Freud Library, vol. 7, Penguin Books, Ringwood, Australia, p. 61.

Heath, S. 1982, *The Sexual Fix*, Macmillan, London.

Jorre, John De St. 1994, 'The unmasking of O' *The New Yorker*, 1 August, pp. 42–50.

Lesage, J. 1981, 'Women and pornography' *Jump Cut*, no. 26, pp. 44–6, 60.

Lumby, C. 1997, *Bad Girls*, Allen & Unwin, Sydney.

McDonald, J. 2000, 'Romance', *The Australian's Review of Books*, pp. 10–11.

Nin, A. 1978, *Delta of Venus*, A Star Book, London, p. 14.

von Sacher-Masoch, 1971, *Venus in Furs*, trans. Jean McNeil, Faber & Faber, London.

Segal, L. 1993, 'Pornography', in H. Gilbert (ed.) *The Sexual Imagination*, Jonathan Cape, London.

Sprinkle, A. 1998, *Post-Porn Modernist*, Cleis Press, San Francisco.

Vincendeau, G. 2002, 'Baise-Moi' *Sight and Sound*, vol. 12, issue 5, p. 38.

Willemen, P. 1980, 'Letter to John' *Screen*, vol. 21, no. 2, p. 59.

Williams, L. 1990, *Hard Core*, Pandora Press, London.

The Darwin Translations, video, Lyndal Jones.

5

The full monty: Postmodern men and the media

Far more commonly the soft, vulnerable charm of male genitals is evoked as hard, tough, and dangerous. It is not flowers that most commonly symbolize male genitals but swords, knives, fists, guns.—Richard Dyer, *Male Sexuality in the Media*, 1985

The men's movement is not a new phenomenon. Throughout the modern era men have been keen to discuss the male role, but not so eager to instigate change. The first modern men's group met in Paris in 1928 to discuss questions of sex, desire, male virginity, male and female orgasms, fidelity, family, sex, perversions and life in general. The group, members of the surrealist avant-garde, conducted twelve round-table discussions from 1928 to 1932. In 1992 these were published in English under the title *Investigating Sex: Surrealist Discussion 1928–1932.*

The image on the book's cover is instructive. It is adapted from a famous montage of 1929, which consists of 16 photographic portraits of the surrealist group, from André Breton to Salvador Dali, forming a grid around the illustration of a naked woman. The men, who are all clothed, have their eyes closed; the woman stands with her left hand covering her pubic area. It is as if the men dare not look at the naked body of woman. Is female sexuality too seductive, confronting or dangerous? Unique in their attempt to disrupt the conservative art world and new bourgeois lifestyle, the surrealists took an open approach to questions of sexuality. They did not always agree, either, and meetings were often fiery.

Like contemporary men's groups of the 1990s, the surrealists also conceived of male sexuality—or masculinity—as a problem.

André Breton, founder of the surrealist movement in Paris, would not have been surprised by American poet John Bly's argument that late twentieth-century men have lost touch with the 'wild' man within and are fearful of irrationality and emotion. Even in the 1920s, the surrealists were disturbed by the way in which modernity was shaping the new man. They railed against the bourgeois lifestyle, with its emphasis on conformity, propriety, the work ethic, materialism, religion, country and family—but did little to transform the lot of women in society.

The surrealists were primarily interested in questions of eroticism, love, dreams, madness, art and the unconscious. Their intention was to document every aspect of sexual love. Although they argued that bourgeois marriage stifled sex and love and oppressed women, their own behaviour towards women was far from exemplary. They criticised the cultural valorisation of the maternal role and the way women were expected to find fulfilment only as wives and mothers, but did little to support women artists. Breton and surrealist poet Louis Aragon argued heatedly over the absence of women from the discussions. Aragon criticised the discussions for privileging a male point of view; others did not agree. The men argued about the nature of the female orgasm yet did not think to ask women themselves about it. At last, women were invited—to the final three sessions—to shed some light on the mystery. These discussions were ahead of their time, but they were also *of* their time. The men were prepared to raise questions about modern love and sexual desire, but they were not prepared to relinquish male power.

The surrealist discussions of the late 1920s and early 1930s were also a forerunner of the consciousness-raising groups of the late 1960s and 1970s in which individuals who belonged to radical movements, such as the women's liberation or gay and lesbian movements, met in small groups to discuss their personal histories, and their experiences of marginalisation and oppression. Questions of sexuality were central to all consciousness-raising groups. Only in the past decade have heterosexual men begun to meet in groups with similar structures and aims. Topics high on the agenda are sex, impotence, family, work and men's relationships with their own fathers and sons.

The initial impetus leading to the formation of men's groups came from the women's movement. In the final decades of the twentieth century, feminism put masculinity—or more accurately 'masculinities'—on the media agenda. Since the beginning of the women's movement in the late 1960s, and the emergence of feminist theory which argued for the psychological and social construction of gender, attention has been directed at male sexuality. Initially men were the focus of attention because they were seen as the problem, the holders and guardians of the patriarchal power which kept women in a position of subordination. Men themselves were not seen as oppressed. Gradually, feminists (and some men) began to question the masculine. Perhaps there was nothing natural about male power and the popular equation of masculinity with leadership, rationality, control, intelligence, power and heroism. Men are still seen as the problem, but the male gender role is now seen as something open to change.

Marilyn Lake, Professor of History at La Trobe University, argues that masculine practices have always been conflated with 'human' or 'national' practices. Cultural commentators and 'historians have been slow to recognise "manhood", "manliness" and "masculinity" as social constructions requiring historical investigation and elucidation' (Lake 1986, p. 116). In *The Hite Report on Male Sexuality* (1981), Shere Hite argued that beneath their aura of machismo, the majority of men feel unsure of and insecure about their sexuality. In 1984 Eve Kosofsky Sedgwick, Professor of English at Duke University, published her controversial *Between Men*, in which she explored the continuum in English literature between homosocial and homosexual male desire. Sedgwick argued that male homosocial desire (not to be conflated with homosexual desire) signifies a social, economic and cultural system in which men support men, love men and bond with other men in order to 'promote the interests of men' in all realms of society—social, economic, familial, religious, political (Sedgwick 1984). The promotion of male interests in most areas of life has resulted in the ubiquitious glass ceiling and a lack of equal rights for women in terms of salaries, opportunities and recognition.

By the mid-1980s men began to publish their own views on male sexuality. Some were quite radical. In 'Male sexuality and

the media', Richard Dyer argued that male sexuality has always been a given, that we 'look at the world through ideas of male sexuality'. Dyer argued that whereas female sexuality is symbolised in the media by a variety of bodily sites from breasts to hips, male sexuality is primarily centered on the penis, or 'an evocation of the penis' (Metcalf 1985, pp. 28–9). Dyer finds this strange, given that male genitals are 'fragile, squashy, delicate things', not at all like their 'hard, tough weapon-like' (Dyer 1985, pp. 30–1) media surrogates: guns, sports cars, fists. He concluded that media fetishisation of the penis had the effect of reducing male sexuality to the penis and also of associating male sexuality with aggression and violence, absolving them of acts of rape because they are unable to control their animalistic urges. As a consequence, it is difficult to represent male sexuality in terms of 'tenderness or beauty' (Dyer 1985, pp. 31–2).

US cultural theorist Peter Lehman wrote a humorous article, 'Penis-size jokes and their relation to Hollywood's unconscious', in which he drew attention to the preponderance of jokes in film that are based on the size of the penis (Lehman 1993). The truth was finally out. Freud got it right when he conceived his theory of penis-envy; the problem was that he attributed it to the wrong sex. It is not women, but men, who suffer from a fear of becoming phallically challenged.

The movie industry also began to examine its traditional hero from the new post-feminist perspectives. Male directors explored three main themes: the flawed hero, the feminised man and the excessive (postmodern) hero. Clint Eastwood analysed the male psyche in *Play Misty For Me* (1971) and *The Beguiled* (1971), and Woody Allen commenced his cycle of comedies about the tormented, insecure male with *Play It Again Sam* (1972), in which he plays a film buff who is coached in the art of seduction by the ghost of one of the screen's tough guys, Humphrey Bogart.

In the 1980s, Hollywood released a number of slightly absurd films in which high-profile stars cross-dressed as women. This was not a new phenomenon. Hollywood stars had cross-dressed from the early days of cinema—but usually in the name of comedy. Films of the 1980s depicted men 'becoming woman' in order to experience femininity. Hollywood led the way with

Tootsie (1982), which starred Dustin Hoffman playing a woman in order to get a job; the irony was that he became a much nicer person as a woman than he ever was as a man. When Dustin Hoffman discarded his female persona, the film's magic instantly evaporated—audiences preferred Tootsie to testosterone.

A decade later male stars were still experimenting with role reversals—this time trading biceps for forceps in order to experience the joys of motherhood. In the box-office hit *Three Men and a Baby* (1987), a trio of bachelors change from hopeless ditherers into super fathers when they find an abandoned baby on their doorstep. *Switch* (1991) was about a womanising male who is murdered by a group of angry ex-lovers; he returns to Earth as a woman, becomes pregnant, and finally learns to release his feminine self. Robin Williams starred in *Mrs Doubtfire* (1993), in which he became a mother's help in order to gain access to his children after an acrimonious divorce. The following year, Arnold Schwarzenegger made *Junior* (1994), in which he was persuaded to have a baby. The fertilised egg was injected into a stomach cavity, the embryo grew to full term and the infant was born by caesarian surgery. The catch was that Arnold then did not want to relinquish his baby. His uterine experiences also transform him, and he becomes a much more sensitive man.

Not to be left out of the cross-dressing stakes, Mel Gibson, another classic hero-turned-woman, starred in *What Women Want* (2000). A stereotypical chauvinist, Gibson is the victim of a freak accident and subsequently discovers that he is able to hear women's thoughts. Transformed by the experience, Gibson also becomes a much more likeable and caring person. The moral of these films seems to be that in order to become sensitive new age guys, men must first experience what it is like to be a woman and a mother, because women are subject to oppressive patriarchal social structures that are so invisible men do not even notice their operation.

The re-evaluation of masculinity came into its own through the influence of postmodern theory on cultural practice. The master discourse of 'Manhood' could no longer be taken seriously. In response Hollywood began to make films in which the hero could only be seen as a parody of classic notions of masculinity.

Actors such as Sylvester Stallone and Arnold Schwarzenegger played heroes who were so pumped-up that they could not be taken seriously; they assumed a comic-book style of machismo which provided ironic comment on the traditional belief in the hero as a giant of a man, a man among men, a man who would always defeat the forces of evil and restore law and order to the world. One Melbourne critic went so far as to describe Arnie as looking like a condom stuffed with walnuts.

Another way in which the media have been eager to support role reversal for men is through bodily objectification. The male sex object, however, is not new. The practice of men displaying their physical and sexual attributes has a long and venerable history: in their eagerness to attract women, or other men, men have resorted to a variety of attention-grabbing tricks; they have artificially enlarged their chests, endured the torture of whalebone corsets, padded their thighs and calves, and stuffed falsies into their crotch—a fashion recently revived with padded Y-boxer shorts. There is no doubt, however, that sexual objectification of the male body reached great heights in the latter part of the twentieth century. Men have appeared as sex objects in different and imaginative contexts—many of which are very profitable.

In a Melbourne television series called *Man O Man,* in which contestants dressed up and strutted down the catwalk, the all-female audience took great delight in eyeing the men while commenting loudly on their physical attributes. 'Show us your tits, luv!' was a popular cry from female audiences thrilled at being able to turn the tables. The women selected their favourite and the losers were pushed into an awaiting pool. *Man O Man* caused a controversy in the newspapers—some women described it as sexist exploitation of men, while others saw it as good fun and a victory for equal opportunity. A completely different male sex object appeared on the Gold Coast in 1993, when a lifeguard made history by becoming the first man to win an Australian beauty contest. Organisers suggested wryly: 'The next Miss Australia could be a bloke'.

Since the 1980s it has become fashionable for sporting heroes to work as photographic models or pin-ups on the centrefolds of women's magazines such as *Cleo* and *Cosmopolitan*. In late 1991,

when *Australian Women's Forum* ran its first full-frontal centrefold of a naked man, it sold out. The documentary *For Her Eyes Only* is about special clubs around Australia where women gather for a fun night watching male strippers perform raunchy acts. Some women even leap onto the stage to help the bashful discard their G-strings.

Not all agree on the desirability of women looking at men. While some argue this change represents a genuine advance, others claim that to turn men into sex objects is a setback for equal opportunity. While consensus is impossible, at least the debate has made one crucial gain—it has forced general recognition that women do, and should be allowed to, derive pleasure from looking, an activity that for too long has been the preserve of men. Men, however, are not always prepared to reveal their 'all'. In the hit film *The Full Monty* (1997), a group of unemployed men decide to earn their keep by staging a male strip show. When the curtain finally parts the men reveal everything to their eager audience but the cinema audience is spared even a glimpse of 'the full Monty'.

By the 1990s, the term 'masculinities' emerged in a number of academic publications (Lehman 1993; Biber 1999; Bullock & Coleman 1999); its use emphasised that there are many different kinds of maleness, and that their make-up is influenced by class, race, sexual preference, age and colour. Just as the feminist movement in the early 1980s was forced to recognise that women embraced a diverse range of positions, so also it has been acknowledged that there is a complex range of masculinities. The concept of 'masculinities' also reinforced the view that gender was a constructed rather than a pre-given category.

It was the men's magazine market—as distinct from the press—which first began to discuss male issues such as relationships, intimacy, sex, impotence, loneliness, domesticity, ageing, hair loss, prostate cancer, fatherhood. In response to public interest, the weekend newspapers began to discuss the male role, particularly the plight of divorced fathers separated from their children. In the late 1990s, the various weekend magazines of the major newspapers focused on masculinity. One feature story, entitled 'The father load: from IVF to stepdad, a father's role carries more

weight than ever', examined fatherhood as men's biggest responsibility in life (*The Australian Magazine* 2–3 September 2000).

Another weekend magazine, *The Men's Issue*, was almost entirely devoted to the problems of being male. Topics included: the new men's movement, fathers' rights, circumcision, what men fear most about women (*Good Weekend, The Age Magazine*, 26 August 2000). Australian academics McKay and Ogilvie argue that a close study of the Australian media reveals a deep concern about the so-called 'feminisation of men' (McKay & Ogilvie 1999). One feature story in the *Sunday Magazine* examined this prospect in an article titled 'The gender project: the social experiment that's destroying masculinity'. The article looked with alarm at an American project which was supposedly designed to 'reconstruct' boys to be more like girls (Summers 2000).

Some critics argue that while film, lifestyle magazines and popular culture are prepared to examine masculinity, they are not prepared to question male power itself. This seems as true today as it was 70 years ago, judging by the surrealists' discussions. The mainstream press and television news programs rarely (if ever) articulate awareness of the existence of a range of masculinities; they promote masculinity as a unitary category. The press rarely (if ever) question the nature of masculinity being displayed by male politicians, sporting heroes, leaders of industry and heads of the defence forces. Masculinity is a transparent, singular, obvious quality. Cultural theorist Jackie Cook confirmed this view in her study of representations of the male body in men's magazines (*Ralph, Flex Magazine, Musclemag*) in the late 1990s. Cook concluded that although more attention was given to the body and health issues, there was no real change in images of masculinity itself, 'especially in relation to its ongoing social and cultural dominance' (Cook 2000, p. 184). Men may adopt seductive poses that were once the domain of the female supermodel, but women continue to be depicted as ornaments. *FHM* specialises in soft-porn images of women who look as if they can't decide whether they are modelling clothes, having an orgasm or both. If anything, these magazines represent a backlash against feminist arguments that men must dismantle the structures which maintain male power in society.

Much popular entertainment offers images of aggressive encounters between men, which are usually attributed to the influence of testosterone. The typical response is that 'men will be men'. From a different perspective these images could be viewed as sado-masochist encounters. This dynamic is central to contact sports such as football, boxing and wrestling, as well as to action, crime and war films, all of which depict men beating and killing each other. Clearly, it could be argued that media representations of male-to-male violence serve a cathartic function in that spectators can experience violence—a necessary part of life—vicariously from the safety of their seats. In this context, displays of male sadism and masochism may function as a cultural safety valve.

The problem is that these representations are rarely recognised for what they are—displays of masochism and sadism; the culture more readily accepts the sadistic face of masculinity, which is termed 'aggression', but not its masochistic side, which has historically been associated with femininity. In the main, the masculinist culture is not ready to examine its own pathologies when these cast doubt on the popular belief that masculinity is unproblematic, powerful and rational. However, there are exceptions, such as the recent films *The Boys* (1997) and *Boys Don't Cry* (2001), both of which presented powerful critiques of masculinity and male violence. There are also popular films, such as *Fight Club* (1999), which pretend to examine male violence while nostalgically endorsing violence as belonging to a mythical time when men were free to be men.

The sadistic side of adult masculine culture was reflected in a recent legal case affecting Trinity Grammar, one of Sydney's most exclusive private schools. Police alleged that a 'culture of violence' existed at the boarding school. Four boys aged 15 and 16 were alleged to have committed more than 75 sexual assaults on two boys who were tied up and assaulted with wooden dildos. One boy claimed he had been 'tied to a bed with a belt and sexually assaulted more than 20 times in six months' (Overington 2001, p. 1). The attacks were described as part of the 'bastardisation' that existed in the boarding school; there have also been bastardisation scandals in other private schools and the armed forces.

The sado-masochistic 'culture of bastardisation' points to the pathological nature of some masculine cultures, particularly where men live in predominantly male institutions. It also emphasises the sado-masochistic fabric of mainstream culture and male society in general. Unless men are prepared to question the nature of male power—its alignment with aggression and its subordination of women and children—it is difficult to envisage any lasting or worthwhile changes taking place.

The sustained critique of masculinity which dominated the 1980s led to the formation of various men's groups. These polarised into two camps: profeminist and mythopoetic, only one of which argued for the need for men to relinquish power. Under the direction of the American poet Robert Bly, mythopoetic men established a men's movement of their own in order to identify and attend to men's inner hidden wounds through the healing power of myth. The media took an immediate interest in Bly's philosophy, which they saw as critical to the development of a men's movement in America, but their interest soon waned as the more bizarre aspects of the mythopoetic movement became public.

A colourful and charismatic figure, Bly won the National Book Award in 1968 for his poetry. In the television documentary *A Gathering of Men* (Wayne Ewing 1990), Bly is interviewed by Bill Moyers, who also conducted the series of famous interviews with Joseph Campbell, the Jungian anthropologist. Filmed shortly before the publication of his book *Iron John*, Bly speaks at length about his fraught relationship with his father, who was an alcoholic, and the sense of loss he experienced until he took steps, when he was around 45 years of age, to heal the relationship. We see Bly playing a drum, telling fairytales, reciting poems about his father, talking to a group of men about fathering and grief, and analysing his feelings with Moyers.

Big, powerful, wearing colourful clothes and sporting a mane of white hair, Bly comes across as a strong charismatic figure with a feminised aura. He never attempts to 'blame' women for men's problems; he focuses on the cultural and economic changes of the past 150 years, which occurred as a result of the Industrial Revolution. Bly argues that the latter undermined

family structures and separated boys from their fathers, who worked all day, and often into the night, away from the home. Boys now grow up without any way of learning about 'the male mode of feeling' or of being initiated into the adult male world. Bly argues that men, who have lost contact with nature and their fathers, feel grief. Grief, he argues, is the 'door to male feeling'. Taught to deny grief as unmanly, men have repressed their pain and anguish.

Women, on the other hand, have over the past two decades developed a much clearer and stronger sense of their identity and of the warrior within them; women know what they desire. Men need to rediscover the warrior within. They also need to find an older man, a male mentor or 'mother' who will nourish them. The best way for men to learn is through mythology and fairy-tales, time-honoured male narratives which offer them symbolic figures who will guide them through the difficult times. Learning such as this can take place at what Bly calls retreats or 'gatherings of men'. At these gatherings men contact their inner 'wildman' by throwing off their city trappings and bonding through the ritual practices of donning loin cloths, painting their bodies, dancing, chanting and embracing their inner 'primitive' self. Men's groups in Australia have attempted to re-discover their own 'wildman' by adopting what they believe to be ritual practices from Aboriginal culture—this has been controversial (Bullock & Coleman 1999, pp. 4–5).

In 1990 Robert Bly published *Iron John*, in which he set out his thesis about the male mother/mentor in detail. Man must set out on a ritual journey in order to confront 'his fear of wildness, irrationality, hairiness, intuition, emotion, the body, and nature' (Bly 1990, p. 14). There he will meet Iron John, a kind of inner father figure who will enable man to cross 'civilised' boundaries and confront the unspeakable, the abject. Men need to develop a 'willingness to descend into the male psyche and accept what's dark down there, including the nourishing dark' (Bly 1990, p. 6).

The Iron John figure appears to signify a set of qualities traditionally attributed to woman—irrationality, emotion, intuition and the body. From a Jungian perspective, Wild John signifies

man's repressed dark anima, a primal force once linked to the witch and the 'woman who runs with wolves'. Media commentator Vivian Hansen argues that Wild John offers the possibility of man reinventing himself as an androgynous figure; the danger is that he may run wild, wreaking further violence on women and the world (Hansen 1999, p. 276).

Bly's mythopoetic approach to masculinity opens up a number of questions about the media's representation of men. He is critical of the media, particularly television comedies and soaps, because they frequently portray the father as ridiculous or as absent. Bly also argues that the media only talk about what people *want*—material goods, a comfortable home, money, success—but never about what people *desire*. The difference between wanting and desiring is that the former involves objects that are attainable, whereas what we desire is something which is not obtainable. Men are still encouraged to look upwards and out rather than inwards and down, into themselves, he says. He also argues that America as a nation no longer knows how to grieve. While Lincoln and Walt Whitman led the nation in mourning over the Civil War, presidents such as Reagan were incapable of or unable to do the same, neither over the Vietnam War nor over what was done to the Native Americans. By implication, he suggests that the media should play a more positive role in criticising nationalism and racism and in helping men get in touch with their grief and with other men, particularly the absent or weak father.

Profeminist men adopt a very different approach (Jardine & Smith 1987; Kimmel 1995). Profeminist men do not seek to encounter the wildman within through weekend retreats and ritual practices. Since the mid-1970s, profeminist men have developed two major aims: first, they support the feminist movement, and second, they seek to change or modify the concept of masculinity by encouraging men to be more caring of and responsible for others. In his edited collection *Politics of Manhood*, Michael Kimmel set out the practical steps of their political agenda: instead of working in men's groups, they devote their energies to working with women in the public arena:

> Profeminist men work with batterers, convicted rapists,
> and sex offenders to stop the violence . . . We work with
> corporations to prevent sexual harassment and warm the
> 'chilly climate' for women in the workplace. Profeminist
> men believe that men have a collective responsibility to work
> against the violence, injustice, and inequality that define and
> confine the lives of women in our society (Kimmel 1995, p. 8).

Profeminist men criticise the mythopoetic men's movement, which they argue is more committed to men's own emotional development than to widespread social change and equality for men and women.

Some feminists, such as Susan Faludi, argued that Bly was partly responsible for the 1990s' backlash against women in that, at weekend male gatherings, men blamed women—particularly mothers and wives—for preventing them from getting in touch with their true feelings. She claimed that Bly's intention was to wrest power from women and 'mobilise it for men' (Faludi 1991, p. 310). The mythopoetic men's movement appears to share some aims with the late nineteenth-century masculinist groups, who also retreated into male gatherings to protect their threatened freedoms and masculine feelings.

In the late nineteenth century, men in Melbourne and Sydney met in groups whose aim was to celebrate the masculine ideals of freedom from family life, male companionship and libertarian-style sexual relationships which did not involve commitment. Marilyn Lake argues that the masculinist press of the time, the Sydney *Bulletin* and Melbourne *Bull-Ant*, actively encouraged men to denigrate family life, fatherhood and monogamy (Lake 1986, p. 118). Men established clubs and held all-male smoke nights where, among other things, they discussed the way modern life and the gradual emancipation of women had eroded the traditional male role and male power. A group of male artists retreated to a farm where they could enjoy, in the words of one such artist, 'free sunsets, and none of the cruel distractions ordinary honest men have to face such as rent, firing, butcher's bills, complaining wives and squalling children' (Lake 1986, p. 119). The attack on women reached its zenith in the 1930s, when

some men called for the 'extermination' of the flapper, a woman perceived to be a sinister threat to tradition.

The news media report more extensively on the activities of Bly's mythopoetic men's movement than on profeminist men. In particular, the media privilege stories of men left alone, without custody of their children, after acrimonious divorces. While some areas of the media (weekend magazines, editorials, television documentaries) have put masculinities on their agenda, the mainstream news media have not. This constitutes a crucial problem for gender equality. Those areas of the media devoted to 'reporting' events in the real world, such as newspaper journalism and television news, use the device of 'objectivity' to uphold a masculinist perspective. Newspapers, for instance, report 'objectively' on social problems such as war, violence, terrorism, rape, pedophilia, religious feuding, serial killers, car accidents and alcoholism. Rarely, if ever, do the media *gender* social problems, the majority of which, if analysed, may well be seen as a consequence of male behaviour.

A probable reason for this 'neutrality' is that the Australian Journalists Association (AJA) Code of Ethics states that journalists 'shall not place unnecessary emphasis on gender, race, sexual preference, religious belief, marital status or physical or mental disability' (Hartley & McKee 2000, p. 309). The International Journalists' Federation Code of Ethics is more progressive than the AJA Code; it states that 'the journalist shall be aware of the danger of discrimination being furthered by the media and shall do the utmost to avoid facilitating such discrimination based on, among other things, race, sex, sexual orientation, religion, political or other opinions and national or social origins' (Hartley & McKee 2000, p. 309). At least the International Code urges journalists to be 'aware of the dangers of discrimination'. The problem is that by observing 'neutrality' in relation to sex, that is by not gendering news items at all, the news media render invisible the gendered nature of destructive, anti-social behaviour, which is predominantly male.

It is crucial to have a space of flexibility in which boundaries can shift over time; while this has occurred in the areas of the media that report on 'lifestyle' and 'issues', the mainstream news

media remain committed to what could be described as a conservative, phallocentric approach to journalism. The final decades of the twentieth century witnessed a dramatic erosion of the boundaries between public and private. At the same time, the new political and social movements of the late twentieth century, such as the women's, peace, environmental, ethnic, sexual liberation and lifestyle movements, became active throughout the western world. These new movements of the postmodern era developed philosophical and political positions based on notions of identity and self-hood. They rejected master discourses of modernism such as Progress, Technology, Religion and Patriarchy. While some areas of the media (film, television) have begun to explore these changes, the mainstream news media have clung tenaciously to the older discourses about power.

In refusing to consider seriously the feminist argument that sex and gender are crucial determinants of the social and political spheres, the news media have aligned themselves with traditional male ideals of rationality and objectivity. In the interests of so-called objectivity, the media report on the state of society, its workplace hierarchies, political institutions, parliament and economic structures without drawing attention to the fact that women all over the world do not earn equal pay and are not likely to be in positions of power in the workplace. The fact that men hold power in the majority of institutions and earn greater incomes is rendered invisible because the media accept this as a given, a natural part of the status quo. To do otherwise would not be seen as a normal part of reporting the news. The media rarely comment on the fact that the majority of newspaper and television headline stories are about men. The majority of sporting events reported and televised are male sports. The majority of reporters, editors and presenters are also men.

It speaks for itself that in 2000 the United Nations, in an attempt to focus public interest on the media's glass ceiling, invited the world's newspapers to ask 'male news executives to stand aside and allow women to control the world's news' for one day and take a major role in reporting the news on that day—International Women's Day, 8 March (Riley 2000, p. 10). The Secretary-General, Kofi Annan, stated that 'women should be

represented with "equal strength and equal numbers" in the media'. The idea originated with the director-general of UNESCO, Koichiro Matsuura, who said:

> The free flow of independent and pluralistic information is best ensured if all talented journalists have an equal chance of becoming editors and media executives purely on the basis of their professional ability and without regard to gender, ethnic origin, religion or any other unconnected factor. (Riley 2000, p. 10)

The dominance of male images and events engenders in the female reader/viewer a sense that the media is composed of inherently homosocial institutions. The discourse of media 'objectivity' renders invisible the inequalities (gender, racial, class) at the heart of all social, economic and cultural institutions. In short, it could be argued that men, throughout the last century, have gathered in groups which have excluded women: political parties, professional organisations, religious ministries, academic and military professions, unions, municipal councils, sporting groups and social clubs. Men (and some women) have historically represented the masculine world as synonymous with the world of 'human' affairs. The media themselves are essentially an organ of the masculine world, which chooses to be 'sex-blind' and 'gender-blind'. Through the media men talk to themselves about their primary concerns: power, politics, war, economics, sport and the law. Male interests are conflated with 'human' interests.

The past decade has witnessed a backlash against the feminist movement and what it is perceived as having 'done' to men. Naturally, the leaders of the backlash are women. Susan Faludi's recent study, *Stiffed: The Betrayal of the American Man*, and Bettina Arndt's steady flow of articles defending the patriarchal order while attacking the damage feminism has inflicted on men indicate the rush to conservatism of many men and women: these are troubled times, and many wish to return to an era when gender roles were clearly demarcated and fixed, and as such brought comfort to those unable to cope with too much change. Even Erica Jong revived the Freudian lament in her 1998 book, *What do Women Want?*

Various writers have pointed to the way in which the virtual media, with their power to create instant global communication, have also created new ways of thinking about identity. They argue that postmodern identity in a world of global communication is fluid, multiple and malleable (Turkle 1995; Ling 1999). The older forms of the media (newspapers, TV news) continue to posit male identity in its classical modernist mode: singular, transparent, complete. Cultural theorist L.H.M. Ling warns of the problems which arise when masculine identity continues to be defined as a 'hypermasculinity' and pitted against its opposite, 'hyperfemininity'. Binary forms of thinking tend to permeate structures of division and inequality. It is crucial that masculinity be rethought, particularly in relation to the new global media (see Chapter 11).

Phallocentrism is thus normalised as the dominant discourse by the traditional media. To see masculinity as fluid and malleable (feminised), or to present the news of the world in gendered terms, would run counter to everything that the so-called discourse of objectivity is intended to uphold: specifically, male power. The topic of masculinity and its problems tends to be ghettoised, reserved for editorials, special issues of magazines or one-off television documentaries. Nor are the media ready to adopt the philosophy of profeminist men; to do so would mean that the masculinist media would have to relinquish their own power.

It seems as if we have come full circle from the surrealists' debates of 70 years ago, when they too asked the question, 'What do women want?' At least they eventually invited women to join the round-table discussions. It is time to ask: 'What do men want?' The danger is that the problem of gender inequality will become women's problem just as the problem of racism is displaced onto its victims—those least able to change the power structures. Women do not need to make a film in which the heroine suffers a freak accident and can suddenly hear what men are thinking. They already know.

References

Biber, K., Sear, T. and Trudinger, D. 1999, *Playing the Man: New Approaches to Masculinity*, Pluto Press, Sydney.

Bly, R. 1990, *Iron John*, Addison-Wesley, New York.

Bullock, C. and Coleman, D. (eds) 1999, 'Examining/experiencing masculinities' *Mattoid 54: A Journal of Literary and Cultural Studies*, Deakin University, Melbourne, pp. 18–35.

Cook, J. 2000, 'Men's magazines at the millennium' *Continuum: Journal of Media and Cultural Studies*, vol. 14, pp. 171–86.

Dyer, R. 1985, 'Male sexuality in the media', in Andy Metcalf and Martin Humphries (eds) *The Sexuality of Men*, Pluto Press, Sydney.

Faludi, S. 1991, *Backlash*, Chatto & Windus, London.

Hansen, V. 1999, '*Iron John*: myth e/merging man' *Mattoid 54: A Journal of Literary and Cultural Studies*, Deakin University, Melbourne, pp. 274–7.

Hartley, J. and McKee, A. 2000, *The Indigenous Public Sphere*, Oxford University Press, Oxford.

Hite, S. 1981, *The Hite Report on Male Sexuality*, Alfred A. Knopf, New York.

Jardine, A. and Smith, P. (eds) 1987, *Men in Feminism*, Methuen, New York.

Jong, Erica 1998, *What do Women Want?* HarperCollins, New York.

Kimmel, M.S. (ed.) 1995, *The Politics of Manhood*, Temple University Press, Philadelphia.

Lake, M. 1986, 'The politics of respectability: identifying the masculinist context' *Historical Studies*, vol. 22, no. 86, pp. 116–31.

Lehman, P. 1993, 'Penis-size jokes and their relation to Hollywood's unconscious', in P. Lehman, *Running Scared: Masculinity and the Representation of the Male Body*, Temple University Press, Philadelphia.

—— (ed.) 2001, *Masculinity: Bodies, Movies, Culture*, Routledge, New York.

Ling, L.H.M. 1999, 'Sex machine: global hypermasculinity and images of the Asian woman in modernity' *Positions*, vol. 7, no. 2, pp. 277–306.

McKay, J. and Ogilvie, E. 1999, 'New Age: same old men: constructing the "New Man" in the Australian media' *Mattoid 54: A Journal of Literary and Cultural Studies*, Deakin University, Melbourne, pp. 18–35.

Metcalf, A. and Humphries, M. 1985, *The Sexuality of Men*, Pluto Press, Sydney.

Overington, C. 2001, 'School goes on trial in unholy Trinity case' *The Sunday Age*, 4 February, p. 1.

Pierre, J. (ed.) 1992, *Investigating Sex: Surrealist Discussions 1928–1932*, Verso, London.

Riley, M. 2000, 'UN issues challenge for a media with a female force' *The Age*, 3 February, p. 10.

von Sacher-Masoch, L. 1971, *Venus in Furs*, trans. Jean McNeil, Faber & Faber, London.

Sedgwick, E.K. 1984, *Between Men: English Literature and Male Homosocial Desire*, Columbia University Press, New York.

Summers, C.H. 2000, 'The gender project: the social experiment that's destroying masculinity' *Sunday Magazine, Herald Sun*, 9 July, pp. 8–12.

Turkle, S. 1995, *Life on the Small Screen: Identity in the Age of the Internet*, Simon & Schuster, New York.

6

Mills & Boon dot com: The beast in the bedroom

She had wondered what sort of man lay beneath the hard mask he presented to the world. Now she was finding out and the primitive desire he had unleashed frightened her. And excited her.—Robyn Donald, *The Interloper*, 1981

If there were one word that summed up the characteristics of the typical Mills & Boon hero, it would be 'beast'. Dark, handsome, suave . . . he is described in terms which seem to have been gleaned from fairytales and animal husbandry. 'A superb male animal', he exudes a powerful 'animal magnetism' and barely hidden 'ferocity' which the heroine is unable to resist. Like the beast of medieval fairytales, he possesses eye-catching genitalia. His 'narrowed hips' and 'massive thighs' emphasise his 'virile male shape' which is masked by an erotic play of shadows.

In her fascinating study of fairytales, *From the Beast to the Blonde* (1994), Marina Warner argues that the 'cascade of deliberate revisions of the tale' over the centuries has created a situation such that at the close of the twentieth century, the woman is, more than ever, in need of the beast. Robert Bly, a founder of the 1990s' men's movement, also argues that man is in need of the beast, in order to experience the dark force of nature buried deep within his psyche. Whereas in the earliest fairytales and their illustrations the beast represented a repellent, threatening creature, his primitive sexuality now signifies the regenerative powers of nature: 'He no longer stands outside her, the threat of male sexuality in bodily form . . . he holds up a mirror to the force of nature within

her, which she is invited to accept and allow to grow' (Warner 1994, p. 307).

Warner was not referring to Mills & Boon in her erudite and witty analysis of the fairytale, but her discussion of the symbolic function of the beast—to awaken the heroine to the erotic power of natural, animal sexuality—is directly applicable to the woman's romance. The Mills & Boon hero is a liminal figure who stands at the boundary between the civilised and the natural world. His promise of an erotic journey into the 'dark abyss' of primal passion is one which the heroine, after a desperate struggle with her conscience, is unable to resist. The beast/man is, after all, a key player in modern media formats, from women's romances to television, film and CD-ROMs. Even Carrie, the narrator of *Sex and the City*, prefers the sexy beast, Mr Big, to Mr Nice-guy. Jean Auel's series of finely researched bestsellers about daily life in the Neolithic, from the early *Clan of the Cave Bear* to her recent *The Shelters of Stone*, contain explicit scenes of primitive, bestial sex.

The beast/man is absolutely central to the cinema. Hollywood has openly explored bestial desires with a range of man-beasts: Count Dracula, who, with his snake-like charm, has bitten his way into many a young virgin's heart; the wolfman, doomed romantic hero of a series of box-office hits; Tarzan, closer to the ape than human; Mr Hyde, of the Dr Jekyll and Mr Hyde films, who was frequently portrayed as a wolfman; and, of course, the brute lover who is all beast, King Kong. More recently, Hollywood has transformed Jack Nicholson into a werewolf in *Wolf* (1994) and Robert Redford into the erotic lover of *The Horse Whisperer* (1998). Batman, an urbane, sophisticated man about town by day and exotic creature by night, continues to haunt the screen. In *Max My Love* (1986), Japanese director Nagisa Oshima portrays Charlotte Rampling as a married woman having an affair with an ape. Tim Burton's recent remake of *The Planet of the Apes* (2001) completely blurs the boundaries between human and animal, with the Helena Bonham-Carter ape-woman giving symbolic birth to a simian/human infant. Other female beasts include those in Jacques Tourneur's *Cat People* (1942), the female Dracula of vampire films, Cat Woman in the *Batman* films,

Dietrich's ape-woman in *Dishonoured* (1931), and the beast/ woman from *The Island of Dr Moreau* (1977).

Classical mythology is replete with tales of human/animal transformations and attractions, as is European art. Famous artists have celebrated these unusual matings in the many versions of 'Leda and the Swan', 'The Rape of Europa' and 'The Virgin and the Unicorn'. In fact the nexus between human and animal is central to the myths and art forms of all cultures. Even the passionate heroes of Victorian literature dwell on the side of the beast. Catherine, in *Wuthering Heights*, describes Heathcliff, the bedrock of earthy desires, as 'a fierce, pitiless, wolfish man'. Rochester, in *Jane Eyre*, and Max de Winter, in *Rebecca*, are also brute male heroes. Coleridge also knew the appeal of the beast. His poem 'Kubla Khan' is erotically charged with the sounds of a 'woman wailing for her demon-lover'.

The psychoanalyst Carl Gustav Jung, in his discussion of the key role played by dreams and myths in the collective unconscious, stressed the importance of the animal. Dutch author Midas Dekkers has made the love of people for animals the subject of a book-length analysis. In *Dearest Pet: On Bestiality* (1992), he examines bestiality, still a taboo topic for some, across a range of discourses, including religion, mythology, art, literature and advertising. The Australian bioethicist Peter Singer recently caused a furore when he reviewed Dekkers' book and supported human/animal sex as long as it didn't hurt the animal.

In redefining traditional notions of the self, particularly theories of the Oedipal self, French philosophers Gilles Deleuze and Felix Guattari have stressed that human subjectivity is made up of a multiplicity of desires. They analyse the desire of the individual to *become* something other—central to this is the experience of 'becoming-intense, becoming-animal' desire. They are not talking about literally becoming animal, but about what is created in the act of desiring, of becoming animal. 'What is real is the becoming itself' (Deleuze & Guattari 1987, p. 238). If any one thing epitomises the nature of desire at the beginning of the twenty-first century, it is the desire to break down boundaries between self and 'other'. Those who wish to 'become' an animal can join a multi-user-domain (MUD) on the Internet, create an

animal self, and interact with other 'animals' on the site. There are also sites such as 'Zoophilia' where the participants take their bestial desires very seriously.

Mills & Boon novels are generally seen as escapist fantasy for frustrated female readers. Germaine Greer dismisses the genre as 'dope for dopes' (Pearce & Wisker 1998, p. 26). However, the romances play a key role in women's desire to traverse borders. The key border that these romances cross is that between the proper and the pornographic. There is no doubt in my mind that these sexy tales offer a form of soft-core pornography for women. My intention in the rest of this chapter is to discuss the theme of bestiality in Mills & Boon as well as the broader status of the romance as a form of soft-core pornography.

It is also important to note that popular romance publishers have not been slow to take advantage of the global market, which suggests that their wolfish tales have universal appeal. Romance publishers have launched their fiery heroines and animal heroes onto the Internet, where they sparkle next to other modernist icons of cyberlife. Publishers of romance, such as Mills & Boon, have their own Websites with chat rooms and notice boards. So, too, do their top-selling authors. The global popularity of romance fiction has been attested to with the establishment of Internet sites. There is even an online romance Website which offers discussion of real-life matters for the romance community as well as a bookstore and a write-your-own-romance learning site.

Although romance on the Internet suggests that the love story may have incorporated new elements such as virtual dating, the stories remain true to the traditional romance formula. Since its beginnings in the 1850s, romantic fiction has remained one of the most profitable of all popular genres. From the relatively asexual novels of the mid-Victorian era, such as *The Heir of Redclyffe*, to the sizzling paperbacks of contemporary Mills & Boon, and now the mushrooming dot com sites, romance continues to boom. Apart from its bookshop outlets in the western world, Mills & Boon has outlets around the globe, including Malaysia, Singapore, Korea, the Philippines, Thailand and Eastern Europe (Hooks 1993, p. 15). According to figures from the Romance

Writers of America group, romance in general accounts for 18 per cent of all adult fiction sold, and for US$1.35 billion in sales (Fuller 2001, pp. 36–41). Every year Mills & Boon sells over 250 million copies of 600 new titles in 24 languages. There is no doubt that the typical hero and heroine exert universal appeal (Hooks 1993, p. 15). Around the globe, women readers want handsome, sexual, commanding heroes who exude animal magnetism; and attractive (if not beautiful), moral (if not virginal), independent, fiery heroines.

Over the past century and a half, romance has encompassed many sub-genres: Gothic bodice rippers; religious romances; desert abductions; historical romances; doctor–nurse romances; the 'new woman' romances of the 1930s; tales of repressed sex; and the explicitly 'sexy' romance of Mills & Boon. And yet romance narratives remain the same. Only the amount of sexual activity permitted has changed. Nor does the field itself conform to a single type. Mills & Boon categorises the novels under different headings such as 'sweet romances', 'historical', 'medical' and 'sexy romances'.

Mills & Boon's 'sexy romance' belongs to the sexually explicit category. These romances offer the reader a prolonged exploration of sexual encounters which can justifiably be described as offering a form of soft porn. The 'sexy romance' heroine is no longer a virgin, and she and her sexy, animal lover are permitted to engage in most forms of erotic activity, including spanking and oral sex.

A central function of the woman's romance is to question taboos. Over the years the romance has pushed at the boundaries of sexual permissiveness, with some texts opening up a previously only fantasy world of eroticism, sado-masochism, sexual excess and perverse pleasures. The erotic fantasy conforms to specific structures regardless of readers' cultural backgrounds. The Mills & Boon romance, in all its variations, offers a prime example of this universal structure.

The typical Mills & Boon hero is tall, dark and handsome, but also arrogant. The chief recipient of his arrogance is the heroine, whom he treats throughout with a worldly cynicism and sometimes with misplaced contempt; in these instances he (mistakenly) believes she is sexually permissive. He is invariably described as

'devastatingly good-looking' and as possessing a primitive appeal which the heroine is unable to resist.

Despite superficial differences, he remains the same animal beast he has always been:

> [He] exuded powerful masculinity from every nerve and muscle. A superb male animal with all the latent qualities sufficient to quicken the beat of many a female heart— including hers, she perceived wryly (Bianchin 1981, p. 9).

> He was dressed all in black. A black T-shirt fit snugly across his broad shoulders and chest. Faded black jeans clung to his narrow hips and long legs . . . He looked wild, and dangerous, and magnificently male. He was not a dream. He was flesh and blood and he had come for her (Marton 1999, p. 62).

Like Rochester in *Jane Eyre*, his body is often marked with a sign of vulnerability, which only serves to increase his powerful allure: 'she noticed the tracery of scars writhing up the left side of his lean throat and licking up under his jaw: the unmistakable scars of an old burn' (Napier 1999, pp. 28–9).

It is essential to the narrative structure of a Mills & Boon text that the hero is a master in the art of sexual arousal, for the narrative is specifically concerned with his ability to arouse the heroine sexually and bring her to the heights of sensual pleasure. His kiss is 'a ruthless invasion' which plumbs the very depths of her being; she submits despite herself:

> She had always hated him, never trusted him, yet now he was all her senses craved, and she submitted unquestioningly to his ruthless invasion of her awakening senses (Craven 1981, p. 84).

> He danced Alexandra Thorpe into a corner, bent her over his arm, and crushed her mouth beneath his. He heard the insulted hiss of her breath, felt her first frantic struggles . . . and then, with a little sigh, she parted her lips and let him in (Marton 1999, p. 32).

One of the most important features of the hero is his eyes. He never simply looks at the heroine—rather, he 'pierces' her with

his eyes, which are capable of an amazing range of optical feats. Usually, his eyes are described as 'chips of ice' that bore into the heroine, leaving her in a state of extreme discomfort and, of course, chill:

> His eyes were like chips of ice, so pale a blue that they seemed almost colourless against the deep tan of his handsome features (Gordon 1980, p. 26).

Sometimes his look confronts her with her own sexual desire:

> As if he felt her eyes on him, his gaze swept down on her in a lazy caress that upset her heartbeat. She quivered all over inside with the desire to have him make love to her. It was faintly shocking to be so completely aroused by just a look (Dailey 1981, p. 96).

Often his eyes develop unusual tactile powers:

> It was as if his fingers, not his eyes, were caressing her, and Verna could literally feel his touch (Gordon 1980, p. 36).

Usually, his eyes just bore into her, penetrating to the depths of her soul, making her decidedly uneasy:

> His swift glance raked her with an intensity that was nerve racking (Bianchin 1981, p. 20).

> . . . those cynical blue eyes flickering all over her, making a strange, hot pulse start to beat inside her body (Lamb 1999, p. 32).

Freud wrote about the connection between the eyes and the phallus. The parallel is also there in myth and legend: Peeping Tom was punished with blindness for looking at the naked body of Lady Godiva; any man who dared look upon the Medusa's head, with its writhing snakes that symbolised female sexuality, was instantly turned to stone; and Oedipus put out his own eyes for having enjoyed the body of his mother. The connection between the act of looking and sexual arousal is so marked in the

Mills & Boon text that I would argue that the hero's penetrating look is symbolic of genital penetration, but that the emphasis is on desire rather than its fulfilment.

The heroine has transformed more dramatically over the years than the hero. Her image has responded to social and cultural changes brought about by the widespread influence of the feminist revolution of the late 1960s and 1970s. In 1982 Les Ward, managing director of Mills & Boon in Australia, described the house style of the heroine as: 'Fairly dependent but developing a streak of independence. She's not the frail lily she was years ago. I think we'll always be behind [feminism] but we are catering to a demand' (Cooke 1982). A decade later, Luigi Bonomi, senior editor with Mills & Boon, maintained that while the hero's characterisation had remained constant, the heroine had changed in response to changes in society and the role of women: 'With the rise of feminism in the '70s we started to see a lot of heroines becoming fed up with the status quo and actually demanding and achieving greater positions of equality' (Hooks 1993, p. 15).

The most dramatic change in the typical Mills & Boon heroine is that she is no longer required to be a virgin. Traditionally, she was young, somewhere between eighteen and 23 years old, and inexperienced. She was invariably beautiful, spirited and natural. Despite her youth and innocence, she was also marked by an air of independence and determination. The contemporary heroine is also beautiful and fiery, but is much more a woman of the world. She is possibly divorced, and enjoying a successful career. She is aware of woman's inequality.

> This was still a man's world. Women might get good jobs these days; they might live more independent and successful lives. But where men were concerned they were still second-class citizens (Lamb 1999, p. 64).

If she is not a virgin, it is almost always because her marriage or relationship has failed, or her partner has died. It is important to note, however, that she usually has not had a sexual relationship since the collapse of her marriage. She is 'virgin-like' in that she normally does not have casual sex with men; she may even have retreated into an almost frigid state as a

result of a past marriage or romance. Thus, although she may not be a virgin, the reader is made aware that she is—in Madonna's words—'like a virgin'.

The narrative of *More Than a Mistress* exemplifies these changes. The opening scene takes place at a Bachelor for Bucks charity night among the wealthy clans of Los Angeles high society. Alex Thorpe, the heroine, is wealthy and divorced; she had never experienced orgasm or enjoyed sex with her husband, who derided her for being frigid. When she wins Travis Baron for a weekend of pleasure at the charity auction, she has no intention of actually claiming her prize. He, however, is immediately overpowered by her cool beauty and is determined to possess her. His desire is described in animal terms. His 'hot green eyes' are 'fixed on her as if he were a hawk and she were his prey' (Marton 1999, p. 10). His desire is 'primal':

> He wanted her. Wanted her with a primal need and desire that surpassed anything he'd ever known. He wanted to kiss that mouth, caress that body . . . and melt the coldness that clung to her like an invisible sheath of ice (Marton 1999, p. 14).

Alex, in turn, finds herself unable to resist:

> Tall, and gorgeous, with those hot eyes. And a nose that surely once had been broken. And that mouth. That sexy, almost cruel mouth . . . That man she'd won was handsome. He was gorgeous . . . And he was dangerous (Marton 1999, p. 22).

The entire narrative consists of scenes of explicit sex, interrupted by misunderstandings which force the couple apart, until the next reunion, followed by more sex. This pattern runs throughout the novel, each reunion more sexually adventurous than the previous one. Even oral sex is no longer taboo in the contemporary Mills & Boon:

> 'My turn,' she said softly, and knelt over him, kissing her way down his hard-muscled body, taking him into her mouth, loving him with teeth and tongue until he groaned and rolled her beneath him (Marton 1999, p. 157–8).

Given that the Mills & Boon reader, like the reader of detective fiction, knows the eventual outcome of the story, knows that the hero and heroine will fall in love and live happily ever after, why does the reader keep on reading? The answer to this question relates to the status of the Mills & Boon text as a form of pornography, whose primary aim is sexual arousal, and also to what might be described as 'subversive elements' in the texts themselves. For instance, the heroine is allowed to sexually objectify the hero, who functions as the object of both her look and her sexual desire, as in this case:

> She looked at the rippling muscles of his upper arms and then moved her gaze further down to where the shadows played along narrowed hips and massive thighs (Gordon, 1980, p. 14).

It is clear that the heroine is deliberately taking the hero as the object of her gaze, which moves down his body, coming to rest on his genital area. The appeal of these texts can be partly explained in terms of the pleasure offered to the female reader through identifying openly with the active power of an erotic female gaze:

> Her gaze moved restlessly over his shirtfront. She watched the steady rise and fall of his chest . . . saw the brawny muscles beneath the shirtsleeves over his upper arms. It was a disturbing observation of his utter masculinity (Dailey 1981, pp. 42–43).

These romances abound in descriptions of the hero: his strong physique, animal magnetism, muscular thighs, dark curling body hair, powerful torso and arms, piercing eyes, long curling lashes and male scent.

One of the main functions of the animal hero is to arouse the heroine to the heights of sexual and sensual pleasure, even if against her will. The narrative is constructed in such a way that there are moments of heightened eroticism spaced throughout the story, so that the hero and heroine—and the reader—are caught up in a situation of continuous sexual tumescence. In 1980s Mills & Boon, the language employed was often euphemistic:

His thighs excited, the feel of his legs touching hers, his hands
in her hair. Then that hand moving to find the swelling
femininity, caressing her skin into exquisite sensitivity, moving
tantalisingly in arousal and bringing to her body a weakness
which carried her to the brink of surrender (Peake 1981a, p. 66).

Descriptions of the hero's erection were not uncommon, although
often the euphemistic phrases broke new ground in the art of
mystification:

With his muscular thighs pressing down into the soft mattress,
and the swollen evidence of his manhood thrusting against
her, she found her emotions impossible to control (Mather
1981, p. 129).

Repeated references to her 'swelling femininity' and his 'swollen
evidence' signpost the reader's path to the inevitable moment of
sexual union, but this is held in abeyance for as long as the narra-
tive permits. This pattern of arousal continues to dominate
contemporary romances, although his 'swollen manhood' is now
described in bolder language, as 'a rigid shaft' or a 'blunt force'.
The hero's function is still to 'open up a new world of eroticism
to her'.

From the moment he invites her to enter this once-taboo
world, the narrative is structured around their sexual encounters,
which are, in many texts, mixed with elements of violence,
and which are often interrupted before orgasm so that the
heroine/reader is left in a state of arousal and frustration. The
'new world of eroticism' is presented, partially explored, then
held in abeyance until the next encounter. The reader is left to
fill in the details, and presumably she will do this—at either a
conscious or unconscious level—in terms of what she finds erotic.

The pattern of interrupted sexual encounters creates an atmos-
phere of suspense while encouraging the reader to participate
imaginatively in the fiction and to keep reading until the next
sexual encounter/clash takes place, each one constituting a part
of the jigsaw puzzle of this 'new world of eroticism'. Herein lies
a major part of the appeal of the Mills & Boon romance—the
pleasure of reading as an erotic activity, the pleasure residing

more in the promise of further sexual encounters than in the encounters themselves.

Many of these romances take the reader further into the realm of sexual taboo— playing with the erotic fantasies of bondage and bestiality. Here the heroine realises to her horror and secret delight that he is going to force himself on her with or without her consent:

> She had wondered what sort of man lay beneath the hard mask he presented to the world. Now she was finding out, and the primitive desire he had unleashed frightened her. And excited her, for her breath came rapidly through her lips as he touched her in the most intimate caress she had ever experienced, his fingers moving across the most sensitive areas with damning skill (Donald 1981b, pp. 99–100).

Here the key words are 'hard mask' and 'primitive desire'. Repeated emphasis in a Mills & Boon text on the hero's face as a 'mask' and on his desire as 'primitive' indicates that these terms have a symbolic function. In *The Dark Abyss*, the hero's eyes are frequently described as 'hooded', his face a 'merciless mask', 'a sexy mask', and 'an enigmatic mask'. There are repeated references to his 'male scent', his 'animal magnetism' and his predatory hawklike glance. He is not just like an animal; he *is* an animal. One of the heroine's friends comments:

> He reminds me of a tiger at the zoo, beautiful and lazy and good-humoured as it stretches out along a log, but you know that beneath that sleepy exterior there's a cold brain and a ferocity which is barely hidden (Donald 1981a, p. 108).

There are references to the 'latent cruelty' beneath his civilised veneer, and to 'some deep primeval hunger in him'. His power over the heroine is also described in animalistic terms:

> Held by the sensual snare of his eyes, she felt like a rabbit entranced by a stoat, powerless, pushed by the sexual charisma of the man into a bondage more fearful than that of her empty mind (Marton 1999, p. 53).

Her mind is 'empty': that is, her mind is powerless against the desires of her body, and she knows 'in some primitive instinctive part of her' (Marton 1999, p. 161) that this is what she wants. The 'new world of eroticism' that is opened up for the Mills & Boon heroine is a world of primeval, animalistic mating. She gives herself up to the primitive urges of her body—urges which are located outside rationality and civilisation: 'with every word, every look, every touch, he was drawing her closer to the brink of a dangerous abyss' (Napier 2000, p. 74).

It is interesting to note that it is the hero, not the heroine, who is located outside 'civilisation'. Traditionally, in art, drama, film, myth and literature it is woman—as nymphet or femme fatale—who is located within nature, an alien force whose sexual desire threatens to destroy the orderly functioning of civilised society. In Mills & Boon it is the heroine who signifies culture: the hero, although at home in the civilised world, signifies primitive sexual desire.

His representation as a primitive, overpowering force suggests that a dominant sexual fantasy of the Mills & Boon heroine is of being overpowered by a stronger partner, taken against one's will. Part of this fantasy may also involve pleasure in 'taming' the beast. Men, too, fantasise about being overpowered and forced to submit, as is evident in masochistic pornography, in which men submit to a dominant woman. Thus the Mills & Boon heroine undergoes what might be described as a voyeuristic journey into the sexual underground of sado-masochism and animal passion. The reader accompanies the heroine, knowing full well that she/the heroine will arrive safely at the end.

The crucial aspect of the heroine's journey is that she is not responsible for what happens to her—her body has defeated her mind/conscience, releasing her so that she can be transported into a realm of sensual and sexual pleasures that her conscience would never permit her to experience in normal circumstances. Frequently, this process is foregrounded in the texts themselves:

> His attack, for that was what it had been, had opened to her a
> world of sensation she had never imagined. A world where the
> values and principles so carefully instilled by her mother had

been swamped by a raw sensuality, as primitive as it was powerful (Donald 1981b, p. 70).

In *The Dark Abyss*, the hero poses the question of sadomasochism:

> 'We can do it easy or we can play it rough,' he said calmly into her ear. 'Is that what you like? Do you enjoy being hurt, Luce?' 'Would you hurt me if I said yes?' She spoke into his throat, furiously, the words hissing between her teeth. His laughter frightened her. 'Yes. I'm always ready for new experiences' (Donald 1981a, p. 87).

In other texts, his very presence and voice invoke the suggestion of cruelty: 'although the tone was soft it was like being flicked with a whip' (Lamb 1999, p. 86).

An analysis of this 'new world of eroticism' reveals that its dominant fantasy—of being overpowered and taken against one's will—is also central to much pornography, and as such has been attacked by some feminists. The whole question of sexual pleasure for women (and men) and its relationship to this fantasy is extremely complex. Women often feel ashamed because they have fantasies of dominance and submission. Yet as Julia Lesage points out: 'Women may use these fantasies to heighten sexual tension and as a metaphor for abandonment to sexual pleasure, the pleasure of the fantasy residing in the woman's complete control over the scenario even as she imagines being compelled' (Lesage 1981, p. 47).

Certainly, the Mills & Boon fantasy of being overpowered works in this way—the heroine is ultimately in control of every sexual encounter (the hero never forces her beyond a point to which she wishes to go), even as she is being compelled. Given that the reader is encouraged to identify with the heroine—she, not the hero, controls point of view—then it is possible that the reader derives pleasure from identification with a figure who ultimately controls the sexual scenario, with its emphasis on the fantasy of being taken against one's will. The relationship between sexual pleasure and our imaginative life is complex, but it is possible that the Mills & Boon text opens up a space in

which we may begin to talk about this difficult area. Pat Califia stresses the crucial importance of the relationship between imagination and desire. 'To limit or expurgate the sources of our erotic imagination cramps and censors our erotic aspirations' (Califia 1980, p. 1).

What the Mills & Boon text is doing, then, is endorsing perverse forms of sensual and sexual pleasure for women. I find this most interesting, given that there is still a popular misconception today that it is only men who seek out the pornographic. The conventional view does not argue that women do not have perverse sexual desires; rather, it holds that 'proper' women can only find true sexual fulfilment within love and that this may involve unconventional sex. It could be argued that the Mills & Boon narrative endorses the myth of romantic love, because the heroine always falls in love with the hero, marries him and prepares to bear his children. It is true that this is what happens. Yet it is crucial that the 'in love' episode only occurs at the close of the story; the rest of the narrative actually involves sexual encounters in which the world 'love' is never uttered. I would suggest that the narrative structures of the Mills & Boon text are, to some extent, subversive of the ideology of romantic love. The reader's pleasure resides in undertaking a sexual journey into the dark abyss of highly charged eroticism, of surrender to and domination by the animal lover.

Given the above interpretation, the aggression and the animalistic passion of the hero figure can be viewed in a different light; these become as much a function of plot as an expression of his sexual passion. If he were not aggressive, forcing her to submit to his overpowering animal magnetism, there would be no story, and the sexual fantasies would be of a different order. The heroine must be 'forced' to submit—if she is to remain a heroine with whom the self-respecting female reader is prepared to identify. The hero's aggression absolves her of all responsibility. She fights his overpowering magnetic sexual attraction with her mind, but she loses the battle—yet, one might add, she wins the war of the senses.

This interpretation also helps explain another curious aspect of the romance novel. Despite the aggression of the hero, the

heroine, in a curious way, seems to be in control of the action. The hero is very much an instrument of her pleasure. He is everything she desires—tall, dark, handsome, rich, powerful, gentle, aggressive, magnetic, sensual—and he is able to arouse her to the heights of sexual pleasure where every other man has failed. Her pleasure is his dominant concern:

> His face was hard and glazed, his eyes locked with hers, all his attention focused on her approaching climax (Napier 1999, p. 154).

> He told himself to go slowly this time, to touch her gently and learn all the places that brought her pleasure (Marton 1999, p. 66).

It is also interesting that there is little emphasis on genital penetration in the romances; even in contemporary romances, far more time is expended on descriptions of foreplay, the events which lead up to penetration. The heroine appears to be more aroused by sensual stimulation than by the sexual act. There is even a 1980s' Mills & Boon in which the heroine's best friend falls in love with and marries a man who has lost his genitals in a bomb explosion. (One wonders what kind of bomb could possibly blow up a man's genitals while leaving everything else intact!) In short, the hero is a symbolic figure, a fantasy whose representation is constructed in such a way that he cannot be resisted. He is the key, the magic potion, Marina Warner's animal hero; he who enables her to 'forget' the dictates of her conscience/religion/morality and plunge herself into this 'new world of eroticism'.

Another important issue raised by the romance novel concerns the relationship between sexual pleasure for women and patriarchal ideology. For instance, do the sexual fantasies represented in Mills & Boon privilege a male view of female sexuality? Are we/the heroine simply fantasising roles assigned to us by/within a patriarchal society? The problem that arises if we answer 'Yes' to this question is that the answer is based on a notion of sexuality as fixed. If we answer that women living in a non-patriarchal society would never have fantasies of being sexually overpowered, we are positing a notion of an innate

feminine sexuality—a highly problematic concept. The notion of an innate femininity (women are naturally gentle, passive, loving, submissive, etc) and an innate masculinity (men are naturally tough, active, independent, dominating) is the very concept that has been used to justify women's subordinate position in the first place.

In Mills & Boon, the definition of romantic love draws on perverse forms of sexual desire which erode the old boundaries between the proper and the pornographic. The beast-hero, a mythical, archetypal figure, takes the heroine on an erotic journey in which she willingly sheds the trappings of civilisation for the primal experiences offered by a descent into the dark abyss of eroticism. In Deleuze and Guattari's words, she surrenders to the 'becoming-intense, becoming-animal' desire. The universal popularity of the romance, its translation into many languages and the ease of global dialogue on the Internet suggests that the romance speaks across national, religious and gender boundaries, undermining traditional notions of what constitutes acceptable erotic and sexual desire for heroine and reader alike.

References

Note: Sections of this chapter originally appeared as 'Embroidering the framework', *All Her Labours*, vol. 2, Hale & Iremonger, Sydney, 1984, pp. 47–69.

Anderson, J., Butterworth, J., Devery E. and Wilson, H. 1981, *Mills & Boon: Love and Oppression*, Faculty of Humanities and Social Sciences, Occasional Paper no. 10, NSW Institute of Technology, Sydney.

Armstrong, L. 1981, *Spitfire*, Mills & Boon, London.

Bianchin, H. 1981, *The Savage Touch*, Mills & Boon, London.

Califia, P. 1980, *Sapphistory: The Book of Lesbian Sexuality*, Naiad Press, Tallahassee.

Cooke, K. 1982, 'The insidious whisper of a sweet nothing' *The Age*, 30 April.

Craven, S. 1981, *Dark Summer Dawn*, Mills & Boon, London.

Dailey, J. 1975, *Fire and Ice*, Mills & Boon, London.

—— 1981, *One of the Boys*, Mills & Boon, London.

Dekkers, M. 1992 *Dearest Pet: On Bestiality*, Verso, London.

Deleuze, G. and Guattari, F. 1987, *A Thousand Plateaus: Capitalism and Schizophrenia*, trans. Brian Massumi, University of Minnesota Press, Minneapolis

Donald, R. 1981a, *The Dark Abyss*, Mills & Boon, London.

—— 1981b, *The Interloper*, Mills & Boon, London.

Firth, S. 1981, *Master of Shadows*, Mills & Boon, London.

Freud, S. 1976, *The Interpretation of Dreams*, Pelican Books, Ringwood.

Fuller, K. 2001, 'Mills and boom' *The Australian Magazine*, 24–25 March, pp. 36–41.

Gordon, V. 1980, *The Sugar Dragon*, Mills & Boon, London.

Hooks, B. 1993, 'Luigi and his lovers' *The Age*, 26 May, p. 15.

Lamb, C. 1999, *The Seduction Business*, Mills & Boon, London.

Lesage, J. 1981, 'Women & pornography' *Jump Cut*, no. 26, December.

Lindsay, R. 1981, *Untouched Wife*, Mills & Boon, London.

Marton, S. 1999, *More Than a Mistress*, Mills & Boon, London.

Mather, A. 1981, *A Haunting Compulsion*, Mills & Boon, London.

Mortimer, C. 1981, *The Flame of Desire*, Mills & Boon, London.

Napier, S. 1999, *The Revenge Affair*, Mills & Boon, London.

—— 2000, *Secret Seduction*, Mills & Boon, London.

Peake, L. 1981, *Gregg Barratt's Woman*, Mills & Boon, London.

Pearce, L. and Wisker, G. (eds) 1998, *Fatal Attractions: Re-scripting Romance in Contemporary Literature and Film*, Pluto Press, London.

Strutt, S. 1981, *On the Edge of Love*, Mills & Boon, London.

Warner, M. 1994, *From the Beast to the Blonde: On Fairytales and their Tellers*, Chatto & Windus, London.

Way, M. 1981, *The McIvor Affair*, Mills & Boon, London.

Weale, A. 1981, *Bed of Roses*, Mills & Boon, London.

Westwood, G. 1980, *Zulu Moon*, Mills & Boon, London.

Winspear, V. 1981, *No Man of Her Own*, Mills & Boon, London.

van der, Zee, K. 1981, *A Secret Sorrow*, Mills & Boon, London.

7

Cybersex: From television to teledildonics

I believe that organic sex, body against body, skin area against skin area, is becoming no longer possible . . . What we are getting is a whole new order of sexual fantasies.—J.G. Ballard, *Re/Search*, 1984.

A pair of giant, slightly parted lips pout provocatively from a television screen, inviting the startled hero, Max Renn, to clamber inside. Max has discovered a secret television program which features torture, sex and death. The program is transmitted by a signal known as 'videodrome'; this signal directly affects the brain, causing hallucinations and eventually physical mutations from which the addicted viewer will die. Directed by David Cronenberg, this film, *Videodrome* (1982), was an immediate cult hit.

The videodrome signal has been devised by Brian O'Blivion, a scientist who hopes to bring about a union of human and machine, through television—to create a technological subject—in preparation for a more advanced society. Viewers become addicted to videodrome because it offers pleasures associated with taboo topics, such as sex and violence. As Max's hallucinations take over, reality blurs. Does Max really clamber through the woman's inviting lips? Is that a gun he keeps inside a vaginal pouch secreted within his stomach? Part of the pleasure offered by a film like *Videodrome* is that the viewer is drawn into the fantasy.

One of the main themes explored by *Videodrome* is the nature of the pleasure generated in the screen/spectator relationship. What images do viewers find erotically stimulating? Is it possible to

create a virtual reality in which the spectator is 'linked' directly to the visual experience? What kind of narratives seduce the viewer? What is the difference between reality and fantasy?

Cronenberg developed his script in the early 1980s. His ideas seemed like science fiction then, but today his scenario is a reality. Anyone with a computer and the right information can tap into the Internet world of computer sex, without *Videodrome*'s attendant dangers. While some warn of the addictive nature of surfing the Net, for many, sex in cyberspace offers new possibilities and pleasures.

The online Computer Library Center estimates that there are about 74 000 adult Websites (Cone 2002, p. 102). Cybersex travellers interested in erotica can—if they know the correct addresses—call up pornographic material. Studies indicate that the images most frequently downloaded from cyberspace are sexual.With a few keystrokes, viewers can tap into a porn site— it might deal exclusively with fetishes or perversions or just plain ordinary sex. Cybererotics, Sex.com and Bondage.com are some of the most successful/profitable sites. Sex is interactive or viewer-controlled. By clicking on the relevant control, the viewer can make the cybersex star perform numerous erotic acts. Viewers can salivate as cyberbunnies strip and wiggle.

Users can now watch and interact with performers on a range of Websites. Porn stars such as Danii perform for users across the globe. Danii is one of the most watched woman on the Internet. It is also relatively easy to find written material (short stories, poems, jokes) on any form of sexual variation. The key word 'Zoophilia', for instance, opens up a world of 'interspecies sexuality, including animal role play, totemism, bestiality and zoophilia'. Some of the short stories are explicit and confronting. Sites with titles such 'Boobtropolis' and 'Hardcrank' make their focus explicit. There are sites that cater to lesbian and gay, transgendered and transsexual users. Sites such as 'College Lesbians' no doubt have wide appeal. Feminist porn stars such as Annie Sprinkle have their own Websites, where viewers can experience a very different approach to the taboo.

An article published on the Internet by Eric Sabo, medical writer for CBS Health Watch, pointed out that more women are

using the Net than before. They constitute 15–20 per cent of the market. This increased demand has led to the creation of specific Websites for women, giving women access to pornography or erotica that was once reserved for men (Sabo July 2000). Because the Internet is open, accessible to anyone and relatively easy to use, it means that women can also log on or create a Website of their own.

Edward Cone, contributing editor of *Wired*, has pointed out, however, that the online porn industry no longer offers easy money. The major companies, such as Cybererotica and Sex.dom, control most of the market and make the large profits. They also pay money to smaller companies, such as Voyeurdorm or The Gay Gallery, for introducing surfers to their sites. According to a recent poll, up to half of the porn sites make less than US$20 000 a year. There are other problems: banks are refusing to offer credit card facilities to online porn producers; many porn surfers who actually state they will buy membership later claim they made no such offer; and the porn producers have to be certain that they are not circulating images that are protected by copyright (Cone 2002, p. 102).

The Internet is an inexpensive, fast, global form of communication. The estimated number of people with access to the Net is the subject of much debate, but the numbers range from tens of millions to 100 million (Smith & Kollock 2000, p. 24). Pornography aside, there are various other ways in which Internet users can initiate sex and/or commence a relationship. The enormous number of Internet users has made the possibility of meeting someone much more likely. The Net has millions of users seeking romance, even marriage, and subscribing to online dating sites. In February 2000 there were nearly 2500 such sites. Match.com has three million subscribers (Griffin 2001, p. 8).

Internet users who join dating sites can reveal their identities but still enjoy the anonymity of the system. Couples who meet on the Internet and later marry cite the anonymity of the medium as the prime reason for the relationship. 'I could tell him anything' is a frequent explanation. Anonymity encourages people to be more open; they are able to reveal themselves, their inner secrets, without experiencing the discomfort that might accompany a

face-to-face interaction. As media critic Michelle Griffin points out in her fascinating article on the subject of online romance, this is not new:

> As long as people have been able to write letters, they've been falling in love before they met. Women who wrote to unknown soldiers in the world wars married them when they came home. And in the 19th century, romances between male and female telegraph operators were common (Griffin 2001, p. 9).

On-line affairs have led to divorce. 'Cybersex and virtual affairs are on the rise, emerging as a very real problem for a growing number of marriages...according to relationship experts' (Reardon 1999, p. 4). Computer networks allow people to create new social and sexual spaces where they can meet and interact. There are many ways in which the viewer can access a sexual encounter on the Net. Most direct is the bulletin-board system, accessed through a personal computer and telephone line. Thousands of people communicate via any one bulletin board, which is like a small neighbourhood of inhabitants with a common interest. There are boards devoted to almost every conceivable topic: religion, politics, media, sport, hobbies, animal rights, feminism, literature, terrorism and, of course, sex. The sex boards cover a range of interests, from straight to sado-masochistic sex.

While some use the bulletin boards to meet people, others simply talk. A more direct form of communication is 'Internet relay chat' (IRC), in which two people are on the system at the same time. The screen forms two sections; one person's words appear above, the other's beneath the dividing line. Users can find IRC channels that appeal to a range of interests—hetero-sexual, homosexual, lesbian, bisexual, etc. Some users describe their sexual desires and fantasies in minute detail. Participants may change their identity, assume a fictitious name, gender, age, appearance, colour and sexual preference. The enthusiastic can participate in disembodied love-making by tapping out their desires and commands. Naturally, a medium that permits people to assume a completely different identity, without fear of disclosure, has strong appeal.

Other popular cyber-spaces are the MUDs, or multi-user domains, which attempt to create communal places as well as personal interaction. Members of a MUD usually create a new identity for themselves. MUDs first appeared in 1978 and continue to play an important role in cyberspace. They are imaginary or virtual communities that 'live' in a specific place that is organised around linking 'rooms' or virtual spaces.

Members of a virtual community must first create their new identity, then they can 'build' a house, chat with other members, exchange intimacies, create whole new lives. People gather together in the same 'room'. MUDs are virtual stages on which every member is an actor. Communities may build a spaceship and take part in a science fiction adventure. Anything is possible. Members of a MUD may also decide to construct a community devoted to sexual exploration, a community in which they might change their genders, describe their fantasies, engage in virtual sexual encounters:

> MUDS often support simulations . . . of face-to-face interaction
> by framing the lines of text users send to one another as 'say',
> 'think', or 'emote' messages. This allows users to provide
> meta-commentary on their turns of talk and to create 'gestures'
> or make parenthetical comments (Smith & Kollock 2000, p. 7).

The initial response to the possibility of virtual communities in cyberspace was relatively utopian. Users felt that the possibility of total freedom in cyberspace would enable them to expand their sense of self and enrich their experience of identity.

In her study of social control in cyberspace, Elizabeth Reid examined the strategies of control in various MUDs, including a social community. It is generally recognised that the anonymity of virtual communities does encourage users to be much freer in their interactions and more able to form intimate relations. Users who want to form a deeper bond can have their relationship 'virtually consummated through "netsex", a form of co-authored interactive erotica' (Reid 2000, p. 114). However, Reid concluded that there is 'no moment on a MUD in which users are not enmeshed within [the] web of social rules and expectations' which govern the MUD. Disembodied sex does

not necessarily mean characters are free of all restraint, even in cyberspace.

Cyberlife brings with it many of the problems of the real world. Sometimes the unwary find themselves subject to abusive, sadistic messages. Sexual harassment on the Internet became an issue in the mid-1990s. It consists of a virtual imitation of actual practices in the material world. In a disturbing article in *Village Voice*, Julian Dibbell explained what happened on a MUD known as LambdaMOO. One of the community members, known by the name of Mr Bungle, used his computer skills to construct specific commands which enabled him to isolate several female members in the house and subject them to abuse, harassment and rape. Although these acts did not take place in the 'real' world, the victims felt as if they had been abused. One of the women, whose character was known as Starsinger, 'was given the unasked-for opportunity to read the words': 'As if against her will, Starsinger jabs a steak knife up her ass, causing immense joy. You hear Mr Bungle laughing evilly in the distance' (Dibbell 1994, p. 242).

Dibbell explains that one of the women, whom he later met, was so distressed she wept. She also wanted Bungle virtually castrated. In response to this controversial event, made public in the media, one commentator has noted that online harassment draws attention to 'the potentially violent power of words, particularly as they relate to pornography and sexual harass-ment' (Stivale 1997, p. 141). Dibbell concluded that in the virtual world, 'when it comes to sex, perhaps the body in question is not the physical one at all, but its psychic double, the bodylike self-representation we carry around in our heads' (Dibbell 1994, p. 243). As a consequence of the abuse, the virtual community where the violence took place attempted to define commands that might constitute harassment in order to regulate behaviour among community members. In the online discussion of possible regulations, however, the community members could not come to an agreement about how best to regulate behaviour. They organised a ballot to define actions that might be classed as 'rape'. The ballot offered a definition of virtual rape as 'any act which explicitly references the non-consensual, involuntary exposure, manipulation, or touching of sexual organs of or by

a character' (Stivale 1997, p. 141). After much passionate debate, however, the referendum failed. The group did agree to 'toad' Mr Bungle, that is, annihilate the character from the MUD. After his virtual death, the individual who was Mr Bungle re-joined the LambdaMOO community in a new guise, as Dr Jest. When the community realised the true identity of Dr Jest, interactions became very strained. Eventually Dr Jest departed and did not log in again. The LambdaMOO experience raised crucial questions about the relationship between mind and body: one player asked, 'Where does the body end and the mind begin?'; another replied, 'Is not the mind a part of the body?' 'In MOO, the body is the mind', asserted another (Dibbell 1994, p. 250). The incident revealed the difficulty of regulating individuals' behaviour in a virtual community and raised questions about the need for participants to reach some form of agreement about the conduct of relationships in cyberspace (Turkle 1995, pp. 253–4).

Some authorities are alarmed about the use of the Internet for pornography, particularly because it appears virtually impossible to control it. The Internet does not recognise international boundaries. Australia is one of the few countries in the world that attempts to control pornography—with content controls—but experts argue that there is no effective means of filtering out offensive material.

The Australian Internet industry has published a code of conduct. Under the terms of the code, service providers are required to: 'Carry only legal material; take reasonable steps to limit child access to unsuitable material; "takedown" illegal material identified by appropriate authorities' (Rollins 1999). However, it is impossible for national or state authorities to prevent individuals from downloading overseas material. While filtering mechanisms are available, they can only be controlled from within the home (Barker 1999).

The Internet offers a completely decentralised, anonymous form of communication. As one critic wryly commented: 'The Internet was developed to provide communication in the aftermath of nuclear war. If it would survive nuclear war it would certainly survive attempts of [government] regulators to block off bits of it' (Margetts 1999, p. 58).

The amount of pornographic material on the Internet is so vast that the term 'undernet' was initially invented to describe the phenomenon. Authorities do occasionally break pornography sites organised by paedophiles. Although the sheer volume of material on the Internet makes it difficult to track down pornography, every transmission is, in theory, traceable. In their efforts to trace the sources of pornographic images, federal officials in the US have listened in to private conversations and subpoenaed telephone records.

Despite the freedom of the Internet, porn operators still face problems. They are likely to face legal charges if they post an image of an underage model or of an individual who did not give permission for their photograph to be posted on a porn site. In one such case a husband submitted a photograph of his wife to Voyeurweb, which posts images of people engaged in sex acts who are unaware that they are being filmed or photographed. The woman's employer saw the image and showed it to her; she filed for divorce. Her husband tried to claim that he was innocent and that she was performing fellatio on some other man. He did not succeed (Cone 2002, p. 103). In addition, given the global reach of the Internet, many porn site operators end up breaking the law in other countries.

Censorship of the Internet raises the same problems as does any other form of censorship of the media. Who has the right to decide what is fit for other people to read and view? The Internet also raises the key issue of privacy. Do people have the right to expect that others should not put material of a personal and private nature on the Internet? Should special prosecutor Kenneth Starr have posted descriptions of the intimate sexual details of the Clinton–Lewinsky affair on the Internet? Do those in public office have the right to less or more privacy than those not in the public eye? Some have concerns about a future in which the right to privacy is regarded as old-fashioned or not in the public interest. In the future, virtual sex may render the notion of privacy irrelevant.

The form of cybersex that most resembles *Videodrome*'s pleasure-dome is known as 'virtual sex' or teledildonics. Theodore Nelson, the inventor of hypertext, coined the term in 1974. At the moment, it appears that virtual sex will evolve in two quite

distinct, but related, directions. The first, which is possible now, involves sex with a machine or a virtual body; the second, which is predicted to be at least 30 years away, involves sex with people who are not present.

Virtual sex is currently restricted to an encounter with a virtual body—an image of a well-known film star or a fantasy figure existing in a virtual space. The participant dons an eye helmet, with two small liquid crystal displays positioned directly in front of the eyes, and enters a virtual space in which she/he learns to 'travel' by moving the helmet. Having adapted to the artificial environment, which appears 'real', the virtual traveller 'moves' around the space, 'flying' and 'playing' with objects via head movements. Artificial sounds have been pre-recorded to accompany the traveller's movements and increase a sense of reality. The participant can also wear a special sensor suit. The sensors project an image of the participant's body before her/his eyes so that the participant can see her/himself within the virtual world. The user feels as if she or he is actually participating in the virtual world rather than simply observing it. The participant can sexually interact with an artificial partner or manipulate the other 'person' in terms of a sexual fantasy.

The more futuristic form of teledildonics will involve sexual encounters between real people. The participant, wearing special glasses and a sensory vibrator suit, will enter a chamber and dial a partner—perhaps on the other side of the world:

> Embedded in the inner surface of the suit, using a technology that does not yet exist, is an array of intelligent sensor-effectors—a mesh of tiny tactile detectors coupled to vibrators of varying degrees of hardness, hundreds of them per square inch, that can receive and transmit a realistic sense of tactile presence, the way the visual and audio displays transmit a realistic sense of visual and auditory presence (Rheingold 1991, p. 346).

The couple, who control the entire scenario, will make love in cyberspace. The participants will feel every caress and touch of the 'virtual hand' as if they were actually in intimate contact. The

term for this kind of encounter is 'tactile telepresence'. What is actually happening is a form of disembodied sex. According to J.G. Ballard, the traditional form of sex, 'body against body', is becoming obsolete: 'What we are getting is a whole new order of sexual fantasies' (Ballard 1984, p. 157).

The opportunity to experiment with cybersex scenarios has been explored in a number of popular films. *Lawnmower Man* (1992) created a fantastic scenario in which the male protagonist and his partner donned virtual reality suits and entered cyberspace. They seemed to merge into one, their bodies melding together and pulling apart like drops of mercury. *The Matrix* (1999), which plays with boundaries between reality and fantasy, eroticises the characters' encounters with computers. The futuristic fantasy *eXistenZ* (1999) depicted characters 'jacking in' to computer games in a fusion of flesh and metal. Characters have a bioport implanted into their spine, and then hook themselves up to a virtual reality game called eXistenZ. Once you are plugged in you can't tell the game from reality, sex from fantasy. Not even the game's inventor can tell the difference. *Minority Report* (2002), which explores the possibility of multiple avenues of action set in the future, presented a sex shop where individuals could order the virtual fantasy which suited their own perverse desires.

Clearly, sexual experiences offered via the computer screen are vastly different in terms of form and structure—perhaps even in terms of pleasure itself. Virtual sex—available through bulletin boards, the Internet, MUDs—is very different from the sexual experiences traditionally available on television, video and in the cinema. Traditional spectator pleasure offered in the cinema or on television is like a consumer item—prepared and packaged— which the individual purchases. Player pleasures offered via the new technologies will involve the individual in an active sense—she/he will be able to play a more creative part in constructing her/his own pleasures.

Teledildonics—or disembodied sex—will be unlike anything ever experienced by human beings. In her fascinating discussion of cyborg imagery in contemporary cinema, Claudia Springer analyses the manner in which these changes are already being represented. Instead of losing our consciousness and experi-

encing bodily pleasures, cyborg imagery in popular culture invites us to experience sexuality by losing our bodies and becoming pure consciousness (Springer 1991, pp. 307–8).

PLEASURE AND THE NEW TECHNOLOGIES

Theoretical writings on screen pleasure have been mainly directed at the cinema, photography and television. These argue that the human being derives enormous pleasure from looking, and that this can be a highly charged erotic activity. How will this change with the introduction of these new visual forms?

Freud used the term 'scopophilia' to describe the pleasure derived from actively looking at another. He was particularly interested in the behaviour of children, and argued that, for children, pleasurable looking is frequently associated with looking at taboo objects such as other people's private bodily parts, the genitals or the breast. Boys desire to know how girls differ from them, and vice versa. Freud was one of the first to argue that such pleasure has a strong erotic component. In extreme cases looking can become strongly voyeuristic and lead to surreptitious looking. Pornography exploits this desire.

There is no doubt that the cinema appeals to a voyeuristic gaze (see Chapter 1). Audiences sit in the dark, cloaked in anonymity, watching stories unfold that reveal intimate details of character's lives. Films which contain large amounts of sex and violence, such as *Psycho* (1960), *Blue Velvet* (1986), *Fatal Attraction* (1987), *Silence of the Lambs* (1991), *Basic Instinct* (1992) and *American Psycho* (2000), are guaranteed box-office success. Television programs such as those hosted by Jerry Springer and Ricki Lake, which lay bare the aberrant, atypical details of participants' personal lives, draw vast viewing audiences. These shows cover everything from confessions of sexual abuse victims to adults talking about living happily in incestuous relationships.

With the development of virtual sex, players/viewers will be able to construct their own voyeuristic scenarios in order to satisfy their individual desires. This may well lead to a decline in public forms of popular entertainment and pornography as individuals

assume greater autonomy—and perhaps, responsibility—for their erotic lives. It may also lead to the emergence of new narratives, fantasies and sexual scenarios—a factor I will discuss shortly.

The nature of pleasure itself may change. While virtual reality appeals to the visual, of course, it also places prime importance on the tactile. Touch may come to assume the primacy now accorded to the visual. Some players may construct scenarios that displace voyeurism altogether as a dominant source of pleasure.

Drawing on Freud's theories, British film theorist Laura Mulvey argued that the 'cinema satisfies a primordial wish for pleasurable looking' (Mulvey 1989, p. 17), particularly in relation to the male gaze:

> In a world ordered by sexual imbalance, pleasure in looking has been split between active/male and passive/female. The determining male gaze projects its fantasy on to the female figure, which is styled accordingly (Mulvey 1989, p. 19).

While Mulvey's thesis still appears to hold true for certain kinds of film (such as film noir, the detective genre, the slasher film), it has become clear that the gaze is not always active or male. While Mulvey first posited influential theory of the controlling male gaze, other writers (Cowie 1984) have argued for the existence of a fluid, mobile gaze which identifies across gender and other categories, such as class, race and age.

The new technologies encourage such fluidity. Today the majority of films and videos address a certain type of viewer. Leading characters are predominantly young, white, good looking, virile and male. Leading female characters—although fewer—are also likely to be young and beautiful. The roles for non-white characters are minimal. This means that viewers are forced to make some kind of imaginative adjustment in order to identify with screen characters. This situation does not hold for the new technologies. Players communicating with other participants will be able to create their own identity and assume the gender and race of their choice.

Apparently, in the early years of Internet interaction, so many men adopted female identities that it was assumed that a 'woman' on the Net was a male (Rheingold 1994, p. 166). (There

were few women participants in the early years of the new technology.) Players can also change their age, colour and class—in fact, every aspect of their identity. At this stage, anything is possible. US feminist and historian of science Donna Haraway argues for the possibility of using the cyborg concept to free women from the negative effects of gender-conditioning by abolishing gender altogether:

> Cyborg imagery can suggest a way out of the maze of dualisms in which we have explained our bodies and our tools to ourselves. This is a dream not of a common language but of a powerful infidel heteroglossia . . . It means both building and destroying machines, identities, categories, relationships, spaces, stories (Haraway 1985, p. 101).

Some critics argue that cyberspace communication is inferior because it is a disembodied form of contact. Participants cannot see each other or read body language, tone of voice and countless other cues. Participants can only type words to express their feelings, describe their appearance, communicate their desires. French writer Paul Virilio offers a very bleak view of the changes the new technologies are wreaking, not only on the individual's relationship to place and space, but also to intimacy and relationships:

> What was till now still 'vital', copulation, suddenly becomes optional, turning into the practice of remote-control masturbation. At a time when innovations are occurring in artificial fertilization and genetic engineering, they have actually managed also to interrupt coitus, to short-circuit conjugal relations between opposite sexes, with the aid of biocybernetic (teledildonics) accoutrements using sensor-effectors distributed over the genital organs (Virilio 1995, pp. 104–5).

Others argue that the freedoms associated with the new medium are so great that they outweigh the disadvantages. Players are free to express themselves without the constraints imposed by face-to-face interaction and the conventional boundaries that are set

up in actual encounters. The potential of the new media to offer pleasures associated with a dissolution or blurring of conventional boundaries is enormous.

'Becoming' another offers exciting possibilities. Women, for instance, may find pleasure in exhibiting behaviours normally associated with the male, and being responded to as male, and vice versa. It may also be that women will voice their desires clearly and loudly in relation to interactive erotica or pornography. Individuals unsure of their sexuality can experience being lesbian or gay. Men can 'become' women. Cyberlife emphasises the fact that gender is a performance, a social construct that the individual can perform as if on stage.

Virilio's view, that the changes the Internet is bringing about are essentially destructive, seems premature. The new virtual communities, individual interactions and forms of communication that are emerging in cyberspace seem to be fairly complex 'and more complicated than can be captured in one-sided utopian or dystopian terms' (Smith & Kollock 2000, p. 4).

FANTASIES—FROM PRIMAL TO CYBER

Critical discussions of viewing pleasure have centred on the way in which films frequently replay scenarios associated with the 'mysteries' of childhood. In 'The interpretation of dreams', Freud first referred to fantasy in the context of daydreams. A daydream is not unlike a reverie, a moment of musing or rumination in which the subject constructs a setting necessary to the fulfilment of a wish. The difference between a daydream and a nocturnal dream is that the subject can control the shape and direction of the daydream. Not only does the subject shape the daydream through fantasy—there are, according to Freud, three key or typical fantasies which are ubiquitous and which appear in all forms of dreaming.

These are the primal fantasies whose origins, according to Laplanche and Pontalis, are explainable in terms of common infantile experiences. In other words, they originate in the child's

attempts to unravel, or explain, certain key enigmas or mysteries. These are: the mysteries of birth; sexual difference; and sexual desire. The three mysteries can be posed as questions: Where did I come from? Why is she or he different? Who do I desire? The three primal fantasies offer a 'solution' to these puzzles: 'In the "primal scene", it is the origin of the subject that is represented; in seduction fantasies, it is the origin or the emergence of sexuality; in castration fantasies, the origin of the distinction between the sexes' (Laplanche & Pontalis 1985, p. 332). The crucial factor is that fantasy is not just a matter of imagining objects; it is a matter of arranging the objects and persons in a setting, a *mise-en-scène* of desire.

Freud's theory of the primal fantasies has influenced film theories of identification and pleasure. The primal scene, the scene of parental sex, which explains the subject's origins, exerts a strong fascination for the film viewer and is endlessly replayed in scenes in which we watch the couple making love. The spectator looks directly at the couple as they engage in sex, the act depicted in varying degrees of explicitness. So important is this concept that almost all filmic narratives contain reference to, or representations of, a sexual coupling between adults. Pornography, as a genre, is devoted almost exclusively to the representation of primal scenes.

Other film genres, such as science fiction and horror, which represent unconscious fears and pleasures, construct bizarre representations of primal scenes. Here we can see a woman or man raped by a creature or an alien, and then giving birth. In some pornography, women are depicted in sexual encounters with animals.

Awareness of sexual difference gives rise to the second primal fantasy—the castration fantasy. Such awareness also leads to representations of an erotically fetishised female body. According to Freud, the child's first knowledge of sexual difference revolves around the question of the presence and absence of the penis. A popular solution to the question of sexual difference for boys is that the girl was once just like him, but that she has 'lost' her penis.

The fetishist refuses to believe the female has been 'castrated'. The possibility of castration is so vivid and the fear that this could happen to him is so strong that he continues to imagine her as

phallic. In order to avoid thinking of her 'wound' or 'loss', he either overvalues other non-threatening parts of her body such as her breasts, legs or hair, or he prefers to see images of women decorated with phallic shapes. Pornography abounds with representations of the phallic woman—the woman whose body is adorned with phallic symbols—a whip, high-heeled shoes, leather, a gun (Creed 1993).

Whether or not Freud's theory of the castration fantasy seems plausible, there is no doubt that the cinema is obsessed with sexual difference. Almost all films construct visual representations of the sexes, not as different, but as opposites. Male characters are coded as 'masculine', female as 'feminine'. Films which explore sexual ambiguity almost always make this a source of humour (*Sylvia Scarlett*, 1935; *Some Like It Hot*, 1959; *Tootsie*, 1982), or terror (*Psycho*, 1960 and *Dressed to Kill*, 1980). Pleasure lies in abolishing ambiguity and in seeing the opposition between the sexes reasserted.

The third primal fantasy, which is closely related to the other two, is seduction—also a popular theme of many films. Although seduction is central to genres such as the love story and the musical, it figures in almost all films, from the Western to the boxing genre. Seduction takes various forms—passive, active, sadistic. It may be comic, as in the romantic comedy, or frightening, as in some horror narratives.

While the three primal fantasies are endlessly replayed in film narratives, offering pleasure—normal and perverse—through repetition of these key moments, it remains to be seen if participants in cybersex will continue to interweave these themes in the stories they create. As people learn to think differently about their bodies (or lack thereof), they may come to evolve a set of primal fantasies about origins, sexual difference and seduction that are inflected differently. Dibbell's proposition that when it comes to cybersex 'perhaps the body in question is not the physical one at all, but its psychic double, the bodylike self-representation we carry around in our heads' suggests that the sexual experiences we have in the real world will long continue to exert a profound influence on our sexual experiences in the virtual world.

Origin is a central issue in cybersex, in that the participant can

no longer be defined in purely 'human' terms. The cybersex subject is a technological being, a fusion of human and electronic. Cybersex offers the possibility of sexual fulfilment without bodily contact. In the past, many science fiction films (for example, *Metropolis* 1927) have assumed a separation between human and machine. In recent films (*Blade Runner*, 1982; *Robocop*, 1987; *The Terminator*, 1992), the two have been fused via the figure of the cyborg: unlike the robot, the cyborg represents the possibility of a perfect union.

A union between computer and human presents a completely different scenario from the above. Tactile telepresence enables the human to engage in disembodied erotic encounters. If sexual pleasure is no longer produced through the interaction of two physical bodies, but through a union of two electronic bodies, will a new set of sexual fantasies evolve? How might this transformation affect existing fantasies of the primal scene, sexual difference and seduction? Will the cybersex generation see birth as an electronic creation, gender as a completely fluid state and seduction as a meeting of strangers in space?

Will sex occupy a central place in the work day or will it continue to be relegated to leisure time? The dream of continuous sex has attracted many writers. De Sade even planned a 'phallic' machine (Barthes 1976), designed to offer continuous sexual pleasure to women. (Perhaps he—like Freud—should have first consulted a woman to find out what she might want!) Will the world of teledildonics be primarily defined and created by men who make no attempt to explore the nature of female eroticism before launching their project into space?

In addition, given that the 'self' might become a union of the person inside the helmet, operating the encounter, and their image on the screen, will we need a new definition of identity? If participants in cybersex can construct themselves in any way they wish—represent themselves as physically perfect beings of any gender—what will this mean for notions of attraction? According to Howard Rheingold: 'If everybody can look as beautiful, sound as sexy, and feel as nubile and virile as everybody else, then what will become the new semiotics of mating? What will have erotic meaning?' (Rheingold 1991, p. 351).

A related issue concerns the 'double'. Almost all human cultures have been fascinated by the notion of the double, the twin, the doppelganger. According to Lacan (1977), human identity is formed during an imaginary encounter when the infant first recognises itself as a separate entity in a mirror or reflected in the eyes of another. In other words, identity is formed in relation to an image of one's self. The problem is that the infant imagines itself to be already like an adult, and in a more perfect stage of physical development than it actually is. Identity is formed in a moment of recognition and misrecognition. The human subject is forever haunted by an image of itself as an ideal.

Given the opportunity to create oneself in any likeness, will people construct their technological selves or doubles as perfect ideals? Will the future be a space, a screen, in which each human player—like Narcissus—gazes forever at an idealised image of itself which will remain forever out of physical reach? Given the enormous emphasis in our culture on the body, and the particular oppression of people through appearance (in terms of ethnicity, colour, gender), subjects of the twenty-first century may use the new technologies to escape these oppressive experiences. Will they design their new images in terms of existing ideals or will they create new ones?

French philosopher Jean-Francois Lyotard has already asked the question: 'Can thought go on without a body?' (Lyotard 1988–89). If subjects are 'freed' from the tyranny of the body, and from the power of the state to control them through the body, will they think of themselves differently? Will we exploit the enormous potentialities of cyberworld to cling tenaciously to traditional modes of being? Or will the future consist of a new order of virtual erotics which is not based on body politics?

Friedrich Kittler argues that what is fascinating and important about the new communications networks is not so much that technology has become an extension of the body, or that technology has turned us into cyborgs, but that we have become subjects of technology. Kittler's work explores the 'subtler issues of how we conceptually become reflections of our information systems', or how technology is producing us (Ostrow, in Johnston 1997, p. x). In relation to sex, the new technologies are

producing subjects whose desire is shaped not through and by the body and language, but through and by technology. David Cronenberg explored this scenario in his film *Crash* (1996), in which desire is shaped by the car crash—speed, a sudden impact, twisted shapes, the fusion of flesh and metal, bodily scars. This is what his characters find orgasmic. In the world of cybersex, our desires would be channelled through digitisation. According to Kittler: 'if the optical fiber network reduces all formerly separate data flows to one standardized digital series of numbers, any medium can be translated into another. With numbers nothing is impossible' (Johnston 1997, p. 2). On the basis of this, it would appear that in the domain of cybersex, our desires may seem to be discrete and idiosyncratic but end up being homogenised into standardised stream or single flow. Desires may simply become, in Kittler's words, 'mere effects on the surface, or, to put it better, the interface for the consumer . . .' (ibid.). In such a context the erotic primal scene of the technological subject may well be generated by and stored on a piece of software.

References

Note: An earlier version of this article appeared as 'Screen sex: from television to teledildonics', in Jill Julius Matthews (ed.), *Sex in Public: Australian Sexual Cultures*, Allen & Unwin, Sydney, 1997. This article has been revised and updated.

Ballard, J.G. 1984, *Re/Search*, 8–9, p. 157.
Barker, G. 1999, 'The logistics of filtering the Net' *The Age*, 19 March, p. 7.
Barthes, R. 1976, *Sade/Fourier/Loyola*, trans. Richard Miller, Hill Wang, New York.
Cone, E. 2002, 'The naked truth' *Wired*, February, pp. 100–3.
Cowie, E. 1984, 'Fantasia' *m/f*, 9, pp. 71–105.
Creed, B. 1993, *The Monstrous-Feminine: Film, Feminism, Psycho-analysis*, Routledge, London & New York.
Dibbell, J. 1994, 'A rape in cyberspace', in Mark Dery (ed.), *Flame Wars*, Duke University Press, Indiana, pp. 237–61.

Freud, S. 1905, 'Three essays on sexuality', in *The Standard Edition of the Complete Psychological Works of Sigmund Freud, 1953–1966*, vol. 7, trans. James Strachey, Hogarth, London, pp. 123–230.

—— 1900, 'The interpretation of dreams' *Standard Edition*, vol. 4 & 5.

—— 1918, 'From the history of an infantile neurosis' *Standard Edition*, vol. 17, pp. 1–22.

Griffin, M. 2001, 'Cyber studs and virtual babes' *Sunday Life, The Sunday Age Magazine*, pp. 8–10.

Haraway, D. 1985, 'A manifesto for cyborgs: science, technology and socialist feminism in the 1980s' *Socialist Review*, 15/2, pp. 65–107.

Harmon, A. 1994, 'Sex a la "Seedy Rom"' *The Age*, 1 March, p. 32.

Johnston, J. (ed.) 1997, 'Friedrich A. Kittler essays: literature, media, information systems', in *Critical Voices in Art, Theory and Culture*, G&B Arts International, Australia.

Lacan, J. 1977, *Écrits*, Tavistock, Great Britain.

Laplanche, J. and Pontalis, J-B. 1985, *The Language of Psycho-analysis*, The Hogarth Press, London.

Lyotard, J-F. 1988–89, *Discourse*, 11, pp. 74–87.

Margetts, D. 1999, 'Censor and be damned', *The Australian*, 1 June, pp. 53, 58.

Mulvey, L. 1989, 'Visual pleasure and narrative cinema', in L. Mulvey, *Visual and Other Pleasures*, Macmillan, London.

Reardon, D. 1999, 'Virtual sex—a real problem' *The Age*, 20 February, p. 4.

Reid, E. 2000, 'Hierarchy and power: social control in cyberspace', in Marc A. Smith & Peter Kollock (eds), *Communities in Cyberspace*, Routledge, London.

Rheingold, H. 1991, *Virtual Reality*, Mandarin, Great Britain.

—— 1994, *The Virtual Community*, Minerva, Great Britain.

Rollins, A. 1999, 'Cabinet to ban cyberporn' *The Age*, 19 March, p. 7.

Sabo, E. 2000, 'Health Watch', http://cbshealthwatch.netscape.com [July 2000].

Smith, M.A. & Kollock, P. (eds) 2000, *Communities in Cyberspace* Routledge, London.

Springer, C. 1991, 'The pleasure of the interface' *Screen*, 32, p. 3.

Stivale, C.J. 1997, 'Spam, heteroglossia and harassment in cyberspace' in David Porter (ed.), *Internet Culture*, Routledge, New York, pp. 133–44.

Sunday Age 2000, 'Oh, what a tangled Web we weave' 20 August, p. 14.

Tebbutt, D. 1999, 'Censor and be damned' *The Age*, 1 June, pp. 53, 58.

Turkle, S. 1995, *Life on the Screen: Identity in the Age of the Internet*, Simon & Schuster, New York.

Virilio, P. 1998, *Open Sky*, trans. Julie Rose, Verso, London, pp. 104–5.

8

Queering the media: A gay gaze

Queer Theory gives academic credence to something that lesbians and gay men have known all along—that imagination is, by its very nature, promiscuous.—Burston & Richardson, *A Queer Romance*, 1995.

Human desire comes in many forms—gay, straight, bi, homosocial, masochistic, autoerotic. It includes fixation on parts of the human body, the non-human and the abject: breast fixation, shoe fetishism, pet passion, arborophilia, coprophilia—even necrophilia. Individuals can develop erotic obsessions with perfumes, fabrics, vintage wines, mobile phones, cars and guns. Given the range and rich potential of human desire, obsessions and erotic fixations, it is surprising that the dominant culture has attempted to limit forms of sexual expression to a single 'legitimate' mode—heterosexual penetrative sex. So strong has been the desire for sexual orthodoxy throughout modern western societies that many powerful bodies, such as the churches, the legal system, family networks, censors and educational institutions, have expended considerable time and effort in an attempt to impose conformity across the board.

Society was not always obsessed with defining sexuality or parcelling people's sexual identities into categories such as 'gay' or 'straight' and then drawing up sub-categories in order to cover the various fetishes and perversions. The desire to compartmentalise is a peculiarly modern one, and appears to have emerged with the invention of modern filing systems, militarism, bureaucracy and the nuclear family. French theorist Michel Foucault and

others have pointed out that the term 'homosexuality' only came into use in the early modern period. Before that there were same-sex acts, to which anyone might yield, but there was no term to describe a person who engaged in same-sex acts. Foucault points to German psychiatrist Karl Westphal's famous 1870 article on 'contrary sexual feelings' as its birthdate. Shortly thereafter the concept and term 'heterosexual' came into being. 'The nineteenth-century homosexual became a personage, a past, a case history and a childhood . . . Nothing that went into his total composure was unaffected by his sexuality' (Foucault 1981, p. 43). The same could be said of the heterosexual, except that heterosexuality is not seen as a pathology.

The hetero-normative approach to sexuality is based on a completely dualistic way of thinking—that 'normal' sexual attraction can only exist between opposites. According to this model, homosexual men who are sexually attracted to other men must be 'pseudo-women'. Heterosexuality needs its 'opposite', homosexuality, against which to define itself as the norm. Hence gay men are stereotyped as if they were the opposite of men—they are described as if they were women: irrational, feminine and fussy. Similarly, women who are attracted to other women must be pseudo men. Hence lesbians are stereotyped as mannish, predatory and sexually active. Over the course of the twentieth century, the homosexual/heterosexual dichotomy gradually solidified into two discrete categories with stable, fixed meanings.

The notion of 'queer' first emerged in the USA at the end of the twentieth century, in the late 1980s and 1990s. 'Queer' was used as an umbrella term to embrace people from all walks of life—gays, lesbians, bisexuals, transsexuals, transvestites. The impetus for a new approach to gender theory arose from the establishment of Queer Nation in New York in April 1990 (Creed 1994). The militant offspring of Queer Nation was ACTUP. As a result of the AIDS crisis, straight society had become more homophobic, and acts of violence against lesbians and gay men had correspondingly increased. In response, lesbians and gay men fought back, becoming more outspoken and militant in public in order to stem the violence. ACTUP staged marches, confrontational street theatre and cultural events. It created eye-catching

graffiti, pushed gay issues into the public arena, and outed well-known people who were 'in the closet'—although not all members of the queer community supported the latter strategy.

Annamarie Jagose, novelist and theorist, emphasises the all-embracing nature of queer: 'institutionally, queer has been associated most prominently with lesbian and gay subjects, but its analytic framework also includes such topics as cross-dressing, hermaphroditism, gender ambiguity and gender-corrective surgery' (Jagose 1996, p. 3).

'Queer' is difficult to define, precisely because the word sets out to question the belief that there is such a thing as a set of fixed meanings in relation to sexual identity. If we are to attribute a clear and definite meaning to queer, it would be that it challenges the view, first, that there is a fixed sexual identity, whether heterosexual or homosexual, bisexual or transsexual; and second, that there is a set of fixed gender characteristics, whether masculine or feminine. Regardless of sex and sexual preferences, individuals can and do occupy a range of gender positions, from the extremes of the feminine to the extremes of the masculine and all positions in between. Furthermore, individuals can change gender roles if they wish. 'Queer' even challenges the idea that there is an accepted definition of the meaning of 'sexuality' itself. In short, 'queer' challenges the 'naturalness' of gender, arguing that gender is essentially a performance (Butler 1990). It argues that gender identity is similar to a form of impersonation, an enactment that is permeable, transformative, unstable and unsettling. In her discussion of *Pumping Iron II* (1985), a documentary about a Las Vegas bodybuilding championship for women, Annette Kuhn effectively demonstrates that the gendered body is constituted through performance: 'Performance is an activity that connotes pretence, dissimulation, "putting on an act," assuming a role . . . Performance proposes a subject which is at once both fixed in, and called into question by, this very distinction between assumed persona and authentic self' (Kuhn 1989, p. 56).

By the 1990s the world media, particularly newspapers, magazines and television, were fascinated by all things queer—queer lifestyles, queer identities, queer celebrities. Indeed, much has changed since former Prime Minister of Australia Paul Keating,

noted for his colourful turn of phrase, stated that in his view two gay men and a cocker spaniel did not constitute a family. He might have asked the cocker spaniel. The British press carried an article on the discovery that 500 years ago churches in Britain sanctioned same-sex relationships, permitting marriage and joint burials. There was even a discussion of new historical research that indicated that Robin Hood was gay. The article was accompanied by humorous puns that 'Robin Hood quivered over men' and he was 'not the Marian kind'. Popular magazines and newspapers announced that it was chic to be a lipstick lesbian—cool, fashionable, popular. The 'Saturday Extra' section of the Melbourne *Age* published a cover story titled 'Wicked women', in which lesbians were described as 'glamorous, gorgeous and glad to be gay' (p. 1). When we read articles entitled 'Straight up and down: happy to be het' we will know that a queer society has truly arrived.

Television offered various mini-series about lesbian and gay characters, such as *Oranges Are Not the Only Fruit* and *Portrait of a Marriage*. Soaps, comedies and dramas such as *Soap*, *The Simpsons*, *GP*, *Ellen* and *Ally McBeal* also featured gay characters and/or episodes. Other notable queer moments included the lesbian episodes of *Golden Girls* and *Melrose Place*, the famous 'lesbian kiss' on *LA Law*, and the appearance of the Sandra Bernhard character in *Roseanne*. In the USA, daytime talk shows (*Oprah Winfrey*, the *Phil Donahue Show*) continue to exhibit an endless fascination with homosexual issues and celebrity lesbian and gay figures. The problem was that these programs were either tokenistic one-off attempts to appear democratic or used queer to sensationalise events and attract a larger audience.

In 1989, Britain's Channel 4 screened *Out on Tuesday*, the first lesbian and gay series in the world to be commissioned and screened on mainstream television. In Australia it appeared on SBS. The series, which was followed by four more, presented all aspects of gay life, from the serious (persecution in Nazi Germany) to the fun (fashion, music and pets). *Out on Tuesday* was instrumental in making lesbian and gay life visible to the straight world. Ratings were excellent, comparable with ratings for Channel 4's mainstream programs.

Britain has again led the way in queer ratings with its controversial series *Queer as Folk*; an eight-part gay soap, the first series went to air on Channel 4 in 1999, and a shorter two-part sequel was broadcast in February 2000. Daring, bold, gritty, *Queer as Folk* traces the lives of three white, good-looking gay men from Manchester, along with the journey of a young virgin and newcomer to the gay scene. There is a network of family members and friends, including a lesbian couple with a baby, whose lives are central to the unfolding drama. The first broadcast led to a furore as conservative sections of the public complained about the gay sex, boy sex, group sex, excessive sex, nudity and bad language. They also complained about the display of men on Internet porn sites having cybersex. The number of complaints to the Independent Television Commission was second only to the number levelled against Martin Scorsese's *The Last Temptation of Christ* (1988). Worldwide, religion and sex remain the two areas subject to the most stringent taboos.

An immediate cult hit among gay communities worldwide, the British series was re-made in the United States. Set in Pittsburgh, *Queer as Folk* was made for cable, as is *Sex and the City*. Comparing *Queer as Folk* and *Sex and the City*, originally considered a sex-shocker, makes the adventures of the girls from Manhattan look like a naughty version of *Alice in Wonderland*. The American version retains the confronting sex and explicit dialogue, but it has changed the age of the young boy. The 15-year old schoolboy of the British series, who was seduced by an older man, is turned into a 17-year-old—someone over the age of consent.

Surveys of viewers in the USA reveal that more than half are women. Some of the women interviewed state that they enjoy watching gay male sex, because they find it sexually arousing. One viewer was 'struck by seeing two men having sex facing each other. She was so surprised. She just didn't know gay men could look at each other while they have sex' (Kermond 2002). One wonders if she thought the reason was moral, physiological or ocular. Lesbian sex is, of course, a well-known staple of male pornography; the response of women to gay male sex adds weight to the idea that pleasure resides at least partly, and for all

of us, in encounters with otherness and with normally taboo images (see Chapter 1). The title, *Queer as Folk*, is actually a Yorkshire proverb which means that all folk, or all people, are queer. Its meaning resonates with a similar Quaker saying, which my grandmother had in a frame on her fridge: 'All the world is queer save thee and me, and sometimes I think thee a little queer'. The truth of this statement appears to be borne out by the global appeal of the series; it has been bought by free-to-air networks in twelve queer-friendly countries, including Australia, Israel, Yugoslavia, Japan and Brazil.

While criticisms from the general public focus on the scenes of gay sex, critical comment from the lesbian and gay community has addressed political issues. Some have attacked what they regard as the stereotyping of lesbians (they just want to have babies), the gay male obsession with youth, and the nostalgic portrayal of gay male sex. 'It is nostalgic for a pastoral, pre-AIDS era when gay sexuality was discursively associated with excessive, abundant pleasure and unconstrained, guilt-free licentiousness' (Munt 2000). Despite such reservations, the series has proved immensely popular, probably because it also offers the attractions of any well-made soap opera. The difference is that, for the first time in television history, the opera's characters are queer.

Queer is interested in the sexual incoherencies and ambiguities which exist in so-called stable notions of sexual identity, whether gay and straight. 'Demonstrating the impossibility of any "natural" sexuality, it calls into question even such apparently unproblematic terms as "man" and "woman" '(Jagose 1996, p. 3). While *Queer as Folk* is not queer in its interrogation of meanings, it certainly is queer in its confrontational approach. Queer seeks out the vanilla, or 'straightness', in the behaviour of people regardless of sexual orientation. Hence queer would probably regard a very conservative, straight gay couple as decidedly not queer, while a sexually non-conformist, cool, bent, het couple would be seen as clearly queer. With its 'in-your-face' attitude, queer is deliberately provocative.

International fashion magazines (*Vogue, Cosmopolitan, Tatler, Elle*) have been particularly open about using images of male and female models posed in such a way as to suggest same-sex

eroticism. The front cover of the August 1993 edition of *Vanity Fair* displayed an image of super-model Cindy Crawford pretending to shave the boyish, smiling, lathered face of k.d. lang, the lesbian singer. The two were clearly 'male' and 'female', yet both figures were women. A number of fashion magazines trade on the narcissistic stereotype of the lesbian: they display images of look-alike models dressed in similar clothes, striking similar poses, and looking as if they are about to have sex. The butch–femme fashion images break down this stereotype, which is based on the sexist view that women are only attracted to each other because they are motivated by narcissism and auto-eroticism. The butch–femme couple, of course, can also be a stereotype, but where the figures are obviously presenting a parody of gender roles, as Crawford and Lang were, the effect is decidedly queer.

In contrast to patriarchal ideology, queer theory argues that both male and female bodies are fluid, not fixed. Queer bodies appear transgendered and transformative; they blur boundaries between male and female. Queer also enjoys comedy and the carnivalesque. The Melbourne *Age* ran a feature story on 'The misterhood', which discussed the lifestyles of Melbourne drag kings, or male impersonators. 'Welcome to the world of drag kings, where masculinity is mocked, feted and turned on its head . . . It's not easy to work out the social dynamics. A lesbian bar is the last place you'd expect to find so many compassionate, almost affectionate, renditions of manhood' (Merz 2001, p. 1). The analysis of drag kings and their audience emphasised the fluid nature of queer identity. It is the power of the body to change and transform, to signify fluidity rather than fixity, that queer represents.

This is strongly demonstrated in the remarkable documentary *Shinjuku Boys* (1997) by Kim Longinotto and Jano Williams. Shinjuku boys are female to male transsexuals who work at the New Marilyn Club, Tokyo. The boys, who pass easily as men, act as companions and escorts for the women—gay and straight— who flock in every night to have a good time. The club rules permit them to have casual relationships but not live-in ones, although the boys do not always comply. Beautifully groomed

and dressed in suits, the boys sit with the female clients, buy them drinks, dance, tell jokes. The women prefer the company of the shinjuku boys to that of biological men. The three boys, Gaish, Kazuki and Tatsu, speak frankly about their lives and sexual desires. Tatsu, who lives with his partner, has hormone injections to prevent menstruation and to look more masculine. His partner is very jealous of other women. Handsome and moody, Gaish is pursued by female clients. Kazuki, who straps her breasts down, lives with a male to female transsexual who has had surgery; they do not have a sexual relationship but are deeply committed to each other. Kazuki says there is much more to love than sex. They find the conventional male/female gender roles something of a joke. *Shinjuku Boys* presents a persuasive argument for the fluidity and diversity of sexual desire.

One of the political aims of the Sydney Gay and Lesbian Mardi Gras, which attracted huge media attention in earlier years, much more than it does today, was to stage or exhibit, in a deliberately in-your-face manner, the outrageously queer body, that is, the male and female body in drag, leathered and laced as well as clothed, semi-clothed, pierced, tattooed, primped, crimped and costumed. When the ABC decided to broadcast a one-hour edited film of the highlights of the 1994 Gay and Lesbian Mardi Gras Parade, there was, of course, outrage from conservative sections of the public. The main complaint was that such a blasphemous event, which enabled gay people to 'promote' their lifestyle, should not be screened during the Sunday night prime-time 8.30 slot, which should be reserved for 'normal' people to promote their lifestyles.

One way of understanding the appeal of the Gay and Lesbian Mardi Gras, and of queer, is through theories of the carnivalesque (Creed 1995). Inspired by Russian literary theorist Mikhail Bakhtin's writings on Rabelais, theorists have argued that modern-day carnivals are not simple rituals or festivals but also symbolic practices. For Bakhtin, carnival—through its politics of inversion—was basically a populist critique of high culture. Historically, carnival was a time of processions, dancing, costumes, feasting, pranks and trickery. In carnival the social hierarchies of everyday life were deliberately turned upside

down. All normal forms of behaviour were deliberately profaned. A popular reversal was known as 'woman on top'. In this performance the man lies on the bottom and the woman sits astride him; she holds the power both sexually and socially. During carnival the lower parts of the body take precedence over the higher. Normally, people emphasise the superiority of the brain, head, heart and face; in carnival, clowns and jesters deliberately swell their stomachs, extend their buttocks, burp and fart. Bakhtin defines carnival in this way:

> As opposed to the official feast, one might say that carnival celebrated temporary liberation from the prevailing truth and from the established order; it marked the suspension of all hierarchical rank, privileges, norms and prohibitions. Carnival was the true feast of time, the feast of becoming, change, and renewal. It was hostile to all that was immortalised and completed (Bakhtin 1984, p. 10).

The Gay and Lesbian Mardi Gras deliberately turns upside down the conventional norms of every day: queer is lauded over straight; lesbian and gay sex over straight sex; the naked body over the clothed; the lower parts of the body (buttocks, crotch) over the higher; colourful nonconformity over drab conformism; the improper over the proper. One of the most telling reactions came from radio talkback personality John Laws, who described it as 'a sordid event' in which 'boys cut the arses out of their jeans so all us lucky people can see their botties'. By infantilising the event ('boys'/'botties'), Laws clearly intended to denigrate it. He also unintentionally focused on what was then one of the Mardi Gras' main political aims—to put a particularly taboo area of the Australian male body, the buttocks, on public display in order to confront homophobic men.

Chris Berry's review of the film *The Sum of Us* (1995), entitled 'Not necessarily the sum of us', argues that straight men incorrectly assume that all gay men practise anal sex—and that the real man is the one who does the penetrating. As a consequence, straight male culture includes an underlying anxiety about the anal which is revealed through jokes and bizarre sayings such as 'backs to the wall'. Perhaps anxious about their inability to say

no, these men feel in need of a brick barricade to protect themselves from the 'sissy' poofter. Something just doesn't add up in this equation. The Mardi Gras, which almost ceased operation in 2002, is hugely popular with the straight community, which suggests that it fulfills an important symbolic function—it is a necessary ceremony of liberation, change and renewal. No doubt if it closes another similar event will take its place: lesbian, gay and transgendered communities love to celebrate, and the straight world needs a safety valve.

There were many examples in the 1990s of the media's fascination with otherness and willingness to report on all forms of queer news, particularly in relation to celebrities. We need to look no further than stories in the world's mainstream press about Martina Navratilova's affair with k.d. lang:

> Tennis great Martina Navratilova has a new woman in her life—Grammy Award-winning singer k.d. lang. Although the openly lesbian superstars have denied they are dating, we have the first exclusive picture of them out on the town together (*Women's Day*, 17 May 1993).

The world's most public lesbian, Martina was by the 1990s a 'lesbian superstar', her love life no longer a topic of scandal, as it had been in the 1980s, but one of public interest, primarily because of her sporting fame. Even more interesting, the lesbian superstar was dating another superstar. When Martina retired from tennis, she left a gap, one that had as much to do with her accepted public status as a celebrity lesbian as with her tennis stardom.

It is clear that as a consequence of the increasing visibility of lesbian and gay figures, other more 'deviant' desires—transsexuality, transvestism, masochism—have come to the fore. This in turn has led to media discussions of the complex, fluid and varied nature of sexual preference, sexual pleasure and sexuality in general. However, many conservative sections of the community still vehemently oppose lesbians, gay men, transsexuals and transgendered people.

The 1990s' press also focused on repressive areas of society: a Catholic father's anguished denunciation of the cruelty of the Catholic church's condemnation of homosexuality and, as a

consequence, his gay son; the brutal murder of a gay college student in the USA. There has been strong media interest in the fact that worldwide, lesbians and gay men do not enjoy equal rights in matters of marriage, superannuation, inheritance and parenting. Finally, there was the controversy in Australia surrounding the legal right of single women and lesbians to have children by in-vitro fertilisation. Such women were denounced by the Federal Government as 'socially infertile', that is, they were socially 'abnormal' because they were single (not with a man) or lesbian (definitely not with a man). Absurd responses such as this suggest that the old phallocentric order knows it is rapidly losing ground. Meanwhile, single mothers, gay and straight, continue to experience intense discrimination in relation to parenting, maternity leave and social approval.

The politics of queer were much more confrontational than those of the 1980s' lesbian and gay agenda. There is no doubt that the in-your-face attitude of queer politics made a significant difference to social attitudes and media exposure in the late 1980s and the 1990s. However, alongside a more tolerant media, some conservative sections of the western world, particularly the Catholic church, continue to cling to old prejudices and straight orthodoxies. In times of economic hardship and political crisis, social attitudes can quickly become repressive and intolerant.

One area of the media which has provided a free space for the queer community is the Internet. Quick to take advantage of its global nature, queer communities have been able to network in order to organise virtual protests in response to statements from the religious right and other homophobic institutions. The Internet offers a place to keep the global databases necessary for political action. There are newsgroups and mailing lists dedicated to queer issues. There are sites for transsexual and transgendered people. Because the Internet offers anonymity, many individuals have been able to come out in relative safety. Queer viewers can also take part in interactive sex sites.

Related to queer is the popular practice of writing slash fiction. ('Slash' refers to the grammatical slash used to abbreviate and link the names of television characters such as Kirk/Spock or Xena/Gabrielle.) Slash fiction has been described as a virtual

genre; its essential defining characteristic is that the authors describe erotic encounters between television, sometimes film, characters of the same sex. In this example, the virtual author, Lady Charena, has assumed the identity of Spock. Spock is narrating a sexual encounter with Kirk. Spock is in the shower, soaping himself erotically, as he imagines 'the mouth of the human' on his. Kirk appears in the bathroom. Lady Charena/Spock writes:

> His gaze travels down my body and his grin widens . . . he is
> on his knees in front of me. Just the tip of his tongue flickers
> over the head of my straining erection and I have to brace
> myself against the tiles of the wall (Lady Charena 2000).

Another slash fiction writer, Cousin Liz, pictures a sexual encounter between Xena and Gabrielle:

> Xena swallowed hard, already imagining the sweet taste of
> those lips . . . Xena tilted the bard's face up but Gabrielle averted
> her eyes. 'Look at me,' she ordered, and the bard quickly
> complied . . . a low growl emanated from the depths of Xena's
> soul as she hungrily seized the girl's tongue, sucking it into her
> own mouth. Gabrielle moaned into the warrior's mouth as Xena
> slowly released her tongue . . . (Cousin Liz 1997, p. 4).

As US film theorist Constance Penley demonstrates, slash fiction first appeared in fanzines in the 1970s, and had moved onto the Web by the mid-1990s. Slash is primarily written by heterosexual women (Penley 1997). Film academic Sara Gwenllian Jones identifies the ultimately perverse nature of the stories:

> The sexual encounters described in slash stories may be tender,
> fiercely passionate, casual, masturbatory, voyeuristic, orgiastic,
> sadomasochistic or non-consensual. Almost every imaginable
> seduction scenario, narrative context, emotional import and
> sexual practice is somewhere described in slash fiction (Jones
> 2002, p. 79).

As a number of studies have pointed out, the fascinating aspect of slash fiction is that it interrogates and undermines heterosexuality and classic masculinity: men are cast into feminised

swooning roles conventionally enacted by women, for instance. Jones convincingly argues that slash fiction itself is not inherently queer; the cult TV series (*Star Trek, The X-Files, Xena: Warrior Princess*) that give rise to slash are themselves already queer. Slash fiction makes apparent, or explicit, the queerness of these cult programs. The female authors themselves must adopt a queer writing position, though, or enter imaginatively into queer fantasy, to produce their perverse explorations of the sexual.

QUEER LOOKS

Queer theory has also had an impact on the way many people 'read' the media. The popular media is filled with what could be described as unintentionally 'queer moments'. 'Queering the media' can also mean a transformation in viewing practices so that many of us look at/interpret the media through a queer lens: 'Queer Theory seeks to locate Queerness in places that had previously been thought of as strictly for the straights' (Burston & Richardson 1995, p. 1). While the recent tide of media interest in queer stories may have passed its high point, the legacy has been the creation of a queer look or glance, a practice of queer spectatorship, or of 'reading against the grain'.

The practice of reading against the grain was taken up by feminist academics, particularly film theorists, who were influenced by the post-structuralist debates of the 1970s, which held that the meaning of a text often resides not on the surface but in the sub-text. This critical practice argued that the dominant ideology does not necessarily represent itself in a clear, logical, rational manner; gaps and contradictions often mark the ideological argument of a text. It is during such moments that characters can speak, to some extent, in their own voice. By reading against the grain, the critic can focus on such gaps and contradictions, and moments when another viewpoint emerges— even if briefly—in the sub-text. For instance, when the Dustin Hoffman character in *Tootsie* (1982) reveals his true identity, it is expected that the audience will warm to the possibility of a love match between Hoffman and the Jessica Lange character. But the

moment of revelation falls flat—even Lange seems disappointed—indicating that the most interesting relationship was actually between the queer couple: Tootsie, the cross-dresser, and her female friend. The heterosexual imperative does not reassert itself so easily. The police thriller *Black Widow* (1987) explores an intense relationship between a law enforcement agent (Debra Winger) and the suspected killer (Theresa Russell). Despite their apparent heterosexuality the two women share pleasures, clothes, even a passionate kiss. The viewer who can see through the heterosexual surfaces and read between the lines will discover a play of lesbian desire.

The nature of spectatorship in the cinema also encourages a queer gaze, particularly in relation to the area of identification. Feminist film theory argues that in the majority of films, men act and women appear. Men carry the narrative forward; women are there more for their beauty and desirability. The female star is sexually objectified more frequently and intensely than the male star. Given that the majority of mainstream films star men in the main role, it follows that the film audience, male and female, will identify with the hero, the character who initiates the action. Do female spectators, then, also identify with the hero when he falls in love? Do they take the female star as the object of their desire? How do they respond when the female star performs for the camera/viewer and puts her sexuality on display? Do female spectators experience lesbian desire when they watch the female star? What happens when the star, such as Marlene Dietrich or Madonna, deliberately cross-dresses and presents herself as bisexual?

Male stars are sexually objectified in many films, but their sexualisation is not as obvious; the male character is usually eroticised in scenes of action in which the camera focuses on his muscled body. Russell Crowe, Tom Cruise, Bruce Willis, Mel Gibson—the bodies of male action stars are frequently fetishised by the camera. Sometimes the camera eroticises male stars, such as James Dean or Brad Pitt, because of their feminine beauty. Do male viewers experience same-sex desire when the male star is sexually objectified? In a discussion of the gay gaze, cultural theorist Paul Burston argues that *American Gigolo* (1980), which

starred Richard Gere, sexually objectified and feminised the male body in a manner not lost on gay male viewers (Burston & Richardson 1995, pp. 113–17). What of straight male viewers? Did they also feel desire for the male star?

Queer theory argues that in the cinema, processes of identification are very complex; spectators will identify across gender boundaries, even identifying with one or more characters at the same time—that is, the imagination does not obey the dictates of social conditioning. Film spectators can also adopt a practice of imposing other meanings on a film. Burston and Richardson promote the practice of the 'gay gaze' in their edited collection of essays, *A Queer Romance*, which includes a number of witty essays on 'how the gay spectator can impose meaning of his own upon even the most uncompromising material' (Burston & Richardson 1995, p. 6).

A fresh perspective can quickly uncover the queer frolics of Edina and Patsy in *Absolutely Fabulous*. The popular British sitcom, which enjoys a large gay following, is about two best friends who look like drag queens, run a fashion magazine and never seem to have relationships with men. Patsy might find herself in bed with a stud, but the encounter is always brief— Patsy's only lasting relationship is with Edina, her best friend from school. Patsy's passion for Edina is mainly expressed through her extreme feelings of jealousy over Saffron, Patsy's long-suffering daughter. One of the underlying aims of *Absolutely Fabulous* is to satirise the extremes of political correctness that undermined sections of the women's movement in the 1980s. In a similar vein, one can enjoy *Frasier*, which seems to make the most sense if one imagines that Frasier and his brother Niles are actually lovers. Both are psychologists, both are divorced and both abhor anything that hints of straight macho prowess. The character Bulldog is set up as a foil to emphasise the brothers' difference from straight men. Each brother may team up with a woman briefly but, as with Patsy and Edina, they live for each other.

Newspaper articles frequently lend themselves to a queer reading. A 1999 article on tennis star Mauresmo which appeared in *The Australian* was—despite itself—decidedly queer. A new

lesbian tennis star from France, Mauresmo had emerged at the Australian Open. Like Martina Navratilova, Mauresmo was also a power-hitter. The journalist could only accept Mauresmo's lesbian identity by singling the star out as 'different' from other female champions. She was 'broad-shouldered', and 'powerfully built from childhood'. Like Navratilova, she threatened to transform women's tennis into a game of 'musculature tennis', of power rather than finesse. The writer wanted to highlight differences between Mauresmo and her forthcoming opponent, Martina Hingis: 'Princess of Power' plays the 'Queen of Finesse, Martina Hingis'. At this point the article became just plain silly. Trying to fit Mauresmo into the old stereotype of 'lesbian as man', the journalist sounded as if he were writing about two drag queens at the Mardi Gras. In the end, the article read as a queer send-up of straight gender stereotypes.

The French response was also odd. As a result of her astonishing win over world number one Lindsay Davenport, Mauresmo was featured on the nation's top-rating television satire program. The show depicts national celebrities as puppets. The Mauresmo puppet combined a woman's head with the body of Arnold Schwarzenegger. The voice-over said: 'It's the first time in the history of French sports that a man says she is a lesbian' (*The Weekend Australian* 1999, p. 5). The joke, presumably unintentionally, had a queer ring to it.

QUEER HOLLYWOOD

The attention lavished by Hollywood on the subject of cross-dressing might suggest that it too reveres the sexually ambiguous star and her/his power to pass as the opposite sex. Throughout the history of Hollywood, famous stars have cross-dressed for the public. In the silent period, cross-dressing was a staple of comedies and drama. The introduction of sound added to the long list of those who happily disguised themselves as the opposite sex. Many stars drew much laughter from audiences by their attempts to impersonate the voice of the other, as in Billy Wilder's famous comedy *Some Like It Hot* (1989). Some of the famous faces who

took advantage of the cinema's special effects departments after the introduction of sound were the Marx Brothers, Jerry Lewis, Peter Sellers, Danny Kaye, Cary Grant, Katharine Hepburn, Greta Garbo, Marlene Dietrich, Judy Garland, Marlon Brando, Julie Andrews, Dustin Hoffman, Robin Williams and Arnold Schwarzenegger. In his celebrated book *The Celluloid Closet*, Vito Russo documents over 300 films which deal with same-sex love or lifestyle in some form or other.

Although Hollywood could almost be described as the home of cross-dressing, this does not signify that it has—or had—a tolerant attitude to gay, lesbian or transgendered people or queer lifestyles. Hollywood's representation of lesbian, gay and trans-gendered characters has been shameful.

The handful of films—some produced independently—which broach these areas (*Caged*, 1950; *The Children's Hour*, 1962; *Walk on the Wild Side*, 1962; *The Fox*, 1968; *Cruising*, 1980; *Lilith*, 1964; *Second Serve*, 1986; *Midnight Cowboy*, 1969; *Philadelphia*, 1993; *Boys Don't Cry*, 1999) invariably treated same-sex love as a problem. The guilty protagonists were almost always punished at the close of the narrative: sometimes they were murdered, sometimes they died of a tragic illness or conveniently committed suicide. Holly-wood refused to legitimatise gay or queer relationships in any way, presumably because this might have threatened or offended the heterosexual world. More importantly, stories about non-heterosexual lifestyles would have challenged the myth that lesbian, gay and transgendered people live only on the fringes of society.

The Hays Code of the early 1930s forbade the portrayal of homosexual characters in film. This ruling continued to influence Hollywood productions long after the censorship regulations had been abandoned—in most states they went in the 1960s or 1970s. When Rock Hudson, who was dying from AIDS, came out as gay, the public as a whole was scandalised. Although a few stars, including Elizabeth Taylor and Sharon Stone, have actively campaigned to change public attitudes to AIDS, Hollywood remains a 'celluloid closet'. The fact that virtually no Holly-wood stars have come out since Hudson's courageous declaration reveals the continuing power of heterosexual hegemony.

Boys Don't Cry is one of a handful of films that deals with female-to-male transvestism, and the first mainstream film with a queer/lesbian sensibility to win an Academy award. Although it was produced independently, Hollywood lauded the film. Based on actual events which took place in Nebraska in 1993, *Boys Don't Cry* draws upon classical mythology, and the conventions of the road movie and the love story.

Starring Hilary Swank in the role of Brandon Teena, the role for which Swank won the Oscar, the independently produced film won critical praise and international box-office success. It tells the story of 21-year-old Teena Brandon, a female-to-male transvestite who meets and falls in love with Lana Tisdel (Chloe Sevigny). As the romance blossoms, Brandon's secret is gradually uncovered. Brandon is brutally raped by two men—his former friends—and subsequently murdered, on New Year's Eve 1993. The killers could not control their homophobic, misogynistic fury when they discovered that Brandon, the transgendered drifter, was a young woman, not a boy. Two other people—a young white woman and a disabled black man—were also murdered that night by the same men, but the director, Kimberley Peirce, dropped all reference to the black victim, Philip Devine, from the narrative. This decision has met with strong criticism from some quarters (Hendersen 2001, pp. 299–303). The other victim, Lisa Lambert, is partly represented in the film by the character Candace.

The opening scene highlights Brandon's visual transformation from female to male. As Brandon's cousin cuts the final lock of Brandon's long hair, the jubilant youth stuffs his crotch with padding and dons a cowboy hat. Brandon heads for a roller-skating rink, where he invites a pretty young girl to be his date. As they swirl around the ice, she says to him: 'You don't look like you are from around here.' Brandon, whose smooth-skinned, androgynous good looks mark him as different from the other males, is thrilled. He asks her where she thinks he is from— 'Someplace beautiful,' she replies. Her response to Brandon's feminine masculinity points to a need on the part of the young women of Nebraska to meet someone who offers an alternative to the aggressive and misogynistic masculinity proffered by the local males.

Her response to the question also points to Brandon's status as a mythical outsider—the wandering hero whose magical difference initiates a cycle of fruition, followed by destruction, martyrdom and renewal. His androgynous appearance and transgendered identity challenge the gender norms of Falls City, Nebraska, where a cruel and moribund masculine authority has created an emotional and spiritual desert. The aggressive masculine gender role has become completely inflexible, so a female-to-male transvestite is introduced into the social order partly to throw the extremes of masculine behaviour into some relief. In contrast to the other males, Brandon is a feminised male: softly spoken, smooth-skinned, attractive to women, sensitive, courageous.

In contrast to the many comedies of sexual disguise, such as *Sylvia Scarlet* (1936), *Some Like It Hot* (1959), *I Was A Male War Bride* (1949), *Victor/Victoria* (1982) and *Tootsie* (1982), *Boys Don't Cry* does not play with gender in a safe or amusing manner. The film deliberately builds up narrative tension—and a sense of dread—as it plays on the twin dynamics of disguise and fear of revelation. Brandon's exposure as a woman, followed by his/her brutal rape and murder, shifts the film into the realm of tragedy.

Individuals who traverse boundaries of fundamental concepts such as male/female become 'dangerous' or 'polluting', as the work of anthropologist Mary Douglas has revealed. 'For this reason such persons are, potentially, both very vulnerable and very powerful at the same time . . . Like all other mediators, they can perform their function only as long as the dividing lines exist and no merging of categories occurs' (Douglas 1994, pp. 245–6). Boundary ambiguity constitutes a form of pollution, and the individual crosses boundaries at her/his peril. Brandon's tragedy is that he is unaware of the danger in which his gender transgression has placed him. His desire is to pass as male, to become male, in order to be faithful to his 'true' nature. He believes he is a boy trapped in a girl's body, and he eagerly awaits the time he can afford the necessary operation.

Brandon performs the masculine gender role: he straps down his breasts, hides his monthly blood flow and wears crotch padding. Unlike the transvestite performers of *Paris is Burning*

(1990), or Madonna's transgendered dances, Brandon is not 'knowingly' performing or parodying gender roles. Brandon's seductive performance as a male illustrates queer's disrespect for boundaries, but his desire to become the 'other' is fixed in its intent. In so far as queer signifies a fluidity of desire, a refusal to accept that male desire is inherently different from female desire, then Brandon's desire to adopt the identity of a typical male appears to fall outside the boundaries of queer. The film, however, deliberately represents Brandon's response to Lana's realisation that he is female as ambiguous. When Lana makes love to 'Brandon as a woman', Brandon appears to embrace his femininity. So while the first lovemaking scene between Brandon and Lana is presented from a heterosexual perspective, the final lovemaking scene can be viewed as lesbian. The extent to which the spectator responds to *Boys Don't Cry* as a queer text will depend on the former's willingness to see Brandon as a gender rebel, an outsider bent on undermining sex and gender roles.

The film's strong narrative trajectory, provided by the fatal love story, has invited criticism from some viewers, who believed that *Boys Don't Cry* should have adopted a documentary approach to its subject matter. They prefer *The Brandon Teena Story* (Susan Muska and Gréta Olafsdóttir 1998), a documentary about Brandon's life and death and the two other shocking murders which took place in Falls City that might. While I agree with some that the director's decision to erase Philip Devine's story from the film sacrifices the opportunity to explore 'the hard facts of racial hatred and transphobia' and 'reduces the complexity of the murderous act' (Halberstam 2001, p. 298), I do not agree that a documentary approach necessarily offers a superior set of conventions through which to tell Brandon's story.

A fictionalised account which is free to draw upon the traditions of myth and genre, ritual and performativity, can speak to a wide audience and raise questions about the symbolic and political role of gender in society. Through its careful exploration of the transgendered hero, *Boys Don't Cry* offers a powerful critique of masculinity and the sexual dimorphism which characterises heterosexual gender roles, in particular the male role. Insofar as

the queer character blurs the boundaries between male and female, masculine and feminine, she/he threatens the social and moral order of patriarchal heteronormative societies.

The popularity of *Boys Don't Cry* with world audiences suggests that queer has made a difference. Finally Hollywood has embraced a film in which the main character is transgendered. But clearly, the everyday world is not prepared to extend the same understanding to gender hybridity. This can be measured by social attitudes to hermaphrodism. Despite the media's apparent tolerance of the idea of queer, social attitudes to hermaphrodism underline the deeply intolerant nature of the dominant culture to anatomical diversity. In her article 'Hidden genders', Christine Toomey examines the stigma still attached to people born with an 'intersex condition' (Toomey 2001). This refers to those who appear to be one sex, such as female, but are genetically the opposite sex, male. Others are born with mixed gender characteristics, that is, 'ambiguous-looking genitalia'. In the West, since the 1950s the traditional response has been to intervene surgically in order to 'normalise' the body as either male or female.

This procedure might involve removing the clitoris, reconstructing the vagina, changing an abnormally large clitoris into a penis, or a small penis into a clitoris: 'The criterion used is that if an infant's sexual anatomy protrudes away from the body by more than 2.5 cm, the baby is considered male; if the protrusion is less than 1 cm, the baby is female' (Toomey 2001). Surgeons who favour surgical reconstruction argue that children who grow up with an intersex condition usually are made to feel shame, and are sometimes physically beaten up and/or experience discrimination (Toomey 2001, p. 39). According to Toomey, nearly one in 2000 infants is born with an intersex condition.

Toomey points out that part of the 'controversy surrounding treatment is about what constitutes aesthetically acceptable genitalia' (Toomey 2001, p. 38). An intersex individual does not automatically come under the rubric of queer, because queer refers not to a genetic or anatomical situation but to a state of mind or point of view. Queer takes us into the area of the imagination. The intersex controversy, however, is highly relevant to queer debates,

because it powerfully illustrates the social imperative to be straight, to refuse to accept difference or tolerate diversity. Western society persecutes intersex people but, as Toomey points out, in some Eastern and Caribbean cultures, they are 'revered as expressions of divine will' (Toomey 2001, p. 39).

An examination of queer theory in relation to the media indicates that the confrontational politics of queer have had an influence on a number of media formats and programming. This influence was particularly strong in the 1990s. However, the discrepancy between public tolerance in the actual world and media tolerance is not easily measured. *Some* newspaper articles, *some* television programs, *some* films are prepared to be more adventurous than others, and as such move towards greater levels of tolerance. But there are always conservative voices that herald a possible backlash. The Internet and cable television offer a more flexible and freer space than conventional media formats for a free expression of queer desires.

The process is not just one-way, though. It may well be that queer politics, or versions of queer, have surfaced, and always will surface, at times of social and cultural need. Bakhtin's theory of the carnivalesque indicates that the dominant straight world needs its queer underbelly—queer carnivals, television shows, films, celebrities, people and sub-cultures. Queer renews and replenishes the monochromatic, dichotomised, bland fabric of straight life. Queer inspires the straight world with its emphasis on difference and transformation. In the meantime, the gay, lesbian and transgendered communities and individuals around the world will continue, as they have always done, to view the straight world through a queer lens.

References

Bakhtin, M.M. 1984, *Rabelais and his World*, trans. Helene Iswolsky, Indiana University Press, Bloomington and Indianapolis.

Burston, P. and Richardson, C. 1995 (eds), *A Queer Romance: Lesbians, Gay Men and Popular Culture*, Routledge, London and New York.

Berry, C. 1995, 'Not necessarily the sum of us, Australia's not-so queer nation' *Metro*, pp. 12–16.

Butler, J. 1990, *Gender Trouble*, Routledge, London.

Cousin Liz 1997, 'And still she follows' http://cousinliz.com/fanfic/cousinliz_assf.html.

Creed, B. 1994, 'Queer theory and its discontents: queer desires, queer cinema', in Norma Grieve and Ailsa Burns (eds), *Australian Women: Contemporary Feminist Thought*, Oxford University Press, Melbourne, pp. 151–64.

—— 1995, 'Horror and the carnivalesque: the body-monstrous', in Leslie Deverlaux and Roger Hillman (eds), *Fields of Vision*, University of California Press, Berkeley, pp. 127–59.

Douglas, M. 1994, quoted in Grémaux, 'Woman becomes man in the Balkans', in Gilbert Herdt (ed.), *Third Sex, Third Gender*, Zone Books, New York.

Foucault, M. 1981, *The History of Sexuality, Vol. 1*, Penguin, Harmondsworth.

Halberstam, J. 2001, 'The transgender gaze in *Boys Don't Cry*' *Screen*, vol. 42, no. 3, pp. 294–8.

Henderson, L. 2001, 'The class character of *Boys Don't Cry*' *Screen*, vol. 42. no. 3, pp. 299–3033.

Jagose, A. 1996, *Queer Theory*, Melbourne University Press, Melbourne.

Jones, S.G. 2002, 'The sex lives of cult television characters' *Screen*, vol. 43, no. 1, pp. 79–90.

Kermond, C. 2002, 'They're queer and they're here' *Age Green Guide*, 4 July, p. 8.

Kuhn, A. 1989, 'The body and cinema: some problems for feminism' *Wide Angle*, vol. 11, no. 4, pp. 52–60.

Lady Charena 2000, 'A love supreme' www.geocities.com/blairs-dream/startrek/aluvsupreme.html.

Merz, M. 2001, 'The misterhood' *The Age*, Saturday Extra, 11 August, pp. 1, 4.

Munt, S.R. 2000, 'Shame/pride dichotomies in *Queer As Folk*' *Textual Practice*, 14(3), pp. 531–46.

Penley, C. 1997, *NASA/Trek: Popular Science and Sex in America*, Verso, London.

Toomey, C. 2001, 'Hidden genders' *The Weekend Australian Magazine*, 8–9 December, pp. 36–40.

9

The cyberstar: Digital pleasures and the new reality

The cinema is truth 24 times per second—Jean Luc Godard, *Le Petit Soldat*, 1963

Somewhere towards the end of the much-publicised orgy scene in Stanley Kubrick's *Eyes Wide Shut* (1999), a group of men in cloaks, accompanied by two naked women, arms linked, stroll in front of the camera. The figures are not 'real': that is, they have been digitally generated on computer. The group of seemingly casual strollers appear 'real', and seem to have the same ontological status as all the other figures in the orgy scene, but they do not. These figures were inserted in all US prints of Kubrick's film to block from view an explicit sexual scene that would have earned the film a restrictive NC-17 rating. They are not flesh-and-blood actors, paid to perform before the camera; they were probably generated from a whole-body scanner purchased from a special effects studio such as the Californian company Cyberware.

Like the silvery, slippery, 'liquid metal' T-1000 robot in *Terminator 2: Judgement Day* (1991) or the crowd that fills the dock scene in the opening sequence of *Titanic* (1997), the computer-generated figures have no referent in the real world. Virtual actors have also been used as extras in *The Patriot* (2000) and *Gladiator* (2000), in stunt scenes in *Titanic* and in the space-walk scenes in Clint Eastwood's *Space Cowboys* (2000). These are not actors playing a part; they are what is known in the industry as 'synthespians', 'cyberstars' or 'vactors' (virtual actors), enacting the parts of

extras, parts that, until these movies, were played by real people. Various actors have expressed concern about these developments. Tom Hanks has stated that he is 'very troubled' . . . 'But it's coming down, man. It's going to happen. And I am not sure what actors can do about it' (Hanks 2001).

When film was first invented, at the start of the twentieth century, it was hailed as a spectacular and uniquely modern form of entertainment. It brought together the mechanical and mystical—it was a new form of technology that created the illusion of living characters whose images flickered magically on the screen before the astonished gaze of the subject. The cinema operated on many levels. It could create a comforting illusion of the real world; a universe which did not obey the laws of time, space or movement; a surreal stream of images that seemed to match the movement of the unconscious. The technology of camera and celluloid film stock combined with actor and director to create a world which now—at the start of the next century—is about to be transformed by another phase of technological development which should prove equally astonishing. In the future there will still be movies, but no celluloid. If there is one thing that everyone working in the industry agrees on, it is that the cinema of the future will no longer depend on film (McQuire 1997, p. 41). The beginning of the twentieth century saw the birth of the mechanical camera: the beginning of the twenty-first century appears to be witnessing its death.

Digital technology has already revolutionised the cinema: first, in relation to new modes of film production such as picture imaging, sound and editing; and second, in relation to new modes of audience reception, themselves caused by new film forms— the blockbuster, interactive CD-ROMs, the digital creation of virtual worlds. Celluloid cinema dramatically altered the relationship of the individual to reality; the computer-generated virtual image is about to change that relationship once again, and in equally profound ways. Through special effects (animation, miniaturisation) it was once possible to create objects and things which, although creatures of fantasy, did have referents in the real world—objects, drawings, clay figures. Now it is possible to create computer-generated objects, things and people that do not

have referents in the real world but exist solely in the digital domain of the computer. In other words, film has been freed from its dependence on history and on the physical world. Central to these changes is the possibility of creating a virtual actor, of replacing the film star, the carbon-based actor who—from the first decades of the cinema—has been synonymous with the cinema itself. In the future, living actors may compete with digital images for the major roles in the latest blockbuster or romantic comedy.

At the moment, computer-generated images are used either obviously or dramatically to create astonishing special effects, such as the T-Rex chase and creature stampede in *Jurassic Park* (1993), or invisibly, to construct particular moments, such as the digital crowds in the opening sequence of *Titanic*, or to produce feature-length adventure films such as *Final Fantasy: The Spirits Within* (2001), which features an entire cast of hyper-real actors. Based on a Japanese video game, *Final Fantasy* stars Dr Aki Ross, who struggles against alien invaders who are determined to destroy Earth. Described as 'hyper-real', as distinct from 'photo-realistic', the virtual heroine represents Hollywood's most realistic attempt yet to create a fully digital character. Each of the 60 000 hairs on her head is controlled by a computer program, and this program can move each one independently of the others, depending on what the action calls for. Body movements and skin textures appear natural and the lip-synch technique is near perfect. However, all such characters are not completely convincing as 'actual' or real stars—they all have a slightly artificial look, most pronounced in close-up shots. *Final Fantasy* took four years to produce, and used a crew of over 400 people under the direction of Japanese computer-game master Hironobu Sakaguchi.

Although a film with a computer-generated or virtual film star—indistinguishable from an actual star—in the main role has not yet been made, this appears to be the future. A digitised film star is a studio's dream—capable of performing any task, continuously available, cost effective, and causing no scandals, unless, of course, the digital star is given an off-screen life in order to keep alive other areas of the film-star industry such as fan magazines, merchandising and promotions. The possibility of digital stars

playing the roles of main characters in feature films may sound far-fetched, but the signs are there.

In 1987 the Kleiser-Walczak Construction Company commenced the Synthespian Project. Its aim was to 'create life-like figures based on the digital animation of clay models' (McQuire 1998, p. 14). It has been possible for some time to digi-tally paint an actor's face onto another actor's body when the unexpected occurs—such as the death of Brandon Lee during the filming of *The Crow* (1994). A number of scenes were finished in this way. Digital technology was also used to complete the role of Oliver Reed, who died during the filming of *Gladiator*. In 1997 George Lucas's company, Industrial Light & Magic, commenced work on constructing a composite virtual actor—a synthespian made up of the bodily parts of different actors. Prior to the Brandon Lee 'resurrection', the Californian Senate drew up what has become known as the 'Astaire Bill'. The widow of Fred Astaire—backed by the Screen Actors' Guild—sought to restrict the use of computer-generated digital images of her famous song-and-dance husband. Alarmed at the possi-bility of such restrictions, the studios opposed the legislation. The legislation still has to be finalised, but it seems that it will be legally possible to digitise dead stars in the future (Barber 1999, pp. 16–19). Companies such as Virtual Celebrity Produc-tions have already purchased the rights to use images of a number of famous stars, including Marlene Dietrich and Vincent Price. No doubt living stars may, in the future, sell the rights to digitise their images after their retirement and/or death. Arnold Schwarzenegger's famous threat, 'I'll be back', may take on new meaning.

In 1998, the first posthuman talent agency was established by Ivan Gulas, a clinical psychologist from Harvard, and Michael Rosenblatt, co-founder of the Atlantic Entertainment group. Gulas, a specialist in 'the correlation between human emotions and expression' brought Justine, the company's first synthespian, to life using software designed 'to recreate human cells for medical imaging'. According to Gulas, they were 'even able to wrinkle skin so it behaves like real tissue' (Daly 1997, pp. 201–5). Studios are already able to purchase whole-body

scanners to create synthespians for crowd and group scenes from Cyberware. Synthespians have already been used in *Star Trek IV: The Voyage Home* (1986) and *Titanic* (Pescovitz 1998, p. 153). Whether or not it will be possible to create a synthespian capable of giving a fully convincing, nuanced, intuitive human performance is another matter, and one which gives rise to differing opinions. There is no doubt, however, that the presence of cyberstars in films will significantly alter the relationship between the spectator and the image.

Eyes Wide Shut is interesting to consider in this context. Stanley Kubrick's film is based on a novel written in 1926 by Arthur Schnitzler, called *Traumnovelle (Dream Story)*. The title, *Eyes Wide Shut*, suggests a state of dreaming, of seeing a flow of images with one's eyes shut. The film offers an intriguing blend of the real (an actual and well-known couple playing a fictional couple), the imaginary (the narrative of sexual desire and fantasy) and the hyper-real (computer-generated characters in the orgy scene). Although the studio was responsible for the digital alterations, the 'invisible' presence of computer-generated actors in a film about a dream world invites us to speculate about the possible effects the presence of virtual stars will have on audiences. If there is a mix of living stars and synthespians, will the presence of the latter affect the way in which the spectator relates to the former? Will audiences relate differently to the synthespian because the digital star is not human, but is instead an idealised image of those qualities thought to signify star quality?

In choosing Tom Cruise and Nicole Kidman, Kubrick was perhaps playing a little with his audience. With their ideal looks, perfect bodies, star qualities, fame, wealth and exotic lifestyle, Cruise and Kidman seemed to epitomise the Hollywood dream. It is not difficult to imagine that the Cruise–Kidman duo might have offered a perfect combination on which to model a synthespian couple. They could well have signed a lucrative deal to sell their 'images' as the basis for creating a synthespian duo in the future—a duo whose performances could continue well after the living actors were dead. Cruise, in fact, plays a character in *Eyes Wide Shut* who lives on the surface of things, who is in desperate need of a bad dream, a nightmare—an unconscious,

perhaps—to wake him up to the possibilities of the real world. The possibility of the flesh-and-blood actor being replaced by a virtual actor—whether based on a famous dead actor or totally created within the computer—across all genres has interesting implications for a number of areas of theory that are of interest in film and media studies.

In *Acting in the Cinema*, James Naremore defines acting in its 'simplest form . . . nothing more than the transposition of everyday behaviour into a theatrical realm' (Naremore 1988, p. 21). It seems that computer-generated actors have already been able to enact 'everyday behaviour' in a relatively convincing manner. Most audiences are blissfully unaware that they have been watching synthespians performing in films such as *Star Trek IV: The Voyage Home, Titanic, Eyes Wide Shut* and *Space Cowboys*.

But could cyberstars perform with great emotional intensity a range of feelings from the most subtle to the most powerful? The famous experiment by the Russian director Kuleshov during the silent period suggests that this might be possible. Kuleshov wanted to demonstrate that it is the spectator who 'reads' emotion into the situation on the screen. He shot footage of the expressionless face of an actor juxtaposed or edited alongside different scenes (a coffin, a small child, a bowl of soup) designed to evoke emotions. The plan was to create the illusion that the actor was performing with great emotion when in fact his expression did not change from one scene to the next. Audiences praised the actor's wonderful ability to express grief in relation to the scene with the coffin, tenderness with the small child and hunger in relation to the bowl of soup. The emotional impact of each scene was created through the editing process and the willingness of the audience to read emotions into the three different scenarios. It seems likely that a virtual actor would perform exceptionally well in a similar experiment.

Certainly, it would not be difficult to replicate the action performances of a blockbuster hero such as Arnold Schwarzenegger. Given that Schwarzenegger has successfully played the role of a cyborg (*The Terminator*, 1984) without changing his normal acting persona, it should be relatively easy for a cyberstar to play

the action-packed blockbuster roles of a figure such as Schwarzenegger. But could cyberstars give performances that would elicit total audience identification? Could they capture an audience and hold it spellbound? At this point in time, it is impossible to answer such a question—although some theorists and filmmakers argue that such a scenario is not possible. According to Ross Gibson:

> . . . acting is an extraordinarily holistic, intuitive, improvisational display of intelligence . . . not everyone can be an actor, because not everyone has that type of intelligence which is emotional, intellectual and bodily. Certainly not every digital animatromics operator is going to have that kind of intelligence . . . actorly intelligence is an extraordinary thing . . . I don't think it's going to happen (cited in McQuire 1998, p. 8).

But what if it did? In her discussion of science fiction, Michele Pierson states that 'one of the most powerful discourses' on the new technologies relates to the possibility that 'this technology might one day produce images that are so realistic it is impossible to distinguish them from objects in the real world' (Pierson 1999, p. 167).

French theorist Jean Baudrillard has written eloquently about the attack on reality in the postmodern age of the replica and perfect copy. He would no doubt denounce such a possibility as another instance of the 'death of reality' (Baudrillard 1983, p. 8). But how important is the question of 'reality' in relation to representation? The power of technology to alter reality has always been an integral part of the cinematic process. In the coming era of digitised representation, the crucial questions are less to do with reality than communication. The important thing—as Miriam Hansen has argued—is not to deny the aesthetic of the day but to try and understand and relate it to one's own experience (Hansen 1999, pp. 94–110). At the moment, postmodern audiences are still fascinated with the digital special effects associated with blockbusters such as *Jurassic Park*, *Star Wars: Episode II* (2002), *The Lord of the Rings* (2001) and *The Matrix* (1999). Eventually such effects will be taken for granted, just as the appeal of earlier

special effects lost their novelty in the early decades of the cinema (Pierson 1999).

However, the presence of the synthespian in film is not meant to be perceived by the audience as a 'special effect', as animated characters are, or to draw attention to itself; the virtual or synthetic origins of the star will have to be rendered invisible by the text in order for the character to offer a convincing, believable performance—even if in a closed context. According to Scott McQuire in his important study: 'The most noticeable change is that the credibility of CGI is now judged not against "reality", but "camera-reality". This reflects the extent to which camera-based images have been internalised as a standard of true representation' (McQuire 1997, p. 5). But even if the new measure of assessing reality becomes that of the virtual world, the desire for realistic performances will remain a key factor.

END OF THE UNCONSCIOUS

One thing on which all commentators agree is that digital film has a markedly different look from celluloid. The flow of computer-generated images has a greater potential to appear seamless. The image itself appears to lack depth; it has a plastic look. A director can touch up a virtual actor's face—remove or add blemishes, enhance skin colour, accentuate bone structure, deepen eye colour. However, the artificial characters are not completely life-like; a certain plastic look betrays their origins, as evidenced in *Final Fantasy*. Hollywood is confident that eventually the techniques will be perfected, so that a synthespian will be indistinguishable from a human actor.

Will the non-human origins of the cyberstar make a difference? Some figures from the acting industry claim it will, that digital characters do not possess that 'human spark' (Philpot 2000, p. 55). What difference will it make if the spectator knows that the actor, or composite actor, who appears to be a figure of flesh and blood was 'born' in a virtual world? Will this knowledge affect the degree to which audiences will/can identify closely with the cyberstar? Obviously the cyberstar does not have a mind—conscious or

unconscious. The reasons audiences identify with stars are extremely complex (see Mulvey 1989), but perhaps one factor is that the spectator identifies because she/he recognises and empathises with the star—as distinct from the character—as a fellow human being, someone who has been through a similar set of life experiences. Those who read books of course identify closely with characters, and film spectators have always identified with animated characters, but perhaps the power of cinema is so strong because viewers identify with both character and actor.

The cyberstar is not subject to the same experiences as the living star—experiences such as birth, mothering, separation, loss, ecstasy, desire and death. The cyberstar has not been through a process of being civilised, of learning to repress anti-social behaviour or taboo wishes. In short, the synthespian does not have a conscious or an unconscious mind. It is the latter—the unconscious—which is crucial in the formation of the self, and which binds us together as human beings.

In *Final Fantasy*, the first feature film with virtual stars, the narrative actually draws upon the notion of an unconscious to initially establish the heroine, Dr Aki Ross, as 'human'. Aki is unique because of her ability to communicate with the aliens through a series of dreams. Carrying an alien infestation in her body, she is troubled by repressed emotions and disturbing nightmares. In other words, Aki is marked out as different from her virtual companions because of her 'infestation' and her 'nightmares'. She is 'human' because she has an unconscious. Does Aki's different status encourage the spectator to identify with her more strongly than with the other virtual characters?

How much of the power of the experience of identification is derived from the spectator's awareness—conscious or not—that the star as person and as character on the screen has undergone experiences common to the human subject? In her discussion of computer-generated space, Vivian Sobchack argues that virtual space is marked by a new flatness or depthlessness, which critics such as Fredric Jameson have argued is endemic to post-modernism (Sobchack 1987, pp. 225–6). To what extent will the virtual nature of the star's image (the lack of 'humanness' and an

unconscious) induce in the spectator a sense of depthlessness in his/her relationship with the figure on the screen? Perhaps this will make little difference to the spectator, eager to be transported into the life of the character, regardless of the latter's origins. As Fredrich Kittler has stated: 'The unconscious then, in keeping with its definition, develops artful strategies' (Kittler 1997). Who is more artful, then, than the cinema spectator?

In her famous essay 'Visual pleasure and narrative cinema', Laura Mulvey argues that the 'cinema satisfies a primordial wish for pleasurable looking'—not just looking at any human figure, but at the glamorous, erotic star. 'Stars provide a focus or centre both to screen space and screen story, where they act out a complex process of likeness and difference (the glamorous imper-sonates the ordinary)' (Mulvey 1989, p. 18). In particular, Mulvey is interested in the way in which the female star is represented as a 'perfect product'—her body, 'stylised and fragmented by close-ups, is the content of the film and the direct recipient of the spectator's look' (Mulvey 1989, p. 22). The potential of the new cyberstar—male and female—to be constructed as a 'perfect product' is enormous. Given the iconic qualities that Mulvey notes are associated with the close-up, the spectator may easily surrender to the hypnotic power of the 'perfect product' on the screen. But the problem of depth—in relation to the image, the origin of the synthespian and the identificatory relation-ship—remains. Will the spectator experience an excess of pleasure in identifying with the cyberstar, subjecting the image to his/her erotic look, or will the spectator feel removed or distanced from the image on the screen because he/she is aware that the figure is not human, that it is an image which dwells permanently in the imaginary, totally removed from the symbolic order of loss, trauma and death? Knowing that a cyber-star cannot die in the human sense must, surely, affect the way in which the spectator responds to his/her appearance, partic-ularly the star's beauty—a quality whose meaning always invokes its opposite, the threat of loss of beauty brought about by ageing and death.

The potential for the cyberstar to epitomise a digitised form of beauty that is flawless, combined with the seamless nature

of the digital image flow, will create a clean, plastic cinema based on organisational modes of creativity rather than on a play of improvisation and intuition. McQuire states that many

> digital effects in contemporary cinema are concerned not to create the perfect image, but to reproduce a camera image, so they'll add flaws like edge halation, lens flair, motion blur, even grain. This suggests that our point of reference has changed. It's not the real world, but cinematic representations of the world, which have become our ground of comparison (McQuire 1998, p. 13).

Even if digital filmmakers add noise or texture to the image of the contemporary blockbusters, an impression of one-dimensionality may remain. The emphasis on spectacle and narrative tends to render the workings of the unconscious invisible. This tendency would become even more marked in films which featured cyberstars. If spectators relate to the screen as a site where they can play out their fantasies, it may make a significant difference if the characters on the screen are played by actors without a conscious or unconscious mind.

Perhaps it is this latter factor which has led to the transformation of the cyberstar into a virtual pin-up or object of cyberlust. Lara Croft, the exotic and lethal heroine of the *Tomb Raider* video games series, has become a sex symbol in her own right. Some might argue that she is more of a porn star. Her image is one of the most downloaded on the Internet. This may have something to do with what Emma Tom describes as her additional lethal hardware. Tom states that she is 'a gun-toting Indiana Jones-esque aristocrat with an interest in amateur archaeology (aka tomb raiding) and tits the size of cannon-balls' (Tom 2001, p. 17). The first *Tomb Raider* game was released in 1996—by 2001 world sales had soared to US$700 million.

Another virtual pin-up girl is Japan's Yuki Terai, who was uploaded to a computer animator's Website in 1999. She has become Japan's most popular multiplatform pin-up, and has starred in video games, films, music videos and trading cards. According to Michael Behar, she represents a perfect fantasy figure for males because she is completely 'non-threatening'

(Behar 2002, p. 45). It is not clear, however, that all virtual pin-ups are adored only by the opposite sex. Studies show that girls as well as boys are obsessed with Lara Croft, for instance. The fact that these two virtual stars enjoy the same popularity as actual stars suggests that fans are not unduly concerned about whether or not their fantasies are populated with flesh-and-blood icons or the more insubstantial kind.

One of the most potentially interesting sites for employment of cyberstars is the pornographic—partly because pornographic texts do not require stars with great acting potential, but also because pornography itself is bound up with the question of origins. The aim of the pornographic narrative is to capture and fetishise close-up images of sexual penetration, female expressions of orgasmic pleasure and images of penile ejaculation. The pornographic text is primarily an excessive representation of the primal scene, that is, the moment of heterosexual coupling. In pornography, however, there is no conception. Pornography offers a primal scene without the intent to create new life.

The cyberstar is ideally suited to pornography, particularly as the cyberstar will be able to enact with great ease the bodily contortions required to display close-up images of the act of penetration; in the new world of computer-generated images, all bodily actions, from the simplest to the most complex, will be reproduced by the computer. The new world of digital images will give rise to a new primal fantasy of origins in which human (desire) and nonhuman (stars) will be able to engage in continuous sexual acts. The cyber porn star will literally be a sex machine able to perform without interruption.

If pleasure in looking at the human form is tied to a desire to identify with idealised figures, film stars that are both ordinary and extraordinary, then this desire can clearly be met by the new digital screen technology. French psychoanalyist Jacques Lacan argued that when the infant first becomes aware of itself as separate from its mother (and father) and begins to create an identity for itself, the infant mistakenly assumes that it is just like its parents, and as such is capable of a range of adult actions that are actually beyond its reach. The infant misrecognises itself as more developed or perfect than it is in actuality. The moment of

recognition of self is—according to Lacan—a moment overlaid with misrecognition. This helps explain why individuals tend to identify with larger-than-life characters such as sporting heroes and film stars, even into adulthood. Because of its mistaken infantile belief in its own perfection, the human subject always yearns to be more perfect, more capable, more beautiful than is possible. The desire to be something that one is not, to possess someone that one cannot have, can never be satisfied.

Like the 'real' celluloid star, the new digital star might also offer an idealised image as the basis for spectator identification. Identifying with the glamorous, more perfect image on the screen, the spectator would be caught up in a moment of recognition and misrecognition—not between subject and an ego ideal (an actual star), but between subject and non-subject (a virtual star) which, strangely, may also function as an ego ideal. In his discussion of the 'sublime time of special effects,' Sean Cubitt raises the interesting possibility of special effects generating an image of the 'impossible real' (Cubitt 1999, p. 130). Perhaps the new viewing subject will be caught up in an 'impossible real' of the identificatory processes.

In this context, the experience of identification would be marked by a sensation of strangeness. The experience of strangeness is based on an alteration—sometimes almost imperceptible—of reality, a reconfiguration designed to create an odd, uncanny effect, as in the title of Kubrick's film—*Eyes Wide Shut*. In his essay on photography, *Camera Lucida*, Roland Barthes argues that in every photograph 'is the advent of myself as other' (Barthes 1984, p. 12). He links this other image to 'the return of the dead' (Barthes 1984, p. 9). Asked to identify with a cyberstar, the spectator would be haunted by a sense of strangeness; the image on the screen appears human yet is not human. The glamorous other is a phantom, an image without a referent in the real, an exotic chimera, familiar yet strange. In terms of the writings of French theorists Gilles Deleuze and Felix Guattari on becoming, on merging with machine, animal and other, it would seem that posthuman desire is possible, that we as spectators in the cinema may well identify with—and experience emotions on behalf of—the other self on the screen,

played by a computer-generated star. After all, we have been identifying since the cinema began with images—ghosts filtered through a play of light.

References

Note: An earlier version of this chapter originally appeared in *Screen*, vol. 41, no.1, 2000, pp. 79–86. I am indebted to the research of Scott McQuire on the nature and impact of the new technologies.

Barber, L. 1999, 'The vision splendid' *The Weekend Australian Review*, 25–26 September, pp. 16–19.
Barthes, R. 1984, *Camera Lucida*, trans. Richard Howard, Fontana, London.
Baudrillard, J. 1983, 'The precession of simulacra', in *Simulations*, trans. Paul Foss, Semiotext(e), New York, p. 8.
Behar, M. 2002, 'Multiplatform pinup girl' *Wired*, April, p. 45.
Cubitt, S. 1999, 'Introduction: le reel, c'est l'impossible: the sublime time of special effects' *Screen*, vol. 40, no. 2, pp. 123–30.
Daly, J. (ed.) 1997, 'The people who are reinventing entertainment' *Wired*, November, pp. 201–5.
Hanks, Tom 2001, 'Virtually an actor' *Herald Sun*, 10 July, p. 9.
Hansen, M. 1999, '"The future of cinema studies in the age of global media": aesthetics, spectatorship and public spheres' interview with Laleen Jayamanne and Anne Rutherford, *UTS Review*, vol. 5, no. 2, May, pp. 94–110.
Kittler, F.A. 1997, *Friedrich A. Kittler Essays: Literature, Media, Information Systems* (ed.) John Johnston, *Critical Voices in Art, Theory and Culture*, G&B Arts International, Netherlands, p. 53.
McQuire, S. 1997, *Crossing the Digital Threshold*, Australian Key Centre for Cultural and Media Policy, Brisbane.
—— 1998, 'A conversation on film, acting and multimedia: an interview with Ross Gibson' *Practice: A Journal of Visual, Performing & Media Arts*, no. 3, p. 14.
Mulvey, L. 1989, 'Visual pleasure and narrative cinema', in L. Mulvey, *Visual and Other Pleasures*, Macmillan, London, p. 18.
Naremore, J. 1988, *Acting in the Cinema*, University of California Press, London.

Pescovitz, D. 1998, 'Starmaker' *Wired*, October, p. 153.

Philpot, R. 2000, 'Unreal actors to invade film sets' *The Australian*, 5 September, p. 55.

Pierson, M. 1999, 'CGI effects in Hollywood science-fiction cinema 1989–95: the wonder years' *Screen*, vol. 40, no. 2, pp. 158–76.

Sobchack, V. 1987, *Screening Space*, Ungar, New York, pp. 225–6.

Tom, E. 2001, 'Titillated by Lara's biggest weapon' *The Weekend Australian*, 30 June, p. 17.

10

Crisis TV: Terrorism and trauma

'It's easy to O.D. on crisis TV.'—New York spectator interviewed on television

'But as DeLillo dramatised . . . it is difficult to discuss feelings when the TV speaks so loudly; cries so operatically; seems always, in everything, one step ahead.'—Zadie Smith, *The Age,* 2001

In the first decade of the twentieth century, author Virginia Woolf remarked that 'in or about December, 1910, human *character* changed' (Woolf 1967, p. 320). She was referring to the coming of modernity, and the fact that the qualities of human inventiveness, ingenuity and capriciousness—hallmarks of the new age—were about to transform the world forever. Nearly three decades later, just prior to the outbreak of the Second World War, Gertrude Stein uttered a similar sentiment: 'The earth is not the same as in the nineteenth century', she said (Stein 1984, pp. 49–50). Stein was attempting to explain the new radical style of modernist art and its refusal to conform to established norms. At 9.00 am on Tuesday 11 September 2001, the world was changed again, in ways that Virginia Woolf and Gertrude Stein would probably not have predicted.

When Islamic terrorists attacked the United States of America on September 11, they did so in a bold, unpredictable, unthinkable manner. They hijacked four passenger jets and flew two of them into the glass and steel twin towers of the World Trade Center in New York and the third into the Pentagon in Washington DC, causing a devastating loss of life. The fourth crashed into a field in Pennsylvania, also killing all on board. The terrorists used American planes and American people to kill other

Americans. Up to 50 000 people worked in the Center and between 150 000 and 200 000 passed through on any given weekday. The impact opened gaping fiery holes in the 110-storey buildings, New York's most famous landmarks; both towers eventually collapsed. The terrorists' plan was inspired less by the conventional 'rules of warfare' than by the kind of fantastic scenario one might expect from a Hollywood disaster epic starring Arnold Schwarzenegger or Sylvester Stallone. 'I had seen this before in various blockbusters. The debris, the smoke, the fireballs. On the one hand it was familiar, on the other hand it was a journey into the unknown' (King 2001, p. 2). Others likened the sight of the planes exploding inside the twin towers to an intensely surreal moment, unlike any other they had ever witnessed.

Many world commentators predicted that this unique act of terrorism would change the world forever. Nearly one hundred years after Virginia Woolf's prophetic statement, and after a century of dramatic, sometimes cataclysmic, change, the urbane sophisticated inhabitants of postmodern cities in the West had come to appear impervious to novelty or shock—until September 11. The European Union issued a statement saying that 'It was one of those few days in life that one can actually say will change everything'. An article in *The Australian* lamented the loss of the old era and the profound effect the attack would have on the relaxed lifestyles of liberal democracies worldwide (Sheridan 2001, p. 3). 'World will never be same again', asserted the headline, acknowledging the passing of a century of tradition. One of the reasons the terrorist attack had such an impact—apart from the terrible loss of life—was that at first it appeared beyond comprehension, too unbelievable; even the media seemed at a loss to deal with the horror.

Philosopher Raimond Gaita wrote about the *need* to demonstrate that the attack on the World Trade Center (he excluded the Pentagon) represented 'something new in our political experience', something which was essentially different from other terrorist acts. As well as the realisation that something 'horrifically new had happened, there came the realisation, saturated with dread, that the world would not be the same again'. But

Gaita himself did not see the attack as a 'watershed event' which would change the world forever. He argued that the attack was perceived as 'something new, frightening and awesome' because it made us aware of the world's failure to deal with the ethics of globalisation. Gaita was referring to 'the shameful gap between the rich and poor nations', as well as ecological issues, human rights and equality (Gaita 2001, p. 4). Social commentators argued that these factors were just as significant in trying to understand the reasons for the attack as those given by Al Qaeda: America's foreign policy in the Middle East and its support of Israel in its war against Palestine.

One article, 'When reality TV becomes too much', reported that some television stations were refusing to replay the footage of the attack because it was 'too horrifyingly real'. It pointed out that reality TV shows such as *Survivor* and *Big Brother* did focus on the 'darker side of human nature', but 'no one is going to pull out a gun and kill their fellow contestants' (Stewart 2001). Stewart pointed to the difference between the coverage of the attack and the conventional reality TV program (see Chapter 2).

One New Yorker interviewed in the days following the terrorist attack of September 11 described the presentation as 'crisis TV'. 'It's easy to O.D. on crisis TV,' she said in response to a question about whether or not the media were presenting too much information about the disaster. In her mind there was a clear distinction between the media's coverage of the attack and their normal coverage of the news, investigative journalism and reality TV. Like Stewart, she felt that September 11 did not conform to the reality TV format—it was somehow 'more real'. The most obvious difference between reality TV and crisis TV relates to intention: whereas reality TV's main intention is to present factual information as a form of entertainment, crisis TV is not designed to entertain.

It is notable, however, that CNN's packaging of the disaster gradually adopted some of the elements associated with entertainment, making it 'less horrifyingly real'. At first CNN did not have a title for the coverage; later it called the disaster 'America Fights Back'. One cannot miss the reference to *The Empire Strikes Back* (1980), the third film in the successful Star Wars trilogy, in

the choice of words—they gave the broadcast a fictional element normally associated with popular film. In a similar vein, the 'Desert Storm' television coverage of the war against Iraq recalled the post-World War II sub-genre of 1950s Hollywood movies, set in the Middle East, such as *Desert Hawk* (1950), *Desert Hell* (1958) and *Desert Patrol* (1958).

This chapter will discuss the characteristics of crisis TV in relation to the events of September 11. The reportage of the terrorist attack of September 11 did not create crisis TV; rather it drew attention to a new form of television reporting, aptly called 'crisis TV', which had emerged in the late twentieth century in response to greater public demand for more realistic television programs, particularly for programs dealing with the realities of human emotions and actual lived experiences. Crisis TV is a form that reflects the kinds of changes, such as the desire for shock, sensation and enhanced realism, brought about by the forces of modernity that Virginia Woolf was commenting on with some alarm when she pronounced that 'human nature' had changed.

Crisis TV is a news program which reports a disaster (war, terrorism, genocide, torture, flood, fire, tornado) in which human life is threatened and in which people die, often in a painful and horrific manner. It depicts a crisis situation which unfolds in the present and directly impacts on the nation, either because the disaster has taken place within the nation itself or because its citizens (living elsewhere) have been affected directly. The Bali bombings reportage also depicts scenes which cross the boundaries between what is bearable and what is unbearable for the viewers at home. Crisis TV confronts the abject, or what Julia Kristeva defines as that which lies 'beyond the scope of the possible, the tolerable, the thinkable' (Kristeva 1982, p. 1). The crisis is immediate and palpable. One journalist who was report-ing on September 11 stated that in the past he had been able to describe the most horrific of events, but that in this situation he felt at a loss, unable to control his feelings. 'For the first time in memory, I didn't react to the news as a journalist first. I still feel unnerved by the events I've watched over and over on television' (Pegler 2001, p. 2).

News film of terrorist attacks in the non-western world (such as on US embassies in Nairobi, Kenya and Tanzania) or of terrorist attacks in the West (IRA bombings in London) have not really prepared audiences in America for such a large-scale attack at home. The horror of terrorism which has haunted other nations for decades has now become, for many, a recognisable part of daily reality in America. This does not mean that coverage of world atrocities in other parts of the world is not equally—or even more—tragic, but rather that those which occur in the homeland are perceived to be more so because they speak personally to the viewer. Viewers in Muslim nations, and in the West, watching images of the American bombings of Afghanistan no doubt have also experienced horror at the sight of civilian deaths.

Since 1996, with the founding of Al Jazeera, described as 'the first independent, professional pan-Arab news outlet', Muslim nations have been able to view the wars in the region via a non-western news service. According to one report:

> US officials are upset that Al Jazeera has shed daily and gruesome light on the civilian death toll wrought by the bombing, which the western press has studiously played down. The carnage dismissed as 'ridiculous' by US Defence Secretary Donald Rumsfeld has been on live, 24-hour display to more than 40 million Arab homes.

Hussein Ibish and Ali Abunimah argue that attempts to discredit Al Jazeera are extremely troubling, particularly as the television station signifies a move towards greater 'openness and democratisation in the Arab world. It is long overdue, a two-way street in the global flow of information and opinion' (Ibish & Abunimah 2001, p. 15). With its less interventionist attitude to the kinds of images which can be shown, Al Jazeera's brand of crisis TV is decidedly confronting.

Crisis TV is distinguished by its immediacy. One newspaper article argued that America would never be the same again, not because it was the nation's bloodiest day (that took place in the Civil War), nor because it signalled the country's first loss of innocence (that occurred with Kennedy's assassination), but rather because the events were so shocking because of the presence of

television—'perhaps this was the most shocking day, amplified by the immediacy and ubiquity of television' (Eccleston 2001a, p. 3). Crisis TV draws most powerfully on the media's ability to present 'live' experiences. Our desire for immediacy—a hallmark of modernity—has inspired the creation of on-location filming, new digital media forms, the Internet and virtual reality formats. Televised news programs also attempt to fulfil our need for immediate experience, yet they also constrain the images of the crisis through their deployment of media formats such as split screens, text, graphics, and Website addresses.

Media coverage of September 11 has been described as 'reality TV', but it differs from reality TV in a significant aspect. Where reality TV seeks to reveal all the minutiae of an event in great detail, crisis TV does not reveal everything. Quite the opposite. Because crisis TV by definition reports on a crisis, it is dealing with very confronting, often shocking, material, including images of torture, rape and murder. Crisis TV seeks to control, order and regulate its material. Reality TV, which does not usually depict life and death disasters, also edits and organises its material but, unlike crisis TV, does not usually attempt to contain or censor material that might upset the viewer.

In crisis TV, scenes of the disaster appear transparent, seeming to unfold as they happen—in reality, the coverage has been carefully edited. Crisis TV is marked by a deliberately constructed transparency. This is very evident in CNN's reporting of September 11. If one compares newspaper reports of the devastation at the World Trade Center with television images, it is evident that most of the truly horrific sights were not displayed. One firefighter reported that 'it is unimaginable, devastating, unspeakable carnage.' Another said that he came across 'body parts by the thousands', while yet another stated that he 'lost count of all the dead people' he saw. 'It is absolutely worse than you could ever imagine' (Spencer 2001, p. 3). The streets around the towers were strewn with the bodies of those who had jumped. For weeks New Yorkers could smell the burning flesh from the bodies buried in the mountainous piles of rubble. The coverage provided by television carefully avoided showing scenes of chaos, images of body parts, mutilated corpses, the dead

and dying. A documentary filmmaker who was in the basement of the first tower said in the voice-over of his completed film: 'I hear screams. To my right there are two people on fire, burning. I didn't want to film that. It was like no-one, no-one should see this' (Naudet & Naudet 2001). Whereas the philosophy behind reality TV seeks to capture everything, particularly in relation to the behaviour of people (see Chapter 2), crisis TV aims to broadcast actual crises while editing out the most disturbing images. Crisis TV does not aim to shock beyond what it thinks is bearable.

Camera operators and editors are able to edit out horrific images almost instantly. Because like all TV, crisis TV 'hides' its modes of production (the processes of editing, the selection of images), the viewer is given the impression that the events are unfolding as they actually happened. In actuality, crisis TV is 'constructed' to ensure that images from the devastation are not too unbearable to watch. Television's desire for graphic abject pictures is outweighed by an equally strong desire not to shock the audience beyond endurance. When presenters are concerned about distressing viewers, they warn them that forthcoming sequences might disturb or offend.

The role of the news presenter is crucial in crisis TV. CNN's coverage was delivered by Aaron Brown. During the events, Brown was positioned downtown; he occupied part of the screen while images of the burning World Trade Center either appeared in the background or sometimes took up the entire screen. He commented on the tragedy, introducing interviewees, announcing new details as they came to hand and delivering information in voice-over when the images filled the television screen.

The visual format of the TV screen also helped organise and contain the chaotic events. A line of teletype, which read 'Breaking News', ran continuously along the bottom of the screen; underneath it a second line of type gave a summary of the most recent developments as they came to hand. 'Attacks against targets in New York and Washington', it read. When the footage was 'live', this was announced with the words 'live' posted in the two top corners of the screen. Images of the two towering infernos filled the screen, intercut with the footage of the second plane hurtling into the tower and erupting in a fiery ball on the other side. When

scenes of the attack which had taken place earlier were broadcast, the word 'earlier' appeared on the screen, no doubt to prevent viewers thinking the attack was happening at that moment and panicking. Media outlets have always been aware of the national panic that occurred in 1938, when Orson Welles dramatised H.G. Wells' science fiction novel, *War of the Worlds*, on radio. So convincing was Wells' broadcast, it caused a national panic as terrified citizens took to the streets to flee the alien invaders.

Although Brown described his response, he kept his emotions under control. The most emotive statement he made was in relation to the images of the second attack. He said: 'You can see the plane coming in from the right hand side of the screen going into the tower itself. This is an extraordinary and troubling piece of tape'. Brown described the events carefully. He made it clear whether or not the information had been verified. He conducted interviews with other reporters closer to the site. Brian Palmer described the collapse of the second tower. 'We watched one of the towers of the World Trade Center disappear from the skyline. It basically folded into itself in a plume of grey smoke. A crowd of thousands of people dashed up Broadway, followed by emergency services personnel. That's all we know now.'

Brown carefully orchestrated the media coverage, introducing witnesses, thanking them, assuring the public that everything possible was being done to aid the injured, telling the viewers to pray for families of anyone affected by the tragedy. One commentator stated that this was 'the kind of moment you hope will never come'. Brown prepared New Yorkers for what they would see in the future: 'It's an unbelievable scene as you look down, and we stand here at the same point every day looking out at this city at this time of year. It's extraordinarily pretty, and you see those two buildings high above lower Manhattan, and you look out there today and you see this gaping hole . . .'.

The presenter of crisis TV functions as a guide who escorts the viewer into the disaster area. When events are chaotic and the origins and outcome of the crisis are unknown, the lack of knowledge is likely to leave viewers confused and distressed. In crisis TV the presence of an anchor-figure is crucial. It was clear that

the presenter did not have a pre-prepared script, but he was extremely skilled at appearing to be in control. In taking the audience through the tragedy, the presenter effectively crossed boundaries between the normal and abnormal, the world of the living and that of the dead. In this sense crisis TV performs the role of a liminal guide, one that accompanies the viewer into an underworld of horror and pain but ensures that the journey is not too unbearable to watch.

In the TV coverage of September 11 the media posed the most important questions, which many viewers had already asked themselves. How can those who are suffering be helped? Who is responsible? Why? Could this have been avoided? The media enabled individuals to come together in a communal experience of reliving events, examining responses, seeking resolution and closure.

The director of the program was also careful not to screen many eyewitness accounts of the attack on the World Trade Center. In the first three hours of broadcasting, CNN only included one eyewitness interview with a member of the public. The sequence commenced with handheld camera shots of what was happening on the streets. People were running in all directions, dust and rubble covered everything, emergency personnel were trying to penetrate the scene. The camera movements became very jerky. The picture broke up. Suddenly a young woman came into focus. She described what she saw. 'We heard a big bang. We saw smoke. Everybody started running. And we saw a plane on the other side of the building.' Her voice verged on the hysterical as she focused on the events which troubled her most intensely—what was happening to the victims, not the buildings. 'People are jumping out the windows. Over there. People are jumping out the windows. I guess because they're trying to save themselves. They were telling us to get out but there is nowhere to go. And then another plane hit. If you go over you can see people jumping out the windows. Oh God!'

At this point the broadcast cut abruptly from the interview to a television studio in Melbourne, where Tony Jones (Channel 2) was coordinating the coverage from Australia. This horrific eyewitness account conveyed information more shocking than

anything before it; Aaron Brown's studied presentation did not/could not prepare the viewer for such a shocking revelation about people jumping to their deaths. Although CNN repeated three or four sequences from the disaster again and again (the plane hitting the second tower, two women crouching beside a car, people running in the streets) it did not repeat this episode.

In a discussion on CNN, four days after September 11, participants talked about the power of the image. One commented that too much reality was distressing. Another stated that 'Vivid images help people move past disbelief and move on to grief'. It was agreed that there is a fine line between showing too much and too little. One newspaper journalist touched on the symbolic role of repetition in crisis television: 'The images of destruction will be played and replayed. Bit by bit, all across this boldest, most confident of countries, eyes are blinking as brains slowly understand their country will never seem secure for many a long year' (Eccleston 2001b, p. 2). Even so, the media did not broadcast the most shocking of the images in this crisis.

It is instructive to compare the reportage by CNN with the documentary *9/11* (2002), shot by two French brothers, Gedeon and Jules Naudet, who were stationed with one of New York's firehouses, where they were making a film about a probationary fireman. The final feature-length documentary included on-the-spot footage of the disaster, the work of the firefighters, reactions of people on the streets, interviews with firefighters and sequences of two brothers talking to the camera about their own responses and feelings.

Jules, who had accompanied a group of firefighters on a routine call, was on the streets near the World Trade Center when the first jet ploughed into the building. He shot the only known footage of the first attack. The camera work is crude and jerky but the lack of sophistication seems to give the image greater force. Jules tells us he rushed with the firefighters to the towers, where the men occupied the basement. Gedeon, who had remained at the firehouse, headed for the streets, where he filmed the responses of the people to the unfolding disaster. As mentioned earlier, Jules could not bring himself to film the victims of the fire. Instead he focused on the work of the firemen. The

footage creates a powerful sense of immediacy and urgency. As we watch, we hear the sounds of objects crashing to the ground. Jules explains in voice-over:

> The chiefs didn't want anyone going out through the lobby doors. First it was because debris was falling outside. Then it was people falling. You don't see it but you know where it is, and you know that everytime you hear that crashing sound it is a life which is extinguished. That's something that you couldn't get used to. And the sound was so loud. Everyone was looking up and thinking, how bad was it up there that the better option was to jump?

The film is difficult to watch, not because of what the viewer is able to see, but because of what cannot be seen but can be heard—the falling bodies hitting the ground.

Compared with the CNN coverage, *9/11* is much more powerful, capturing the immediacy and urgency of the crisis. The fact that the camera lens is covered with dust and the images are often impossible to make out through the grime only heightens the impact of the footage. There is nothing like this on the CNN coverage. Even though the documentary had been subsequently edited, and included interviews with the firemen shot after the event alongside the tale of the probationary firefighter finally earning the respect of the men, it retains a strong sense of immediacy. *9/11* also takes the viewer on a journey into an underworld, but without the guiding presence of a news presenter; it clearly illustrates by contrast the heavily constructed nature of crisis TV.

Crisis TV almost always involves a lack of closure. Because the disaster taking place is unfolding largely in real time, there is no immediate possibility of closure. In some instances, the viewer is left waiting—weeks, months, years—for final closure. It is possible that closure may never take place. The media impulse, however, is to present dramatic events in a narrative form which always offers the promise of closure. Hence, the option of closure is conveyed in small doses. The first possibility of an intermediary closure was structured around the search for survivors. The chance that rescue workers might find survivors held out hope for a small victory. Shortly after, the Pres-

ident and his advisers offered the promise of a more definite closure. It was announced that America was at war. This was not, however, a conventional war with a clearly identifiable target. The United States declared war on terrorists and those states which harboured them. The President announced that the war might take years. The inability to provide closure led to the policy of replaying key moments and repeatedly analysing the terrorist attack itself. Because the events were so horrific, the repetition was effective. Viewers reported they were still 'glued to their screen' weeks after the attacks. In its desire to present an impossible closure, crisis TV appears in control of the narrative, structured in the manner of fiction, but is ultimately at the mercy of the real.

Watching films which deal with terrorism and violence, and which have closure, may offer catharsis to the viewer. This may explain why, in the days and weeks after the attacks, video rentals of disaster epics, in Washington and New York, rose by 30 percent (Lusetich 2001). Popular titles were terrorist movies such as *True Lies* (1994) and *Die Hard* (1988). The documentary *The American Nightmare* (2000) explored the relationship between viewing horror and catharsis. Directors such as John Carpenter, Tobe Hooper and George A. Romero explained that the main reason they made horror films was to try to come to terms with their experiences of the Vietnam war, the civil rights movement and the peace protests. Public interest in disaster epics suggests that audiences similarly use fictional narratives about violence to resolve anxieties and to think through the often violent nature of their own societies.

Much has been written in recent years about trauma, and about those individuals who, as a result of experiences of war, violence, torture, loss and other disasters, must live with trauma as a daily reality. Crisis TV reports on life events which are so extreme they leave many survivors in a state of trauma. Studies of the survivors of the Second World War, Vietnam and the Gulf War have revealed that apart from their horrendous experiences, they also had to endure a lack of recognition of their suffering when the war ended and they tried to return to 'normal' life. In addition, many of these people returned to discover that their

family, community and social life had also been destroyed. For many the return to society represented a new form of traumatic experience.

One way in which those who suffer trauma have been helped is through the process of storytelling. By telling their stories of the events which left them emotionally and mentally wounded— and being listened to—many survivors find a means by which they can come to terms with what has happened to them (Rogers et al. 1999). Telling stories also offers a means by which others, family and society, can acknowledge what has taken place. Steven Spielberg's Survivors of the Holocaust Visual History Foundation, established in 1994, aims to videotape the experiences of as many survivors as possible and place them on an Internet site so they will be available to all. The amazing success of this project indicates the importance of bearing witness. *The Stolen Children: Their Stories* (Bird 1998) contains written stories about the personal experiences of Australian Aboriginal children of mixed descent (formerly called 'half-castes') who were forcibly taken from their parents and placed into institutions or adopted into white families as part of a government policy of 'breeding out the black'. The stories are a testimony to their emotional and physical sufferings (many were victims of physical and sexual abuse); in addition, their stories have placed the issue firmly in the public arena through a number of television documentaries. Bearing witness has the additional effect of addressing official denial and public amnesia.

In New York, survivors and witnesses of the September 11 attack placed their stories on a Website called 'New York City Stories' (nycstories.com). The website encouraged people to write about their ordeals and to describe their feelings as they wrote. One woman described her feelings as she tried to contact her husband, a New York fireman. Another explained how he escaped the inferno by minutes because he arrived late for work. A young boy described how he wept for the people he saw jumping from the top floors of the towers: 'There were people jumping out, slowly tumbling. Humans . . . with families and thoughts, ideas, goals, and they're going to die now, they're dead now. Imagine groups of people jumping, falling. I cried for them,

witnessing their last moments' (Pasmantier 2001). In this partic-
ular disaster, survivors were interviewed on television about their
feelings and their loss. Telling one's story on television or the
Internet is seen as an important way for survivors, witnesses and
those who lost family members to tell their stories and so help
ease their pain.

As well as personal trauma, Americans also shared a trauma
of collective distress. In the *New York Times*, journalist Peter Marks
described the sight of Ground Zero as 'something lastingly trau-
matic to the eye', because the absence of the twin towers constantly
evokes their lost presence. He quoted documentary filmmaker Ric
Burns, who described the experience for New Yorkers of losing
the twin towers of the World Trade Center as one of bodily loss.
'It's our phantom limb. You feel it, but it's not there; you look to
where you feel it should be.' To Marks, the loss has created a
'psychic wound'. 'It is as if the city, in the myriad individual
responses, is struggling collectively with how to treat its psychic
wound, how to gaze anew at a landscape that doesn't quite look
like itself' (Marks 2001, p. 13). The personalised nature of much
crisis TV can be partly explained in terms of a modernist impulse:
the desire to engage in self-reflection and self-scrutiny and to re-
tell the events from the perspective of the ordinary citizen, the man
and woman on the streets, those to whom the city itself is 'home'.
With its emphasis on presenting interviews, encouraging people
to discuss their feelings, crisis TV reflects this impulse.

The power of the image is so pervasive in western culture that
it's almost impossible to view scenes—even those of a disaster—
without reference to other images. In this sense, crisis TV
sometimes assumes a postmodern style of reportage in which the
immediate images seem to refer to an older stock of images. Scenes
of war or of natural disasters such as earthquakes often appear
to refer back to Hollywood movies on the same topics. This was
particularly true of September 11. To the viewer who has been
brought up on mediated images of disaster, and who has difficulty
in separating the real from the fictional, these scenes conveyed a
sense of the uncanny, that is, something which is 'both known and
unknown, real and unreal'. 'The only reference I had to what was
happening outside my window was the world of entertainment,

a world mostly created by the US' (King 2001, p. 2).

People in the United States who were watching TV saw the second jet crash into the South Tower in real time, as it happened; they have reported that at first they thought it was a media hoax. Some viewers in Australia, who had just finished watching *The West Wing* (Channel 9, 10.30 pm), a fictional, satirical television series set in the White House, suddenly saw scenes of the attack on the World Trade Center and the Pentagon and thought they were part of the preview for the next episode. Two American planes slamming into the World Trade Center, vast burning holes opening up, people throwing themselves from the towers to escape, the twin towers collapsing—the scene was simply incomprehensible. It was easier to believe it was a movie like *Independence Day* (1996), in which America is invaded and the aliens destroy the White House. Even the scenes of terrified people running away from the carnage towards the camera looked like scenes or clips from *Independence Day*.

Once accepted as real, the images become impossible to erase from consciousness. They also attain an iconic status such as that given to fictional images from film. The image of the relatively small hijacked jets hurtling into the gigantic twin towers and bringing them down is reminiscent of the well-known still from the 1933 film *King Kong*, in which the giant ape clings defiantly to the Empire State Building while airforce planes buzz around it, spraying forth streams of bullets. In both instances the alien 'other' is seen attacking symbols of the American way of life. It is sometimes difficult not to measure the key images of crisis TV against those which have emanated from the Hollywood dream factory and have achieved iconic status.

With its instant ability to assemble images, film footage, interviews and explanations in order to re-create events, crisis TV has become an essential part of daily life in a world where disasters—natural and unnatural—have become commonplace. In order to prevent public panic, crisis TV has adopted an interventionist style, deleting images which might shock or traumatise the viewer. Some might argue that the media should not censor images but rather let the viewer decide what she or he can endure. T.S. Eliot wrote in *Four Quartets* ('Burnt Norton') that human kind

'cannot bear very much reality'. Crisis TV seems to have taken this dictum to heart, although the poet may well have intended his observation not as a statement of fact but as a lament.

References

Barber, L. 2001, 'Movies now just a pale imitation' *The Australian*, 13 September, p. 4.

Bird, C. (ed.) 1998, *The Stolen Children: Their Stories*, Random House, Australia.

Bolter, J.D. and Grusin, R. 1999, *Remediation: Understanding New Media*, MIT Press, Cambridge (MA).

Conrad, P. 1998, *Modern Times, Modern Places*, Thames & Hudson, London.

Dudek, D. 2001, 'Talking about reality' *The Courier-Mail* (Brisbane), 13 October, p. 12.

Eccleston, R. 2001a, 'Fateful day will "change everything" ' *The Australian*, 13 September, p. 3.

—— 2001b, 'Shaken to its core, fortress America shuts itself down' *The Australian*, 12 September, p. 2.

Foucault, M. 1977, *Discipline and Punish*, Pantheon, New York.

Friedman, T.L. 2001, 'Make no mistake: this is World War III' *The Age*, 14 September, p. 19.

Fukuyama, F. 2001, 'Fighting the 21st century fascists' *The Age*, 5 January, p. 7.

Gaita, R. 2001, 'Do no evil' *The Age Extra*, 20 October, p. 4.

Ibish, Y. and Abunimah, A. 2001, 'Al Jazeera' *The Age Extra*, 27 October, p. 15.

Kakutani, M. 2001, 'The belief that the attacks will lead to kinder, gentler entertainment belies the historical record of reactions to tragedies' *The Age*, 20 October, p. 17.

Kaplan, E.A. 2001, 'Melodrama, cinema, trauma' *Screen*, vol. 42, no. 2, pp. 201–5.

King, P. 2001, 'New York' *The Age*, 14 September, p. 2.

Kristeva, J. 1982, *Powers of Horror: An Essay on Abjection*, Columbia University Press, New York.

Lacey, S. 2001, 'Terror Stories' *The Age Today*, 16 October, p. 1.

Landes, D. and Landes, R. 2001, 'She devils' *The Australian*,

10 October, p. 31.

Lusetich, R. 2001, 'A piece of reaction' *The Australian*, 18 October, p. 11.

Marks, P. 2001, 'A city learns to live with an unbearable absence' *The Age*, 19 October, p. 13.

Naudet, Gedeon and Naudet, Jules, 2002, *9/11*, documentary film, Woolf Stein.

Pasmantier, D. 2001, 'Story site helps ease the trauma' *The Australian*, 9 October, p. 2.

Pegler, T. 2001, 'For the first time in memory' *The Age*, 14 September, p. 2.

Rogers, K.L., Leydesdorff, S. and Dawson, G. 1999, *Trauma and Life Stories*, Routledge, London & New York.

Sheridan, G. 2001, 'World will never be same again' *The Australian*, 12 September, p. 3.

Smith, Z. 2001, '"This is how it feels", says Zadie Smith' *The Age Extra*, 27 October, p. 6.

Spencer, M. 2001, 'Cell phone saves buried survivors' *The Australian*, 13 September, p. 3.

Stein, G. 1984, *Picasso*, Dover, New York.

Stewart, C. 2001, 'When reality TV becomes too much' *The Australian*, 22–23 September, p. 9.

Tom, E. 2001, 'Get out and knock 'em dead' *The Weekend Australian*, 27–28 October, p. 22.

Woolf, V. 1967, 'Mr Bennett and Mrs Brown', in *Collected Essays*, vol. 1, Harcourt, Brace & World, New York.

11

The global self and the new reality

. . . how well we come through the era of globalisation—perhaps whether we come through at all—will depend on how we respond ethically to the idea that we live in one world.—Peter Singer, *One World: The Ethics of Globalisation*, 2002

In the 1990s media theorists—in response to the emergence of the new media and the Internet—proposed new concepts of the self. They saw these various formations of the self as emerging from the interaction of the individual with the new forms of global technology. (Some have responded extremely positively, others with more caution.) John Fiske has developed a concept of the self under surveillance, or the surveyed self. He argues that some areas of the new media are developing, or have already developed, the technological expertise to focus in on the individual, to gather information about the self, to target and study the individual—its tastes, preferences and desires—in order to sell more effectively goods and services. New technologies of data gathering, closed-circuit television cameras, sophisticated eavesdropping devices and the new generation of home-viewing media units, complete with the 'black box', have created a situation of high surveillance, in which the target is no longer a social group or class but the individual 'self'. No longer in control of the media world, the self is seen as an object of scrutiny and external control. Fiske describes this self as 'the smallest and most targeted market system yet devised' (Fiske 2000, p. 19).

Steven Spielberg's recent futuristic film *Minority Report* (2002) presents a terrifying vision of a society under extreme control.

Citizens are subjected to constant surveillance through 'retina' scrutiny; individuals are arrested and imprisoned for crimes they have not yet committed but of which the police have fore-knowledge. Peter Weir's *The Truman Show* (1998) explored the power of media authorities to control and make public the most intimate details of an individual's life right from the moment of birth. In that film, the media have become so powerful that they have, unbeknownst to the hero, constructed the media suburb where he lives in order to broadcast his 'life' to the world in the form of a soap opera. Hidden cameras subject his every movement to intense scrutiny and commentary from his devoted viewers.

Fiske's concept of the self under surveillance is similar to the views of other theorists who see the individual as an unwitting victim or object of scrutiny by the new media and the Internet. Kenneth Gergen, for instance, has argued that the individual, overwhelmed by the competing voices of the media, has been transformed into a 'saturated self': 'The fully saturated self becomes no self at all' (Gergen 1991, p. 7). Gergen and Fiske see the individual more as a passive object of media control and surveillance and are primarily interested in the question: What is the media doing to the individual? Other media critics such as Bolter and Grusin have adopted a very different position. They do not see the individual as being under surveillance or as an identity as determined by the media; rather they see the subject as a more proactive entity, able to draw upon the media in order to 'define both personal and cultural identity' (Bolter & Grusin 1999, pp. 231–2). Poster takes the argument further, proposing that the self is not a pre-given entity but that it is constructed in the context of its relation to the media. In his discussion of the effects of the Internet on subjectivity, Poster argues that 'Internet technology imposes a dematerialization of communication' and, as a consequence, 'a transformation of the subject positions of the individual who engages with it' (Poster 1997, p. 205).

This view of the self as transformative was discussed in depth during the 1990s. Media theorists such as Sherry Turkle contrasted older notions of identity as stable and 'forged' with the more fluid, multiple nature of the self in the new era. 'The

Internet is another element of computer culture that has contributed to thinking about identity as multiplicity. On it, people are able to build a self by cycling through many selves' (Turkle 1995, p. 178). The self was viewed as fluid and mobile, particularly in the way in which individuals expressed themselves as members of virtual communities (see Chapter 7). According to Turkle, many people began to 'experience identity as a set of roles that can be mixed and matched, whose diverse demands need to be negotiated' (Turkle 1995, p. 180).

Yet in these discussions of identity and the self, very little attention was paid to the politicised self and the ways in which the Internet could empower those who sought to address problems of global social justice. Some individuals were quick to exploit the power of the Internet as an instrument of social and political change. Through electronic mail, virtual bulletin boards and shared mailing lists, they addressed the world's humanitarian problems through global social and political action. One way of thinking about the self in relation to ethical issues is through the metaphor of the self as a global self, that is, the self as a virtual entity, able to transcend national and cultural boundaries, and with a global awareness of social justice issues. The power of the Internet to effect social change is all too often ignored in discussions of the negative effects of globalisation and the Internet.

In his book *One World: The Ethics of Globalisation*, the philosopher Peter Singer examines the crucial need for new forms of ethical behaviour necessary to meet the changes wrought by the economic rationalism of the 1980s and 1990s which gave rise to the concept of globalisation as an economic movement. He argues that in order to find solutions to the pressing issues of poverty, climate change, the deterioration of the environment, genocide and crimes against humanity, issues which demand global solutions, nations must begin to think globally. 'This line of thought leads in the direction of a world community with its own directly elected legislature, perhaps slowly evolving along the lines of the European Union' (Singer 2002, pp. 217–18).

Historically, there have always been visionaries, reformers and people of conscience who have attempted to bring positive

change to the world on a global scale; however, they did not have the benefit of the Internet, which has revolutionised the possibility of thinking and acting globally. The emergence of interactive communication technologies and the Internet have created conditions conducive to the emergence of a global self, that is, a virtual, transformative and empowered self with a global political and social agenda.

The Internet makes communication instant and immediate; it enables individuals from around the globe to communicate with others about issues such as social justice, poverty, race, gender, health and the environment. The Internet enables the individual to realise its potential to become globally interactive, communicative and open to change. For the world is now, more than ever before, directly 'around us'—it is only as far away as the World Wide Web, a computer screen, a mobile phone call, satellite or cable television news, an interactive Website or an email address. All of these communication forms are literally at our fingertips; they embody our seemingly insatiable desire for instant connection to the global networks.

Not every one agrees that these changes are significant. While the 'globalists' claim that the world is being dramatically and irrevocably altered, the 'anti-globalists' argue that such claims are exaggerated, perhaps, even unjustified. To the latter, globalisation is a myth, a new form of media hype that is completely lacking in foundation. The world, they say, is still composed of nations, people still define their identities in relation to place, nationalistic groups continue to defend their boundaries and declare war.

One change, however, which is indisputable, is the communications revolution. Globalisation would be impossible without the new developments in communications. Much has been said about economic and cultural change, less about global protest movements. It is crucial to consider the potentially positive—even radical—changes that have accompanied globalisation in relation to the individual's power to take part in processes that address humanitarian issues. If Peter Singer is right and the world's problems can only be solved at a global level, then we need to consider the kind of global subject that has the potential to usher

in change. Marshall McLuhan once described the power of the media—specifically television—to shrink the world to a 'global village'. At the other end of the scale, the Internet appears to have the power to expand the self into a global entity—a global self that has the potential to address the controversial area of global social justice.

Before examining the nature of the global political action that has emerged since the early 1990s, it is important to first consider the change in thinking which opened up the possibility of talking about a global self. The fact that a number of writers from Turkle to Fiske have attempted to define a new concept of the self indicates that they see the self not as a fixed entity but as one capable of transformation and change. In what sense is the self a construct, produced in response to the transformative powers of the media? Traditional modernist concepts regarded the self as unique, fixed and unitary. Postmodern theory, however, no longer sees the self as simply 'unique', or as a pre-existing divine essence; rather, the self is viewed as an entity constructed both by individual, personal experiences and by the world of which it is an inextricable part (Creed 1993).

The film *Memento* (2001) vividly demonstrates the constructed nature of the self. The hero has lost his short-term memory as a result of an accident; he 'exists' only in terms of the memories he has retained. In order to construct a new self living in the present, he inscribes all the information he receives onto his body. By reading the notes on his skin, and linking them together, he is able to produce continuity and create new memories—in so doing he recreates himself. The problem is, he cannot be certain if the information given to him is true or false. If it is false, his created self has been built on a pattern of lies and misinformation. This could, of course, apply to the construction of the self in real life—the individual must be continuously alert to the possibility that his or her perceptions may be based on misinformation, prejudice and distortions. As with other films about the creation of the self (*Persona*, 1966; *Blade Runner*, 1982; *Robocop*, 1987; *Being John Malkovitch*, 1999), *Memento* argues that the self is not a pre-given essence but a construction, a creation that is fluid, malleable, permeable.

It is this fluid, borderless constitution of the self—in the age of the Internet—that gives it the potential to transcend national and state boundaries and to see problems in a global context, problems that require global solutions. Just as developments in technology and changes in the world economy have led to globalisation, or what is described as a 'borderless' economy, developments in the media are creating a 'global self', a self without borders. Traditional views of the fixed nature of the self have no place in the postmodern, simulated, interactive world of the Internet.

Roland Robertson's concept of 'glocalisation' offers a particularly helpful way of thinking about the nature of the global self (Robertson 1992). He draws attention to the problem faced by those who claim that globalisation leads to the homogenisation of all areas of life. While Robertson accepts that the world is moving towards 'unicity', he argues against such a simplistic vision of the changes that are taking place. The complexities which mark the relationship between the global and the local have created a process he calls 'glocalisation', that is, a process in which global and local come together to create change. According to Robertson, the new global technologies (Internet, computer, digital video camera) combined with new modes of distribution (satellite, cable, community radio and television) have led to an increase in more local productions—from news programs to documentaries and soap operas—being broadcast to much wider audiences.

Robertson's proposal has direct relevance to the concept of the global self which is both a virtual self and a 'glocal' self, that is, a self grounded in the local and the global. The planet might be in the process of compressing and condensing many of its key activities, especially in the realm of economics and communications, but in other contexts it is a collectivity made up of differences—cultural, religious, racial, sexual—that are grounded in the local while simultaneously caught up in the global. In other words, the specific problems of oppressed and under-privileged groups, such as the religious, economic and social inequalities experienced by women in Afghanistan, have emerged from local, culture-specific conditions to be of concern to women globally.

Through the Internet, feminists in other countries have power to share information, rally support and organise electronic petitions. When women in non-first world countries gain access to new forms of communication technologies such as electronic mail they, in turn, will be able to communicate information about their problems to the global feminist community. As Rita Felski has argued, the global political concerns of feminism indicate a new feminist public sphere (Felski 1989). This public sphere is also a virtual feminist global sphere.

Human rights Websites also link the local to the global. OneWorld Online, the world's leading human rights Website (oneworld.net) organises protests with the aim of bringing local justice issues to the attention of the global community. In 2002, Oxfam organised a petition in relation to the legal claim lodged by Nestlé against the Ethiopian government for compensation in relation to a fall in the world price of coffee. According to OneWorld, over 40 000 people wrote to Nestlé in one month alone asking them to drop their claim. Not only did Nestlé reduce their claim from US$6 million to US$1.5, they stated they would immediately donate the money back for famine relief.

In their recent collection *Global Social Movements*, Robin Cohen and Shirin M. Rai argue that globalisation is not a unitary nor a one-dimensional process. Like Robertson, they see it as a two-way process, in which global forces such as multinational corporations shape the landscape from above while social movements create a new global awareness from below. They argue that a 'global public space or forum', brought about by the new media technologies, has emerged:

> The nationalist project was to make space and identity
> coincide . . . Today, a high degree of human mobility, together
> with telecommunications, films, video and satellite TV, and the
> Internet have created or regenerated trans-local
> understandings (Cohen & Rai 2000, p. 14).

In his 1998 article, 'Is there a global public sphere?', media theorist Colin Sparks evaluates the evidence. Sparks draws upon Habermas' definition of the public sphere as 'a realm of our social life in which something approaching public opinion can be

formed' and to which all citizens have access. 'A portion of the public sphere comes into being in every conversation in which private individuals assemble to form a public body'. Citizens form a public body when they have 'a guarantee of freedom of assembly and association and the freedom to express and publish their opinions—about matters of general interest' (Habermas, quoted in Sparks 1998, p. 110).

Sparks examines the various media that Habermas, in 1964, specified as constituting the media of the public sphere: newspapers and magazines, radio and television. Extending Habermas' definition to include newer global forms of the mass media, such as satellite television, Sparks carefully evaluates the situation and concludes that 'the evidence of globalisation in the mass media is weak'. He rightly points out that the existence of media with a global reach 'is not in itself evidence of globalisation', and concludes that 'there is no evidence for the emergence of a global public sphere'. Given the national content of most new media, the existence of government regulation and the prevalence of national, not global, distribution, a better term, he argues, would be 'imperialist private sphere' (Sparks 1998, pp. 115–22).

Sparks, however, does not discuss the Internet, which I would argue offers a very different situation and constitutes a virtual public sphere; the Internet does guarantee freedom of association and freedom of expression. Although not all citizens as yet have access to the Internet, it can guarantee the basic freedoms set out by Habermas. It offers a virtual meeting space in which individuals are free to express their opinions and take action—via electronic mail and human rights Websites—on matters of public interest. As with the conventional media, however, those participating in electronic fora cannot be guaranteed anonymity or freedom from persecution for their beliefs.

Anuradha Vittachi, the co-founder, along with Peter Armstrong, of OneWorld, offers relevant information on this issue in her discussion of 'cybercitizens' (Vittachi 1998, p. 238). Vittachi and Armstrong set up OneWorld Online in 1995 as the Internet voice of the OneWorld Broadcasting Trust. The latter incorporated the traditional media—television and radio—

which, along with the press, Habermas specified as constituting the media that transmitted information in the public sphere. To the surprise of its founders, OneWorld Online quickly became a dominant voice in the global human rights movement; within six months its two full-time staff members had become twenty. Vittachi claims that OneWorld Online's astonishing success was due to the fact that it was designed as a 'gateway'. The traditional media promote their own editorial positions and organisational aims—OneWorld Online does neither:

> Amnesty International tells you about Amnesty's work. Oxfam about Oxfam's. OneWorld, however, tells you about the work of both—and also of the other 280 OneWorld partners from all over the world working in the field of global justice . . . Each of OneWorld's partners has their own, independent Website, where they have complete editorial autonomy. The OneWorld editorial team never changes a word of their documents (Vittachi 1998, p. 240).

OneWorld publishes statements by government bodies or groups that seek to defend actions which others regard as a violation of social justice; there is a shared 'supersite' where Internet users can find material from all of the OneWorld partners, material that is catalogued under themes such as 'racism' or 'child labour', as well as the 'Blast Chamber' and Think Tank Colloquia where people can express their views.

Vittachi is very clear about the issue of control and access. It is crucial that OneWorld users know that it is open and free space:

> OneWorld's job is to provide a citizen's space—and one with a sufficiently high profile, so that people know that this is an open space where readers from NGOs, research bodies, schools, universities, journalists, broadcasters, or people who are just casual surfers can speak, or listen, seriously to their fellow human beings on issue of global justice (Vittachi 1998, p. 240).

Unlike the traditional media which, as Sparks demonstrates, are most accurately described as offering an 'imperialist private sphere', OneWorld Online has successfully realised the potential of the Internet to create a virtual public sphere dedicated to issues

of global justice which clearly come under Habermas' category of 'matters of public interest', defined as crucial to the work of the public sphere. Vittachi describes OneWorld Online as 'a kind of standing conference on global justice, available twenty-four hours per day, 365 days a year' (1998, p. 240). She describes people who participate in some way on the OneWorld Website as 'cybercitizens'. This term points to the changing nature of the public sphere in the age of the Internet. The cybercitizen is informed and responds about issues of social justice in a virtual space, a space which crosses national and state boundaries, a space in which information flows are not restricted, subject to editorial control or bombarded by commercial advertising.

Vittachi's 'cybercitizen' describes the new concerned individual who has become an activist in the virtual public sphere. I have used the term the 'global self' to emphasise that in the age of the Internet, there has also been a fundamental shift in the way we think about identity—a shift that is not captured by the term 'cybercitizen'. As discussed earlier, the global self has developed a new sense of identity, one that is more fluid and open to the possibility of change. In addition, the global self thinks and acts in a global sphere not just in relation to the virtual world, but also in relation to other avenues of political action offered by alternative media, which have made global protest possible. The kinds of actions taken by global social movements range from Earth and women's summits to international consumer boycotts, telethons, concerts and festivals of political films. Cohen and Rai (2000) argue that access to the new communication technologies is vital for social movements. Empowerment in one area—the Internet—leads to empowerment in many others.

The Internet and new technologies can also offer assistance to poorer peoples in unexpected ways. An article entitled 'Casting the Net wider', published in *The Australian* (2001), described a number of ways in which the new communication technologies benefit people worldwide. In a number of fishing villages on the Bay of Bengal an Internet linkup with a naval Website allows villagers to broadcast weather reports over a loudspeaker, to determine the market price of their fish and to download satellite images that pinpoint the whereabouts of shoals of fish. The

Internet also offers a cheap way of accessing medical knowledge and research. The local Medinet site in Bangladesh provides doctors with access to expensive medical journals for under US$1.50 a month. Global Websites such as Healthnet allow doctors in poor countries to keep up with the most recent developments and discoveries in their field. In a number of poor countries, villagers have joined together to purchase a communal mobile phone; this purchase connects the remote village with the outside world.

In his article 'Enmeshed in the Web? Indigenous peoples' right in the network society', Paul Havemann points out that information and communications technologies are employed by 'tribal, pan-tribal, regional and global indigenous peoples' alliances', enabling them to act 'in supra-state and international fora that seem open to assisting their empowerment' (Cohen & Rai 2000, p. 30). Cohen and Rai see social protest and political action as becoming 'more unconventional, open, participatory, direct and focused'. In particular, they emphasise the vital role played by the Internet and the access social movements have to the new information and communication technologies.

The Internet brings new ideas and possibilities, transforming experiences at the local level through knowledge obtained from the global community. Many political and protest groups, such as Greenpeace, women's groups, indigenous groups and gay rights groups, use the Internet and new media to carry out political action across the globe—a phenomenon now known as 'popular globalisation'. It is from this latter complex network of global formations that the active, political form of the global self emerges. Mary Robinson, former United Nations Commissioner for Human Rights, discussed the emergence of a new civil society on a BBC program, *Talking Point* (also a simultaneous Webcast). She pointed to the way individuals dissatisfied with the actions of their own governments used the Internet to present their own views to the relevant United Nations bodies on issues of human rights and global social justice, citing as an example reaction to the plight of refugees in Australia (Robinson 2002).

There is a danger that in times of global crisis, such as war, individuals will withdraw from the global community. Some

theorists argue that since September 11 a new dynamic may have entered the arena—a certain wariness about becoming open. According to Australian academic Anthony Milner, the growing sense of 'interconnectedness' brought about by the new media is likely to become 'an interconnectedness that will promote not a genuine internationalism but a global tribalism' (Milner 2001, p. 13). Alternatively, it is also possible that the borderless world of the new media, in its power to bring people together during periods of crisis, will not create 'global tribalism' but rather strengthen the power of the global self as a force for social, political and economic change.

In his study of migration, globalisation and turbulence, cultural theorist Nikos Papastergiadis (2000) argues that the movement of people around the globe, unprecedented in its scale and complexity, is part of a broader pattern of movement, which seeks to unite rather than divide people. For example, in 2000, it was estimated that half a million illegal migrants and asylum seekers entered Europe, fleeing totalitarian governments in Africa, Asia and the Middle East. If, however, the citizens of democratic nations respond to these refugees with racist attitudes and attacks, the potential for a more unified and united world will be severely curtailed. The global migration of peoples, the plight of the refugee seeking safe harbour—these are key factors that have the potential to shape the nature of the emerging global self as a force for positive change.

If globalisation's positive potential is to be realised fully, nations will need to confront those periods—past and present— in which acts of racism, intolerance and aggression were inflicted on other peoples, in particular the refugee and other victims of war. The global self has the potential to transcend national barriers and as such is able, through the Internet, to work outside the territorial, cultural and religious boundaries of the nation-state. Despite this the individual is still situated in the local; hence the importance of seeing this newly emerging form of identity as constructed through the interrelationship of local and global. If nations are to confront their own unjust actions, the impetus is most likely to come from individuals and groups seeking forms of reconciliation and redress from their nation-states.

Globalisation, postmodernism and the new digital media are changing not only the way in which we communicate, but also our sense of community and our sense of self and of others. They have given birth to the potential for the emergence of a global self—a self which is virtual, fluid, conscious of both its immediate local world or community and of the other 'worlds' and peoples which make up our planet. Born not into the familiar uterine waters of the human womb, the global self navigates through the boundary-less, unmapped domain of cyberspace. The journey is not necessarily a smooth one, however; just as the world operates in contradictory and ambivalent ways, so also the emerging global self has to learn to navigate turbulent waters, but it carries in its wake the potential to change the world for the better.

References

Appadurai, A. 1996, *Modernity at Large: Cultural Dimensions of Globalization*, University of Minnesota Press, Minneapolis.

Bolter, J. D. and Grusin, R. 1999, *Remediation: Understanding New Media*, MIT Press, Cambridge, Mass.

Bukatman, S. 2000, 'Special effects, morphing magic, and the cinema of attractions', in V. Sobchack (ed.), *Meta Morphing*, University of Minnesota Press, Minneapolis.

'Casting the Net wider' from *The Economist*, republished in *The Australian*, 'Cutting Edge', 11 December 2001, pp. 1–2.

Charney, L. and Schwartz, V.R. 1995, *Cinema and the Invention of Modern Life*, University of California Press, Berkeley.

Cohen, R. and Rai, S. M. 2000, *Global Social Movements*, The Athlone Press, London and New Brunswick, NJ.

Creed, B. 1993, 'From here to modernity: feminism and postmodernism', in J. Natoli and L. Hutcheon (eds), *A Postmodern Reader*, State University of New York Press, Albany, pp. 398–418.

Deleuze, G. and Guattari, F. 1987, *A Thousand Plateaus*, The University of Minnesota Press, Minneapolis.

Felski, R. 1989, *Beyond Feminist Aesthetics: Feminist Literature and Social Change*, Harvard University Press, Cambridge, Mass.

Fiske, J. 2000, 'Surveillance and the self: some issues for cultural

studies', abstract of paper presented at the *Television: Past, Present and Futures* Conference, The University of Queensland, Brisbane.

Gergen, K.J. 1991, *The Saturated Self*, Basic Books, New York.

Grodin, D. and Lindlof, T.R. (eds) 1996, *Constructing the Self in a Mediated World*, Sage, London.

Hannerz, U. 1990, 'Cosmospolitans and locals in world culture', in Featherstone (ed.), *Global Culture*, Sage, London, pp. 237–51.

Huyssen, A. 1986, 'Mass culture as woman: modernism's other', in T. Modleski (ed.), *Studies in Entertainment*, Indiana University Press, Bloomington and Indianapolis, pp. 188–207.

Ling, L.H.M. 1999, 'Sex machine: global hypermasculinity and images of the Asian woman in modernity' *Positions*, vol. 7, no. 2, Duke University Press, pp. 277–306.

McDonald, H. 2001, *Erotic Ambiguities: The Female Nude in Art*, Routledge, London.

Milner, A. 2001, 'It'll be life, but not as we knew it' *The Australian* 26 October, p. 13.

Papastergiadis, N. 2000, *The Turbulence of Migration: Globalisation, Deterritorialization and Hybridity*, Polity Press, Cambridge.

Poster, M. 1997, 'Cyberdemocracy: Internet and the public sphere', in D. Porter (ed.), *Internet Culture*, Routledge, New York and London, pp. 201–18.

Robertson, R. 1992, *Globalization: Social Theory and Global Culture*, Sage, London.

Robinson, M. 2002, *Talking Point* Special, Mary Robinson, Live Webcast. http://news.bbc.co.uk.I/hi/talkingpoint/forum/1673034.stm

Singer, Peter 2002, *One World: The Ethics of Globalisation*, Text Publishing, Melbourne.

Sparks, Colin (1998), 'Is there a global public sphere?', in Daya Kishan Thussu (ed.), *Electronic Empires: Global Media and Global Resistance*, Arnold, London, pp. 108–24.

Tomlinson, J. 1999, *Globalization and Culture*, Polity Press, Oxford.

Turkle, S. 1995, *Life on the Small Screen: Identity in the Age of the Internet*, Simon and Schuster, New York.

Vittachi, Anuradha 1998, 'The right to communicate', in Daya Kishan Thussu (ed.), *Electronic Empires: Global Media and Global Resistance*, Arnold, London, pp. 231–42.

Index